GUNG HO!

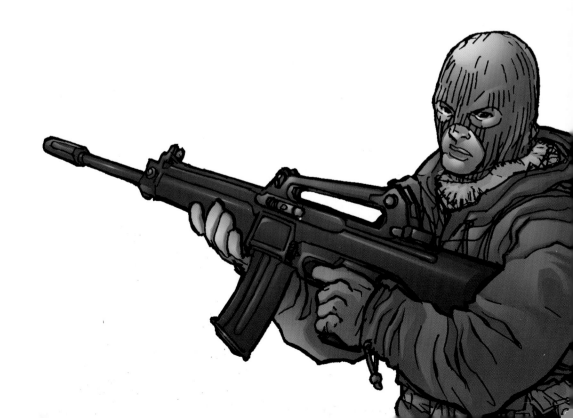

HO!
Fantastic Military Comics

Steve Miller

Watson-Guptill Publications
New York

This book is dedicated to my wife, Heather, the best thing to come out of my enlistment in the U.S. Army.

Art credits: Images not credited here are by Dan Norton. Most of the coloring was done by Jospeh Damon. Selected pieces were colored by Jessica Ruffner-Booth and Steve Miller.

Brett Booth: 45, 55 (arms dealer), 56 (handler), 81 (bottom)

Jason Pederson: 87, 120

Steve Miller: 16–19, 23 (foreshortening), 26–29, 36–39, 42 (top), 66, 71, 76, 97, 109–109 (steps), 116–117, 126–127, 142, 144

About the Title

The origin of Gung ho! is the Mandarin *gonghe*, itself derived from a longer phrase meaning, literally, "industrial worker's cooperative." It was first used by Major Evans F. Carlson as a rallying cry when he commanded the 2nd Marine Raider Battalion during World War II, and for three generations of U.S. Marines, *Gung ho!* has stood for the almost mythical fighting spirit and bonds that develop among members of the United States Marine Corps.

Senior editor: Candace Raney
Editor: Sylvia Warren
Senior Production manager: Ellen Greene
Designer: Jay Anning, Thumb Print

ISBN-13: 978-0-8230-1661-7
ISBN: 0-8230-1661-7

First published in 2006 by Watson-Guptill Publications,
a Division of VNU Business Media, Inc.
770 Broadway, New York, N.Y.
www.wgpub.com

Library of Congress Control Number: 2005935682

Printed in the United States
First printing, 2006

1 2 3 4 5 6 7 8 9 / 10 09 08 07 06

Contents

About the Artists

Arthur Adams has been involved in the comics industry since the early eighties. Arthur combines a dynamic, lively, and often humorous style with well-planned layouts and incredible attention to detail. His credits are legion. Suffice it to say that he has worked for every major comic book publisher in America. Adams's fan base is so well established that he is considered the first choice whenever a cover artist is needed to help attract readers to a new series.

Brett Booth wrote and penciled Wildstorm Productions' *Kindred, Backlash, Wildcore,* and *Backlash/Spider-Man* comic books. He was also the artist on Wildstorm/DC's *Thundercats: Dogs of War* and *Extinction Event.* At Marvel Comics he penciled *Heroes Reborn: Fantastic Four, X-Men Unlimited,* and *X-Men.* Check out his website at demonpuppy.com.

Robert Burrows, who runs his own advertising/design consulting agency, wears many hats, including teacher of combat pistol craft. An expert on firearms, Burrows maintains a Web site—rbgungraphics.com—which features many of his gun-themed artwork. He is currently working on a book, *Illustrated Combat PistolCraft.*

Joe Kubert, one of the best war comics illustrators of all time, has a number of current titles on the stands, including *Sgt. Rock and the Prophecy*, a six-issue miniseries for DC Comics that debuted in January 2006. In addition to running the Joe Kubert School of Cartoon and Graphic Art (Web site: www.kubertsworld.com), he produces *PS Magazine* for the U.S. Army, which uses cartoons to instruct soldiers on preventive maintenance.

Steve Miller is an author and artist who has worked in numerous areas of the entertainment field. His drawings have been used in the production of videos, toys, RPGs, and video games. Steve's latest book is *Thunderlizards: How to Draw Fantastic Dinosaurs.* He lives in Ohio with his wife and two children.

Dan Norton, with 11 years in the business and a lifetime love affair with comics, movies, and video games, has drawn some of the most famous comics characters of the past generation, including X-Men, Spider-Man, and Batman. He has also done conceptual design for several major film and game titles, including *Star Wars Episode III: Revenge of the Sith*, Brittney Spears's video *Toxic*, and Sony's *Everquest.*

Jason Pederson is an illustrator living and working in the Los Angeles area.

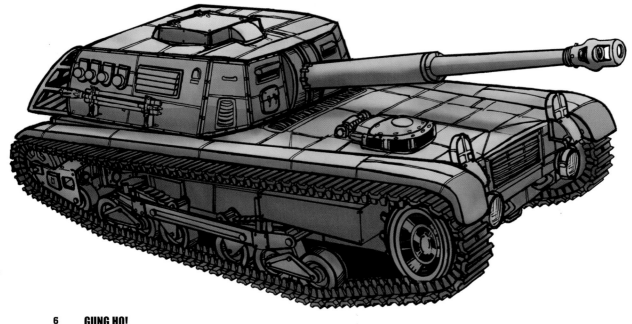

From the Author

War comics offer compelling subject matter for graphic depictions of life-and-death struggles. Depending on the point of view of the writer/artist, the story line can condone or condemn the military action taken, or take a neutral, academic approach, presenting the "facts" and letting the readers decide for themselves. The main characters can be depicted as courageous heroes or as dangerous warmongers. Graphic tales of war may generate excitement in those who revel in war or arouse disgust in those who oppose it. But the effect of a top-notch war story of military action accompanied by dynamite illustrations can transcend a reader's personal view of war.

Drawing war comics gives you the chance to illustrate the universal themes of good vs. evil, life vs. death, man vs. man. And what other subject offers the opportunity to draw aircraft performing high-velocity barrel rolls, thundering tanks tearing up the terrain, Special Forces teams overrunning enemy strongholds, massive rescue operations, warships with fully operational airfields, missile-launching nuclear subs hidden deep in the ocean's depths, and countless other fantastic scenes.

This book is designed to run you through the rigors of a full-force artistic boot camp. In short, it will equip you with what you'll need to survive on the front lines of the world of professional illustration. In the process you'll be transformed from a wannabe soldier-artist into a full-fledged veteran of cartooning combat with all the Right Stuff for total victory.

A Few Words About the Art

The vast majority of the characters, weapons, and vehicles in this book are based on real-world military models. For most of the real-world vehicles, and some of the weapons, I have provided a specifications list, to be used as a general reference only, containing information on such items as dimensions, power source, performance, armament, etc.

In some cases, the images are based on designs that are still on the drawing board, and a few pieces are fantastic examples of what the army of tomorrow may look like.

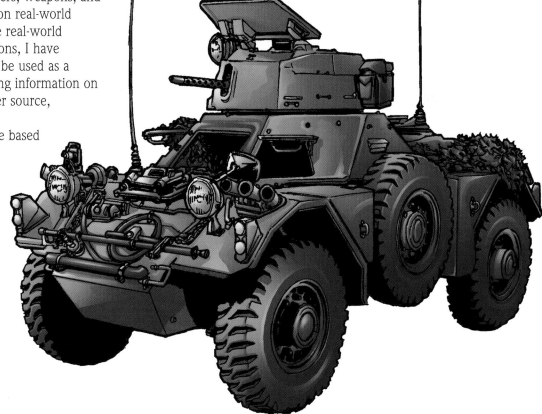

A Brief History of War Comics

Over the past 65 years, war comics have featured most of the biggest and brightest names in the business: Jack "King" Kirby (1917–1994); Will Eisner (1917–2005), who started the preventive maintenance comics *Army Motors* and *P*S The Preventive Maintenance Monthly* for the U.S. Army; Joe Kubert (1926–) and Russ Heath (1926–), renowned for their runs on DC's *Sgt. Rock*; Harvey Kurtzman (1924–1993); and the EC stable of artists, including Wally Wood, Jack Davis, George Evans, and B. Krigstein. Michael Golden, artist for Marvel's *The 'Nam*, and Mike Zeck, artist for Marvel's military vigilante comic *The Punisher*, get gold stars for their military comic service. Comics masters like Dick Dillin, Howard Chaykin, and David Cockrum all cut their artistic teeth illustrating combat tales. Illustrating war comics is one of the most grueling regimens an artist can take on, but the payoff—much like the payoff for enduring boot camp—is the honing of one's abilities.

The history of war comics is almost as old as the comics medium itself. In 1933 Max Gaines printed what is widely accepted as the true first American-style comic book, *Funnies on Parade*. It was really only a reprint of the Sunday funnies in a handier format, but it proved to be extremely popular. The first costumed adventure hero, the Phantom, didn't debut until February of 1936, but by then, comics had started to move beyond funny-animal stories to focus on realistic adventure tales featuring human characters. In the late 1930s, a staple of war stories in the United States was World War I–era biplane dogfights, but once Hitler and his Nazi army began to escalate their aggressive military actions across Europe, comics started to showcase themes that reflected the times. Martin Goodman, the publisher of Timely Comics, which eventually became Atlas Comics, decided to incorporate his growing unease with the Third Reich's conquests into his comic book story lines. As early as February 1940 Atlas Comics were depicting characters who were battling evil Nazi hordes—almost a year before President Franklin D. Roosevelt gave his famous "Day of Infamy" speech declaring war on Japan.

In May of 1940, Dell introduced the first comic devoted entirely to war, the aptly titled *War Comics*. Soon the anti-Nazi theme would become the predominant story line for almost all action and adventure comics. Quality Comics enlisted the help of Will Eisner to create the Blackhawks, a band of Nazi-battling fighter pilots from Europe's free countries, whose first appearance was in *Military Comics* #1 (August 1941). Except for a few realistic titles like *War Heroes* (July 1942), most war stories during the 1940s were tales of costumed heroes with super powers pummeling grotesquely cartooned Nazis and the widely vilified Japanese. Timely's *Captain America* #1 (March 1941) showed that red, white, and blue super soldier clocking Adolph Hitler on the jaw. DC even allowed a group of globe-trotting kids known as the *Boy Commandos* (1942) to tackle the Axis powers.

Television wasn't introduced into American households until 1946, and what the public knew of the war was transmitted over the radio waves or published in newspapers and magazines. The dramatically visual accounts of World War II featured in comics were a hit

Is there any doubt that Art Adams's archetypal G.I. will, against all odds, be able to take out the rest of his enemies?

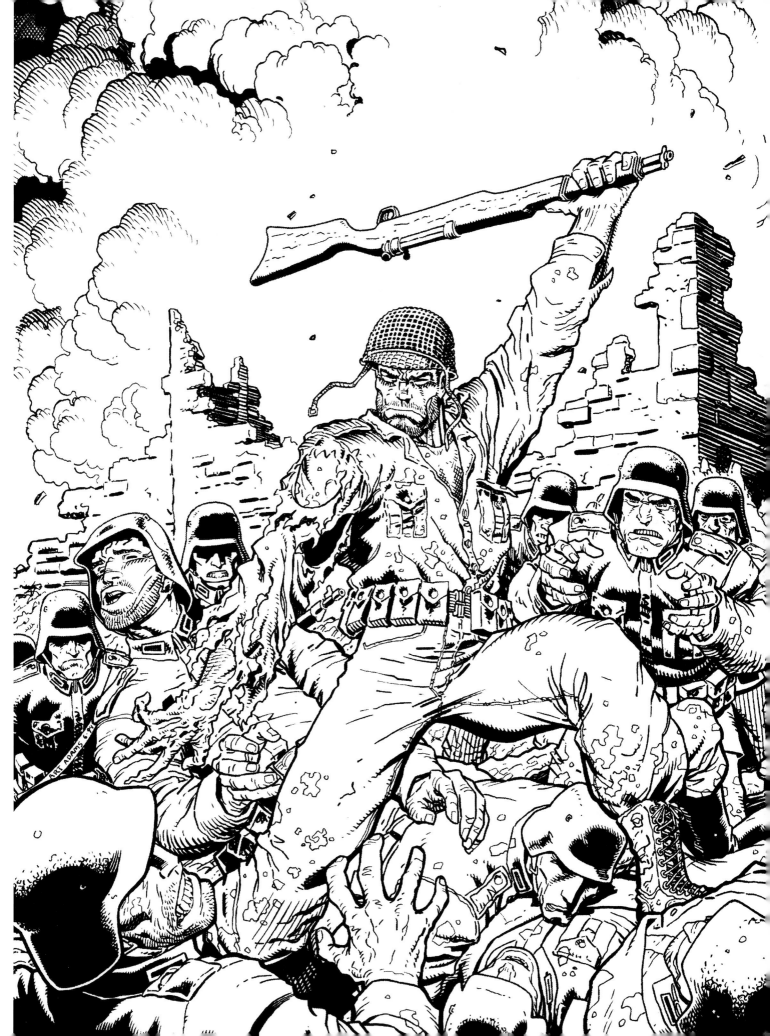

with civilians and soldiers alike. Although paper shortages caused by the war somewhat limited the expansion of new comics titles, by the end of 1943 publishers were selling 25 million copies a month and the industry was worth $30 million.

Several things happened during the mid and late 1940s that diminished the public's appetite for cartoon combat violence. First, after VJ Day, war was no longer center of the public's attention. Second, the carnage wrought by the atomic bombs dropped on Hiroshima and Nagasaki created an undercurrent of unease among Americans: Weapons existed that could annihilate all of humanity. Third, in the late 1940s, the television boom really took off, and by 1949 close to 1 million homes had TV sets. Real-world war stories broadcast on the evening news were stiff competition for comic book tales, and comics writers focused on threats from space and monstrous creations from scientific experiments gone awry.

During the Korean War (1950–53), interest in war comics again boomed. DC Comics began its war comic blitzkrieg with *Star Spangled War Stories* (August 1952) and *Our Army at War* (August 1952). Atlas Comics (soon to be renamed Marvel Comics) offered up *War Adventures* (January 1952) and *War Action* (April 1952).

The war comics published during the Korean conflict depicted the war with increasingly realistic and gritty images and story lines. The traditional tales of extraordinary valor—usually ending with the complete annihilation of the enemy and accomplished with relative ease and little loss of life on the U.S. side—were still featured, but story lines underscoring the misery and anguish of war became more common and wartime devastation was illustrated in horrific detail. One of the forces behind the change in tone was driven by artists who themselves had recently returned from tours of duty. Characters were allowed to show a larger range of emotions, including fear, remorse, and a greater sense of their own mortality.

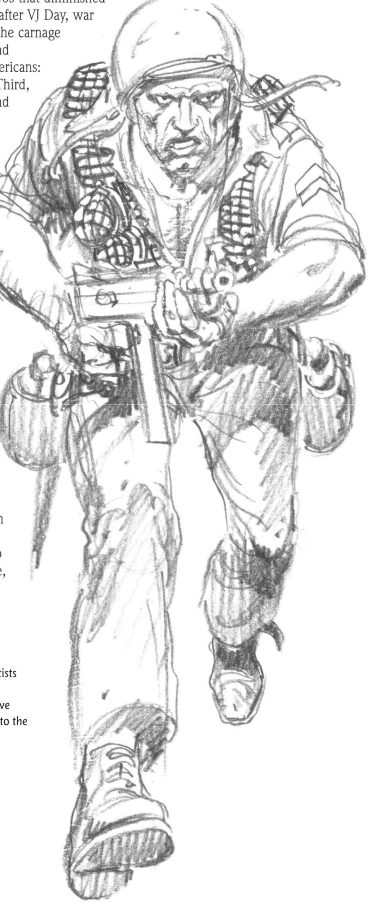

Joe Kubert, one of the best war comics artists ever, here pays his trademark attention to realistic detail, from the two-chevron sleeve indicating that the character is a corporal to the well-worn regulation-issue boots.

The war comics published by Marvel and DC sold well, and other publishers soon followed their lead: Ace's *War Heroes* (May 1952), Charleson's *Fightin' Airforce* (February 1956), *Fightin' Army* (January 1956), *Fightin' Marines* (May 1955), *Fightin' Navy* (January 1956), Farrell's *War Stories* (September 1952), Fawcett's *Battle Stories* (January 1952), Harvey's *Warfront* (September 1951), Hillman's *Frogman Comics* (January 1952), and Toby Press's *Fighting Leathernecks* (February 1952) all shared space on the newsstand racks.

During the 1950s EC Comics began to publish what many today consider to be the best war comics of all time. EC was founded by Max Gaines, the same man responsible for that first comic book, printed back in 1933. In 1945 Max sold most of his creative properties to DC Comics and used the profits to start a new comic book company, Educational Comics. Educational Comics became Entertaining Comics, which was later known simply as EC Comics. Initially, EC concentrated on humorous all-ages fare that proved mildly but steadily profitable. On August 20, 1947, Max Gaines was killed in a boating accident, and his son, William M. Gaines, steered the publishing house into new waters, eschewing the funny-animal stories his father had concentrated on to target an older audience. Harvey Kurtzman (1924–1993), a highly talented young artist and writer, began working on a war title called *Two-Fisted Tales*. *Two-Fisted Tales*, and eventually EC's second war title, *Frontline Combat*, featured realistic stories and artwork based not just on the Korean conflict but also on other battles from America's recent history.

Over at Atlas, now known as Marvel Comics, John Romita, who had begun moonlighting for Marvel in 1951 while he was still serving in the Army, was busy reinventing Captain America as a hero for the 1950s. A few years later DC would offer up a totally different kind of super soldier: the wildly successful Sgt. Rock. *Our Army at War* #81 (April, 1959) featured a WWII unit known as Easy Company led by a hard-driving sergeant known then as "Rocky." Primarily the brainchild of Robert Kanigher (writer/editor) and Joe Kubert (artist), Rocky proved so popular he carried the comic for almost two decades. In March of 1977 (issue #302) *Our Army at War* was finally renamed *Sgt. Rock*. Sergeant Rock's run lasted another 11 years, until falling sales brought his comics career to an end—something no enemy force had been able to do. The final issue, #422, was published in July, 1988.

Not to be outdone, Marvel turned loose its powerhouse writer/artist team of Stan Lee and Jack Kirby to create their own WWII comic, *Sgt. Fury & His Howling Commandos* (1963). *Fury* was not quite as popular as DC's *Sgt. Rock*, but he still managed to tough out an impressive 17-year run, which ended in 1981. Along the way, Sgt. Nick Fury became an agent of S.H.I.E.L.D. (1965). Today—thanks in part to the help of a youth restorer, the so-called "Infinity Formula"—Fury oversees S.H.I.E.L.D.'s latest incarnation in the Marvel universe.

In July 1962, Dell's *Jungle War Stories* carried the first story featuring the growing conflict in that part of Southeast Asia known to the West since the mid-19th century as Indochina (Laos, Cambodia, and Vietnam). Dell also showcased Vietnam material in other titles, such as *Combat* (October 1961) and *Air War Stories* (July 1964). January 1967 saw the launch of *Tales of the Green Berets*, a book totally devoted to presenting U.S. actions in Vietnam in the most accurate, unbiased manner possible.

As public opposition to the Vietnam conflict grew, publishers decided to return to the story lines that had been successful in the past, although DC's core war titles from the fifties continued to thrive long into the sixties. *Our Army at War* #151 (February 1965) introduced another enduring war hero, Enemy Ace, a WWI fighter pilot whose aerial exploits streaked across several DC titles and who turned up in a 1990 graphic novel and several war comics published at the turn of the century.

The seventies saw the infusion of mystery, sci-fi, and horror into tales of military bravado in DC's *Weird War Tales* (September 1971) and *G.I. War* (1973). Time travel, ghosts, dinosaurs, G.I. Robot, and the Creature Commandos (werewolf, vampire, and Frankenstein-type monster in fatigues) all shared space under one cover. *Weird War Tales* even featured introductions by Death personified, who bore a more than passing resemblance to EC Comics' Cryptkeeper.

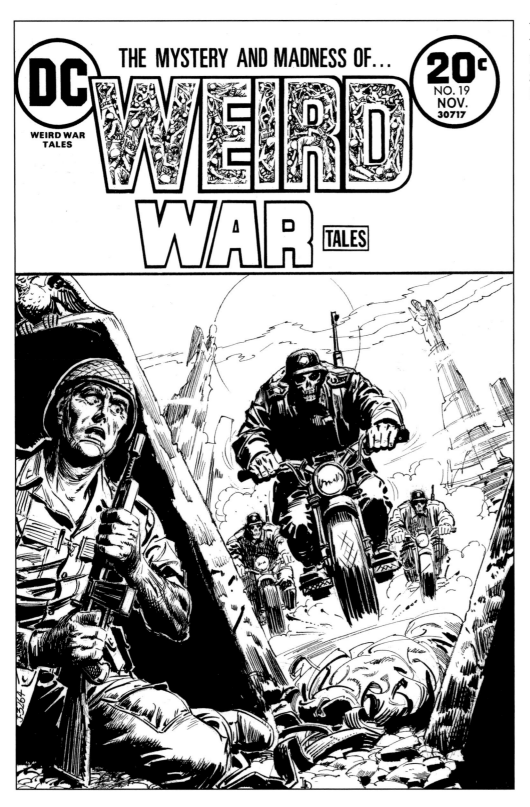

This issue of DC's Weird War Tales hit the stands in November, 1973. Clearly, a graveyard was the wrong hiding place for the hapless G.I.

Issue #151 of *Star-Spangled War Stories* (June 1970) introduced the world to the bandage-encased Unknown Soldier, an enigmatic operative for the Allied forces during WWII. More traditional military action was being covered in *Sgt. Rock* and the new DC title *Men of War* (1977), but by the end of the decade it seemed that comics with purely military themes had been permanently muscled out by spandex-clad icons with super powers.

In the eighties, Marvel would breach the frontline with three successful war comics actions. The first was the launch of *G.I. Joe* as a comics title. Buoyed by the success of the Hasbro toy line and an animated cartoon show, *G.I. Joe* enjoyed a popular run from June of 1982 until December of 1994. A riskier Marvel mission was the publication of *The 'Nam* in December of 1986. *The 'Nam*, a graphic novel intricately illustrated by Michael Golden and edited by *G.I. Joe* scribe Larry Hama, took the novel approach of following one soldier's Vietnam military career from boot camp to his combat experience in the jungle. A third Marvel title, *Semper Fi* (1988), featured tales of the Marine Corps.

True stories of Medal of Honor recipients were retold in Dark Horse's *Medal of Honor Special* (April 1994) and a *Medal of Honor* miniseries (October 1994). In 1995, Dark Horse briefly tried to revive the G.I. Joe line with a four-issue miniseries (December 1995) and later an ongoing series (June 1996). The latter lasted only four issues before being retired from active duty. In September 2001 Devil's Due updated the look and feel of Joe and his team, bringing them into the 21st century, both barrels blasting. DC/Wildstorm continued the assault by creating a successful merger of the war comic genre and the superhero genre with titles such as *Stormwatch: Team Achilles* and *WILDC.A.T.S: Covert Action Team*.

War comics have always given artists the opportunity to illustrate timeless stories of self-sacrifice, courage, camaraderie, valor, tenacity, honor, and pride, themes that seem to work especially well when the characters are in uniform. But today's artists have many opportunities to develop such stories in media other than comics. Working in the comics industry is still a great way to hone your drawing skills, but artists with the ability to draw exciting military characters and equipment are needed to do animation, movie storyboards, video games, toy design, and numerous other illustration jobs. So grab your pencils and prepare to become part of a long and prestigious history. You, too, can become one of the few, the proud, the military artists!

The term grenade is derived from the French word for pomegranate. European soldiers in the 16th century used round pomegranate-sized bombs containing large grains of gunpowder that resembled pomegranate seeds.

Basic Training

All right, listen up you pencil pushers! I'm going to take you undisciplined comic artist wannabes and transform you into highly trained illustrators of war! You will be able to use the skills you learn in basic training to surround your enemies and completely erase them from the face of the planet—or maybe just from your drawing board. All eyes front and center. I know you are anxious to start drawing spectacular scenes of combat, but we need to make sure you have the proper understanding of drawing basics before we send you off to the front lines. If you pay attention, you'll learn what separates the real medal-of-honor artists from the garden-variety noncombatant scribblers. So pay attention recruits! You have just been drafted into the cartoonist army, and you should prepare to draw more before 9 A.M. than you've been used to drawing all day.

Okay, okay, you don't have to start before 0900 hours, but you better be prepared to put in some serious grunt time on mastering your artistic skills. First and foremost you will need to master the art of self-discipline—you will not always have the benefit of Drill Sgt. Miller breathing down your neck. Artists may be born with a gift, but they hone that gift through grueling hours of practice until it is as sharp as a soldier's bayonet. Never miss an opportunity to sketch, never give up, and never surrender. So secure your drawing boards and get ready for an all-out attack on the beachhead of combat cartooning.

Basic Drawing Skills

Just as being a soldier involves a lot more than having the proper gear, being a successful artist requires a lot more than requisitioning the best art supplies. In either case, you have to know how to use your equipment to maximum advantage. Following are some short but important explanations of essential rules. Learn them. Live them. Love them.

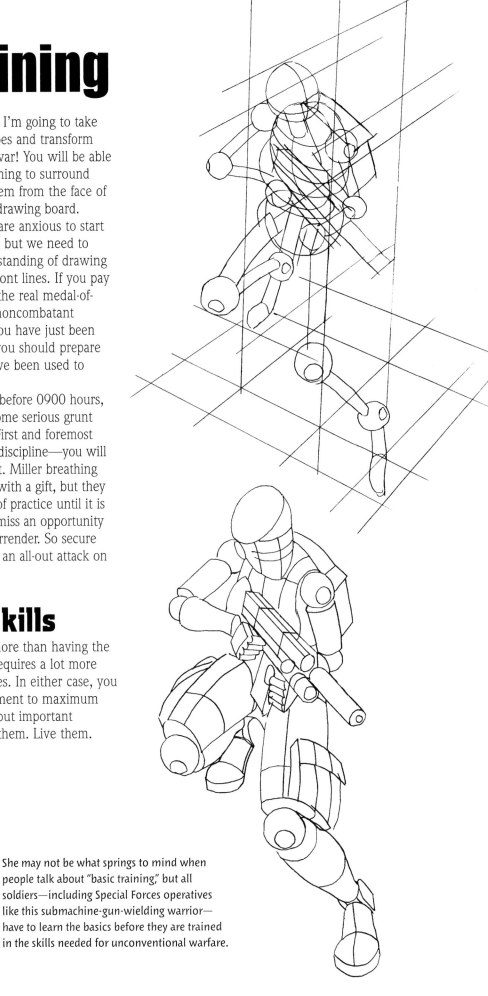

She may not be what springs to mind when people talk about "basic training," but all soldiers—including Special Forces operatives like this submachine-gun-wielding warrior— have to learn the basics before they are trained in the skills needed for unconventional warfare.

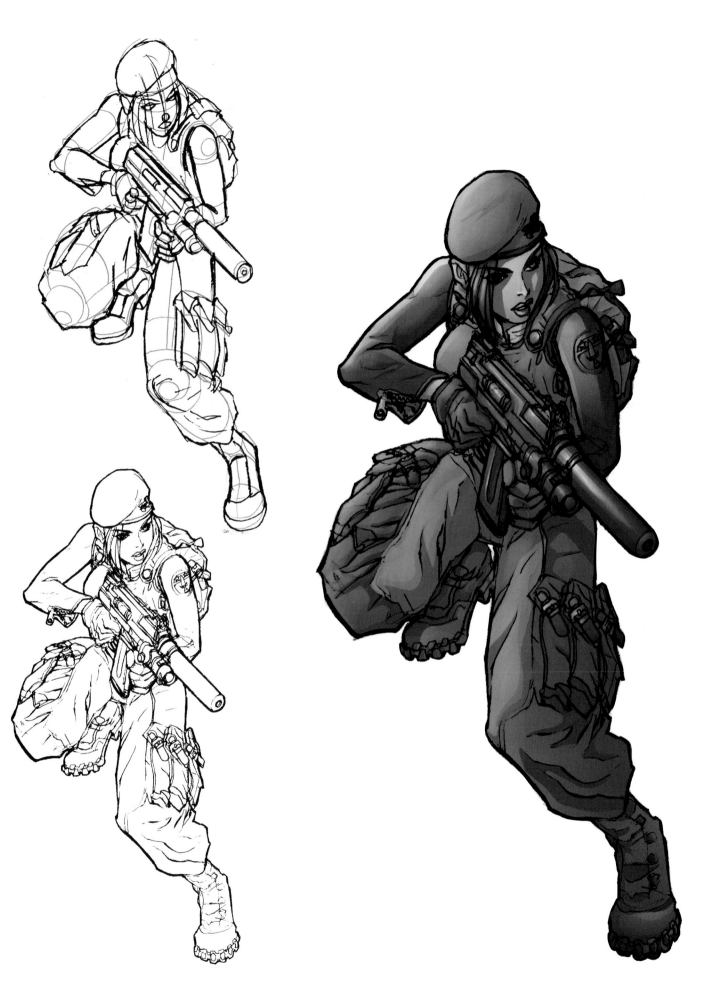

Perspective

Behind most successful drawings is the artist's ability to create the illusion of three-dimensional forms on a two-dimensional plane. If you think of your drawings as flat, they will appear flat, but if you learn to think of your subject matter in terms of height, width, and depth, the drawings will break the two-dimensional paper barrier. One of the keys to fooling the eye is the art of drawing things in perspective. Two basic concepts are horizon line and vanishing point.

The *horizon line* in perspective drawing is a horizontal line across the picture plane. It can be visible in the final drawing (e.g., where ground meets sky in land-, sea-, or cityscapes) or unseen (when it falls outside of the illustration's borders), but it is always the first line you place—either on the paper or in your mind's eye—when you are starting a drawing. The horizon line represents the eye level of the viewer, so the terms "horizon line" and "eye level" can be used interchangeably.

When you are drawing a scene (or object) where the viewer is looking down on the subject, the *vantage point*/eye level of the viewer, and thus the horizon line, will both be high. If the viewer is looking up at the scene, the vantage point/eye level of the viewer, and thus the horizon line, will both be low. The former is called a bird's-eye view; the latter, a worm's-eye view.

The *vanishing point* (VP) in a drawing—or, in the case of two- or three-point perspective, the points—is the point at which lines drawn out from the subject converge. In a one-point-perspective drawing, the viewer is looking at the objects face-on, and all the lines converge at one vanishing point.

In a two-point-perspective drawing, there are two vanishing points on the horizon line and all lines except vertical lines converge at one of the two.

In a three-point-perspective drawing, there will be two vanishing points on the horizon line, and one vanishing point above or below the horizon line.

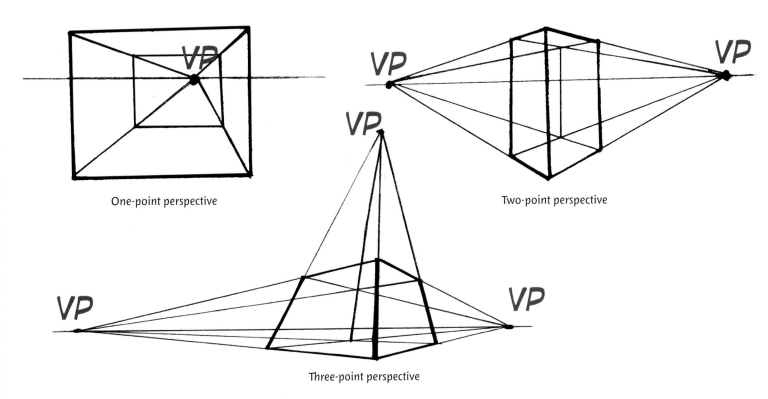

One-point perspective

Two-point perspective

Three-point perspective

The following drawings of military aircraft show how the concepts of one-. two-, and three-point perspective can be applied to complex objects.

In reality, all scenes in the real world are examples of three-point perspective. Artists use one- and two-point perspective drawings as shortcuts when vanishing points are so far apart they are inconsequential.

If all this seems difficult to grasp, it's because perspective is a complicated art technique. There are many excellent books solely on perspective, as well as many websites with information on perspective. But, as with any drawing skill, written explanations will get you only so far. Just keep on drawing. The more you draw, the better your feel for perspective will be.

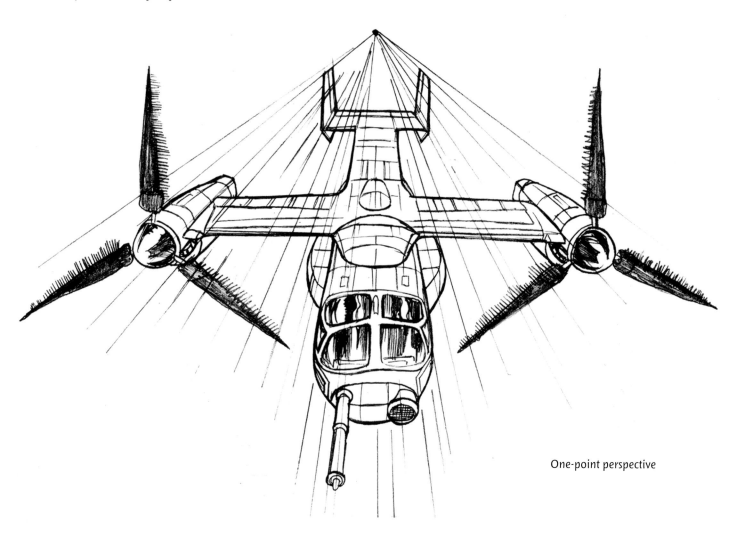

One-point perspective

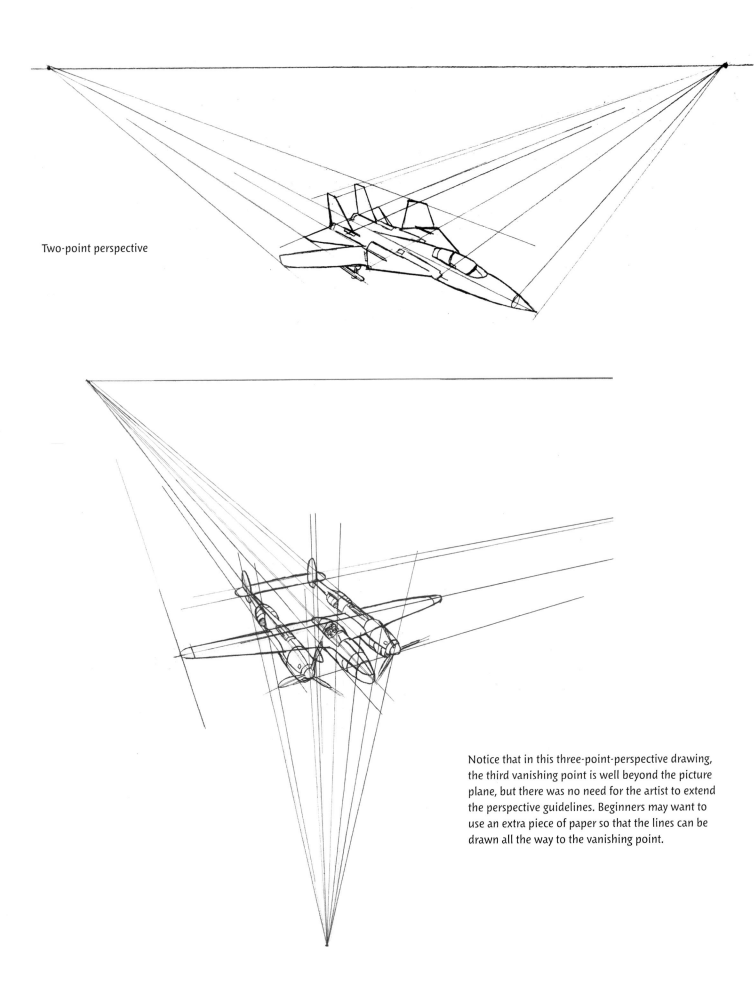

Two-point perspective

Notice that in this three-point-perspective drawing, the third vanishing point is well beyond the picture plane, but there was no need for the artist to extend the perspective guidelines. Beginners may want to use an extra piece of paper so that the lines can be drawn all the way to the vanishing point.

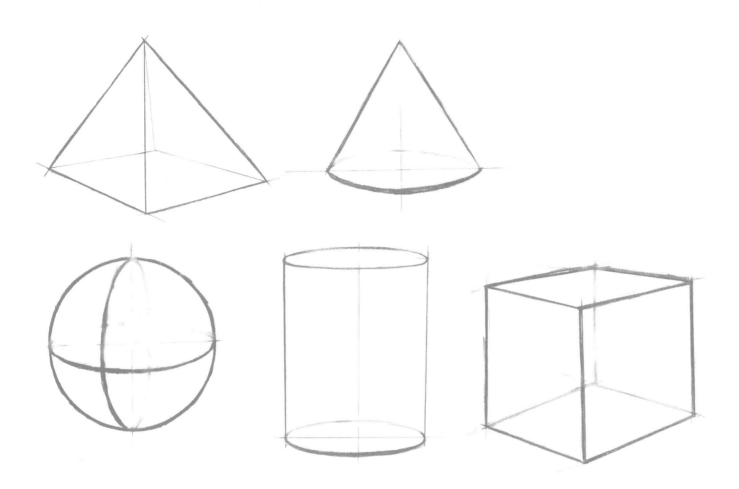

Before beginning to draw, it's a good idea to break down your subject matter in terms of basic geometric shapes: pyramid, cone, sphere, cylinder, and cube (or rectangular solid). And remember: It doesn't matter whether you are drawing a simple cube or a combat tank; your goal is to create the illusion of three dimensions.

The Jeep in Three Dimensions

One of the best known military vehicles of the 20th century is the Jeep, the forerunner to all modern 4WD (4-wheel-drive) vehicles. Its inception was brought about by the Army's need for a fast, lightweight, all-terrain command and reconnaissance vehicle. Several vehicles were in use, but none were ideal for the Army's needs, so a request was sent out to all major automotive manufacturers to create a working prototype in just 49 days. Only one company, The American Bantam Car Company, was able to meet the Army's deadline. Bantam's financial status was, however, so shaky that the Army eventually gave the contract for mass production from Bantam's plans to two other manufacturers, Ford and Willys-Overland.

Over 640,000 Jeeps were manufactured between the years of 1941 and 1945. Once delivered, they started a revolution in the use of small military motor vehicles in the U.S. Army. Motorcycles, the then-reigning champ for quick personal transport, were rendered almost completely obsolete. Jeeps were a resounding success on the battlefield, where they seemed to possess all the winning attributes of U.S. soldiers: resilience, dependability, great strength, and an unshakable determination to complete any and all missions.

Drawing a Jeep in Three Dimensions

When attacking any drawing of a vehicle, a good way to start is by breaking the vehicle down into its basic shapes. In the case of the Jeep, the basic shapes are boxes, cylinders, and circles.

Placement of the Jeep's basic body shape, a box, will determine the placement of all the other shapes. In the two-point perspective drawing shown here, the perspective lines are drawn all the way out to the vanishing points. Obviously this is not a practical way to start drawing any large subjects that fill the picture plane because the finished drawing would be impossibly small.

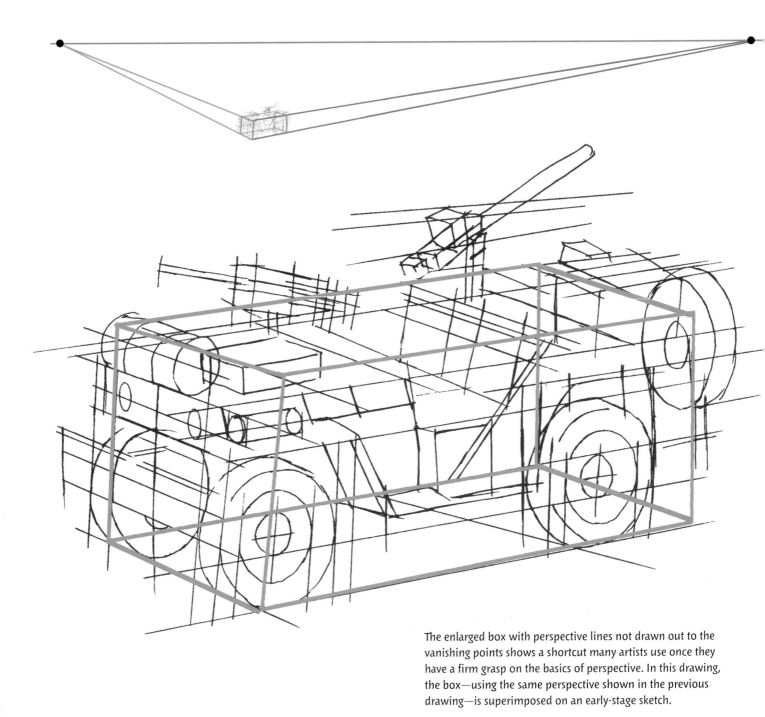

The enlarged box with perspective lines not drawn out to the vanishing points shows a shortcut many artists use once they have a firm grasp on the basics of perspective. In this drawing, the box—using the same perspective shown in the previous drawing—is superimposed on an early-stage sketch.

GETTING WHEELS RIGHT

Here's one approach to drawing realistic, in-perspective wheels.

Draw two rectangular boxes, shown here in red.

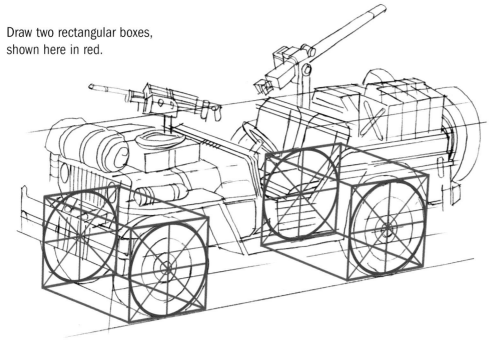

Use the two ends of your boxes as guides for sketching in the wheels, shown here in blue. Notice that all four wheels are drawn in, even though the left front and left rear wheels will be only partially visible in the final drawing.

If you are not confident about your ability to draw the tire ovals, here's a technique you can use:

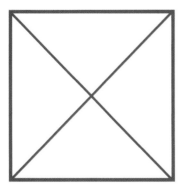

Draw a perfect square, then draw diagonals as shown here.

Draw lines that bisect the four triangles, giving you eight equal segments.

Sketch in the circle by drawing a curved line that touches the four sides of the square at the midpoints and touches the diagonal lines about two-thirds of the way to the corners.

To get an oval, draw a square in perspective, then follow the above steps. Here's an example:

Once you have your perspective guides in place (preferably using a light touch and a colored pencil, so you won't confuse the guidelines with the Jeep's actual components), start lightly sketching in the basic shapes of the various parts of the Jeep. Here's why I recommend using a colored pencil: Guidelines are like scaffolding at a construction site. Imagine if you were building something out of metal of a similar diameter and shape as the actual scaffolding you were standing on, it would be difficult to tell where the scaffolding ended and the building began, but if the scaffolding is bright yellow and the construction is dark gray you can easily differentiate between the two.

As you draw in the Jeep's component parts, you will be erasing most of the guidelines. Just as the Jeep's body can be visualized as a basic box shape, so most of the Jeep's components can be thought of in terms of one or more simple shapes. The seats and gas cans are cubes. The guns are a combination of cylinders and rectangles. (Note that since the guns are pointing in directions not parallel to any of the lines of the basic box of the jeep, they will have different vanishing points, although they will converge somewhere on the same horizon line.) If you are having trouble drawing some of the cool accessories on this vehicle, take a scrap sheet and practice drawing the simple shapes that make up its building blocks.

This is the "inked" version of the Jeep. As with most of the inked steps in this book, this one was scanned into a computer, then digitally inked. Inking can also be done manually, but there is more to it than just tracing your drawings. Advanced skills take years to master, but don't let the difficulty of inking scare you away from learning the trade. There are various types of pens and brushes on the market to assist you in the learning process. I use a combination of crow-quill dip pens of various nib widths; brushes; and technical pens, which have their own ink reservoirs. Give them all a try and come back to the ones you are most comfortable with. Remember, though, while you are still in training, trying to tighten up a drawing with some slick ink work may be counterproductive. Pencil lines are erasable; ink lines are not!

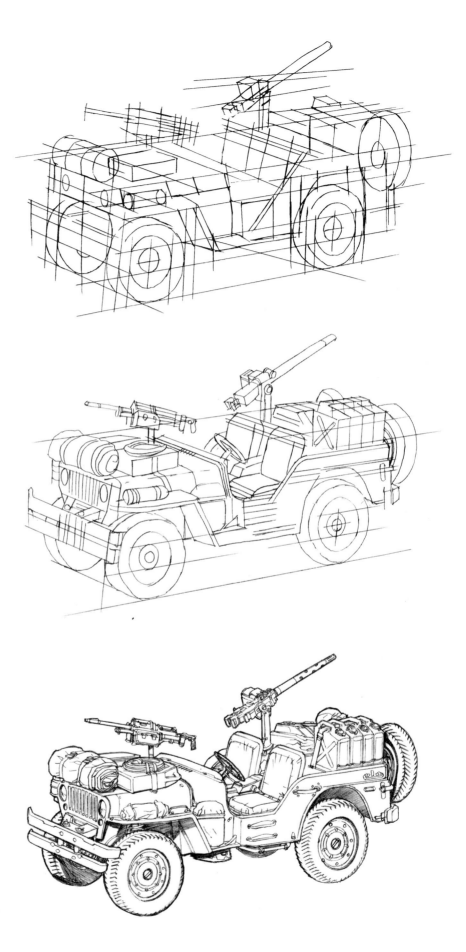

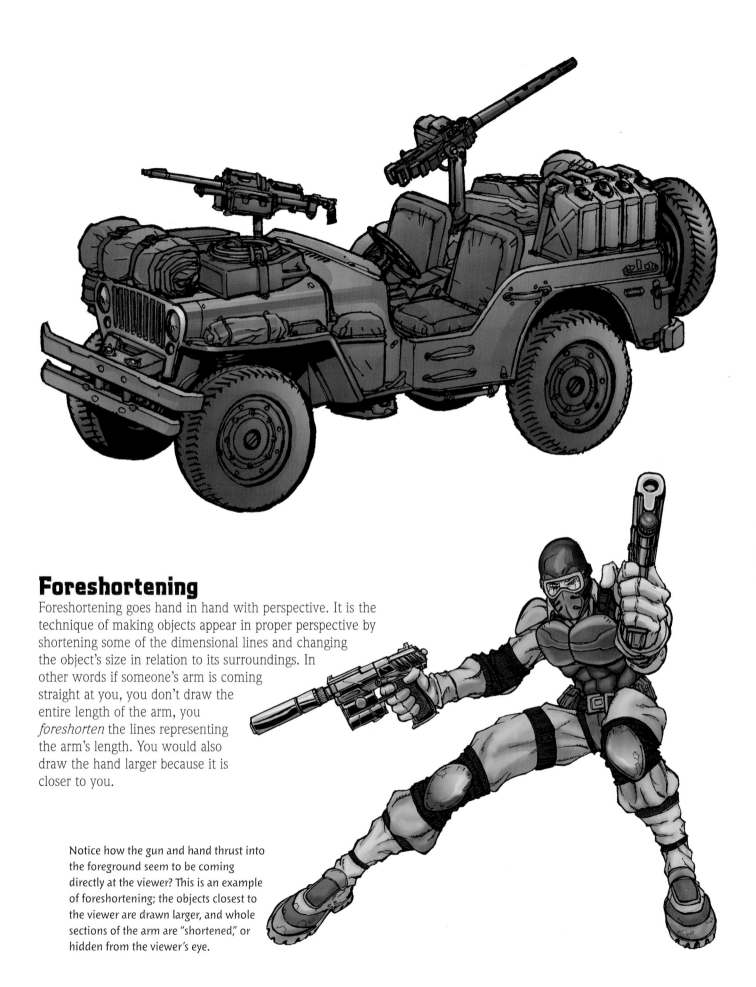

Foreshortening

Foreshortening goes hand in hand with perspective. It is the technique of making objects appear in proper perspective by shortening some of the dimensional lines and changing the object's size in relation to its surroundings. In other words if someone's arm is coming straight at you, you don't draw the entire length of the arm, you *foreshorten* the lines representing the arm's length. You would also draw the hand larger because it is closer to you.

Notice how the gun and hand thrust into the foreground seem to be coming directly at the viewer? This is an example of foreshortening; the objects closest to the viewer are drawn larger, and whole sections of the arm are "shortened," or hidden from the viewer's eye.

The Soldier's Body

Here we have a couple of raw recruits. These are good examples of basic soldier body types, male and female, that you will be designing the rest of your squad around. Before you start outfitting your characters with tons of cool weapons and gear, get to know the basics of building body shapes.

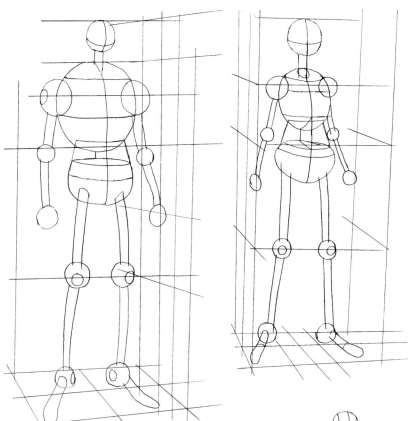

Artist Dan Norton has wisely started by placing the characters in loosely constructed perspective boxes from the first step. This becomes especially helpful in later steps when you'll need to orient all the guns and gear following the same perspective you used for the figure.

The male is 8 heads tall, while the female comes in at 7 heads. (They are slightly idealized. Most real people fall into this 6–7 heads range with an average person being around 6½ heads tall.) This is a good height range for war stories where the appeal is the "everyman" quality; we aren't dealing with mutants or supermen from other planets, but your everyday average Joes and Janes with enough self-discipline and stamina to withstand the intense training needed to turn them into soldiers. (Idealized characters are usually over 8 heads tall, with larger-than-life heroic types being at least 8½ heads tall.)

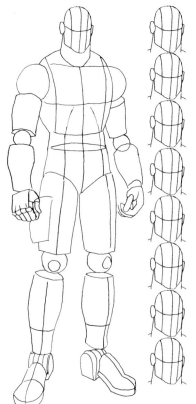

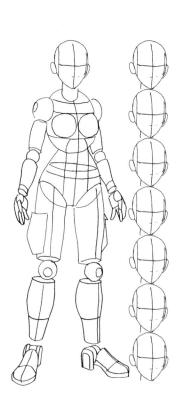

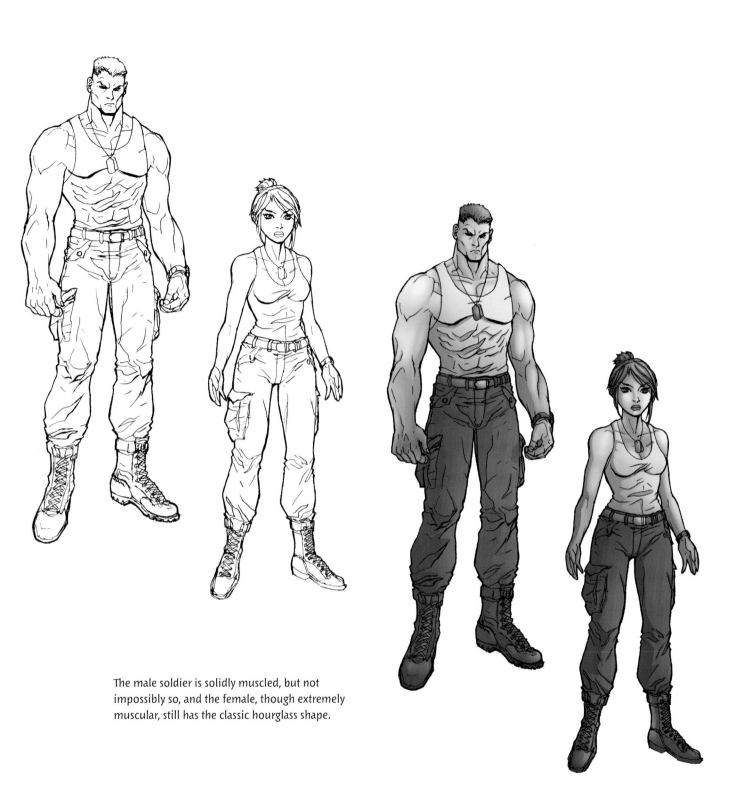

The male soldier is solidly muscled, but not impossibly so, and the female, though extremely muscular, still has the classic hourglass shape.

There are many more important rules governing what makes for a successful drawing, but some lessons are best learned in the heat of battle. All right, fall out and reassemble at your drawing tables. We are getting ready to deploy some of our fantastic military drawing might!

The Right Stuff

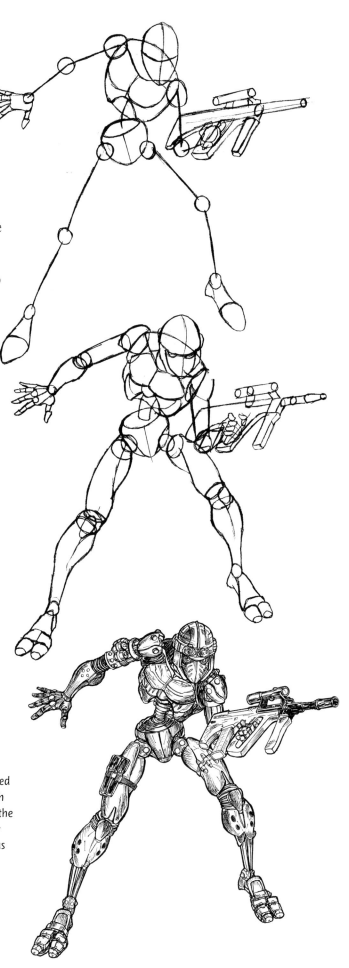

Many civilians are confused about the organization of the U.S. fighting forces. Although there are literally hundreds of organizations, both civilian and military, that engage in defense- and national security–related activities, most of the characters in this book are from one of the following two main groups:

- The men and women in the three Department of Defense branches—the Army, the Navy, and the Air Force—who are trained in one or more "conventional" military occupational specialties. The department of the Navy includes the U.S. Marine Corps. In wartime, the Coast Guard is considered to be part of the Navy; in peacetime, the Department of Homeland Security oversees the Coast Guard.

- The men and women in the military's Special Operations Forces (SOF). These soldiers have specialized training in unconventional warfare and special operations, such as behind-enemy-lines sabotage and reconnaissance, and counterinsurgency. During peacetime, SOF units are under the command of their assigned branch of the military. But in wartime the Secretary of Defense has the authority to place all SOF units under the direct control of the U.S. Special Operations Command (SOCOM). A partial list of SOF units includes Navy SEAL units, Air Force special operations squadrons, Marine Corps Force Recon, and the following Army units: Green Berets (U.S. Special Forces), Delta Force, Rangers, Psychological Operations (PSYOPS), and Night Stalkers (helicopter-mounted lift-and-attack operations).

This chapter covers the conventional arms of the Navy, Marines, Army, and Air Force. The next chapter spotlights the men and women trained for duty in one of the Special Operations Forces.

In May of 2002, the Army began using remote-controlled TALON robots for explosive ordnance disposal, reconnaissance, and communications. Although the TALON bots look nothing like this character (they are, basically, unmanned tread-propelled vehicles), their success in the field has spurred research into the possibilities for robots in combat. Once only the stuff of science fiction, full robot soldiers may one day take the place of human beings for the most hazardous of frontline duties, saving soldiers' lives by sacrificing their own motherboards and silicon chips.

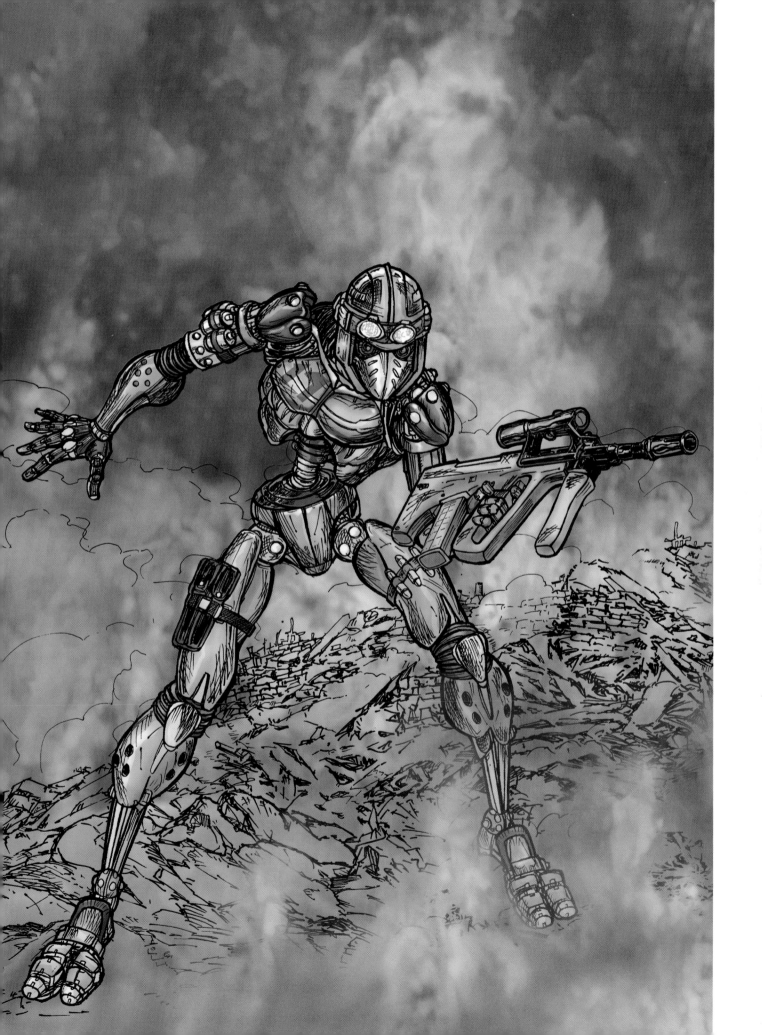

Air Force

The mission of the United States Air Force (USAF) is "to defend the United States and protect its interests through air and space power." The Air Force does a lot more than fly planes. Among its many activities are helping to maintain the military supply chain, providing and maintaining missile and antiaircraft weapon systems and other combat materiel, providing troop support; and training other branches in aircraft-related specialties, to name just a few. There are many highly technical fields open to Air Force personnel, and the Air Force has the reputation as being the "brains" of the armed forces.

Of course, the United States Air Force is most—and justly—famous for tearing up the sky in sleek metal birds of prey. Whether the mission is a dogfight or a bombing raid, USAF pilots—some of the greatest the world has ever produced—routinely match their aviation wizardry with iron nerves and guts of steel.

My approach to the step-by-step drawing of human or animal subject is different from the approach used by Dan Norton (see his soldiers with guns on the following pages). I use either a nonrepro blue pencil for my initial steps, or I use a graphite pencil, but draw the lines very lightly so they are not dark enough to show in the final drawing. (In the interests of clarity, they have been reproduced here much, much darker than I would actually draw them.) I start with simple shapes for the basic three body masses—chest, hips, and head—and draw "matchstick" lines for the limbs. After I have the basic position of the major masses laid down, I build over those shapes with more accurate anatomical forms, such as the modified cylinders I use for the limbs.

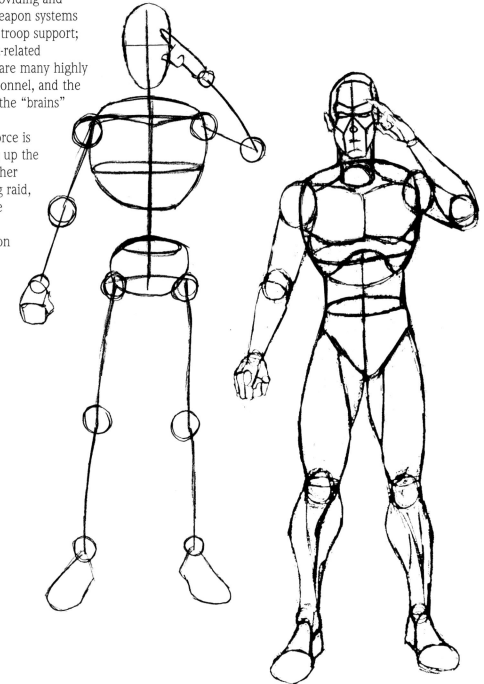

Once I have everything in place, I can go wild adding flight helmet, hinges, armor segments, gas masks, belts and buckles, etc. (You'll need a good photo reference if you want your pilot's flight suit to be believable because there are dozens of pockets, straps, wires, and hoses to accessorize the coveralls with. Find a book or website with clear photos.)

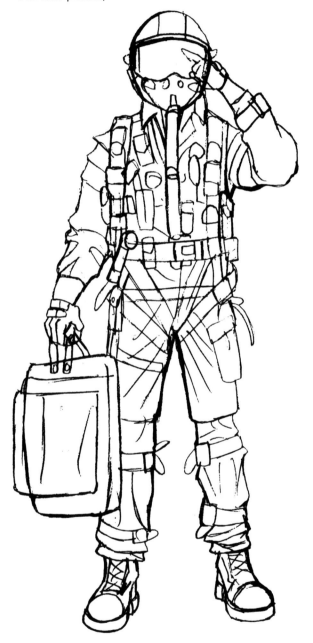

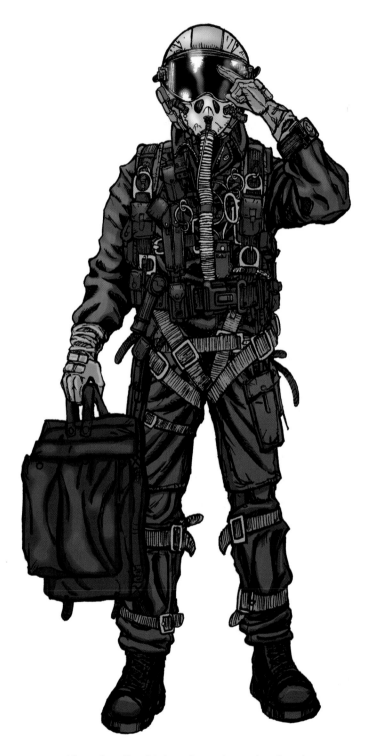

I haven't really added much new here other than the straps on the pilot's flight bag, but in coloring the drawing, I have made sure that the folds and wrinkles of his uniform have been rendered realistically.

Army/National Guard

The Army is the largest of the active armed services, and offers enlistees more training options than any of the other branches. At the end of 2004 there were approximately 76,000 officers and 401,000 enlisted soldiers performing active duty in the U.S. Army. In addition to active forces the Army is supported by two reserve forces, the Army Reserves and the Army National Guard. The Army National Guard has both state and federal roles. State governors can call the National Guard into action, through the state adjutant general, for such emergencies as natural disasters, such as hurricane Katrina, and serious civil disturbances. Only the President can activate the National Guard for federal missions, such as stabilization of operations in overseas combat zones, and only the President, through the Secretary of Defense, can mobilize Army Reserve units.

Active or reserve, the mission of soldiers in the Army is the same: to protect and defend the United States (and its interests) by deploying its ground troops, armor (tanks), artillery, helicopters, and strategic missiles against its enemies.

Artist Dan Norton first roughs in the figure inside a perspective box. The horizon line, represented by the red line in the drawing, is just above the character's waist. The viewer will be looking slightly up at everything above that line and slightly down at everything below that line. For example, we see the side and bottom of the rifle because we are looking up at it; we see the top of the boots because we are looking down on them.

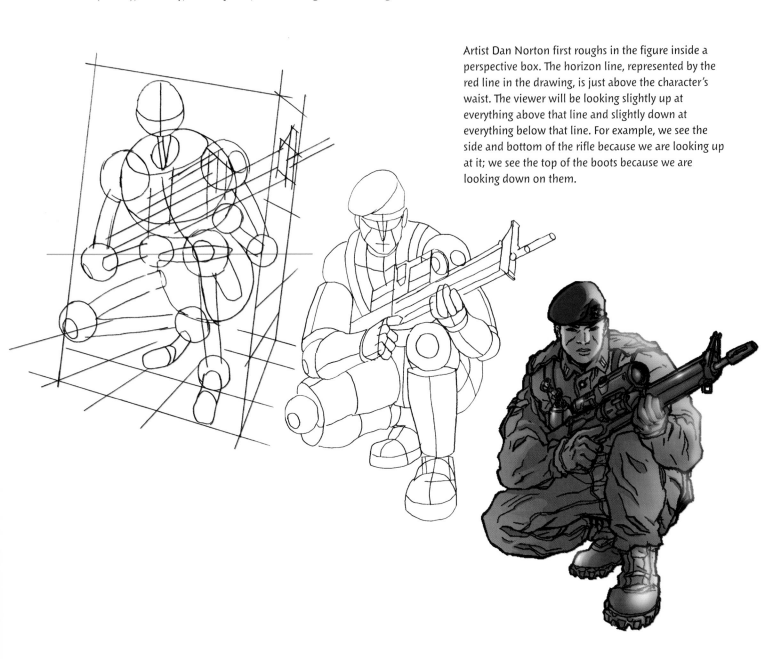

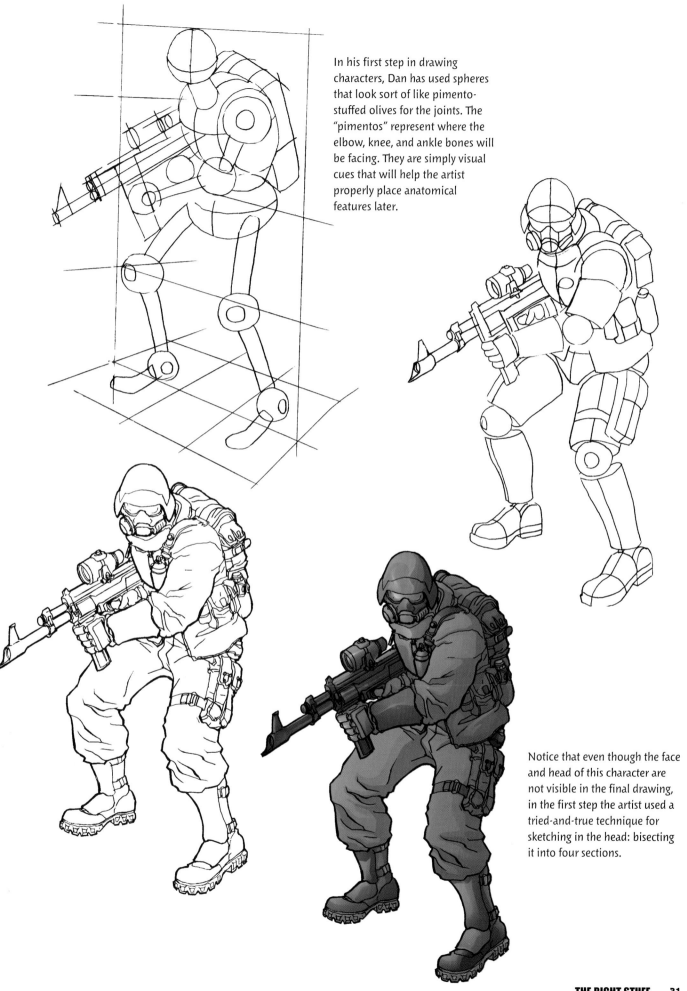

In his first step in drawing characters, Dan has used spheres that look sort of like pimento-stuffed olives for the joints. The "pimentos" represent where the elbow, knee, and ankle bones will be facing. They are simply visual cues that will help the artist properly place anatomical features later.

Notice that even though the face and head of this character are not visible in the final drawing, in the first step the artist used a tried-and-true technique for sketching in the head: bisecting it into four sections.

Coast Guard

The stated mission of the U.S. Coast Guard is to protect the public, the environment, and U.S. economic interests in the nation's ports and waterways, along the coast, on international waters, or in any maritime region as required to support national security. Since 2003, the Coast Guard has been part of the U.S. Department of Homeland Security (USDHS), and the Commandant of the Coast Guard reports directly to the Secretary of the USDHS. In keeping with the goals of the USDHS, the Coast Guard has mounted a number of initiatives designed to close security gaps that could make the United States vulnerable to terrorist attack.

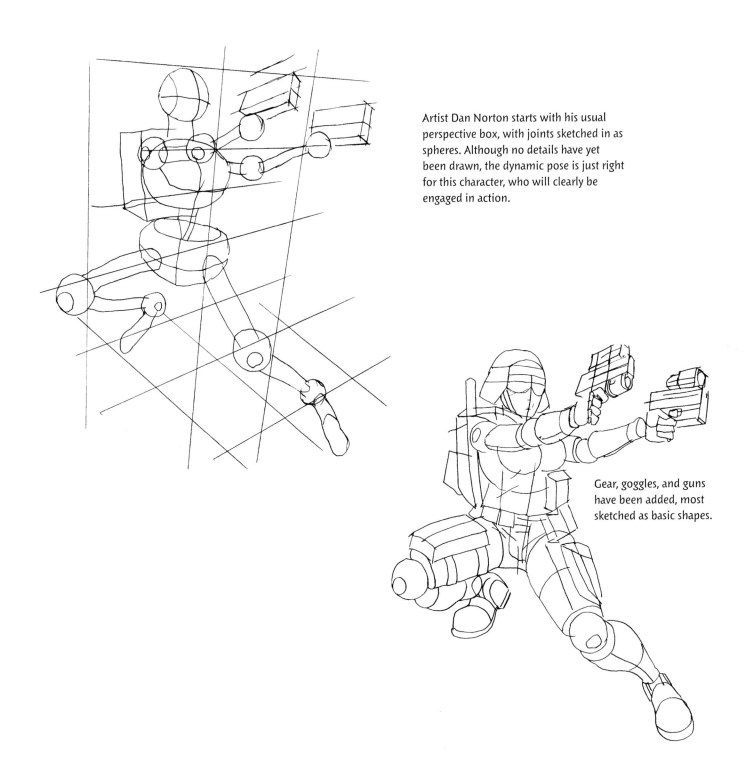

Artist Dan Norton starts with his usual perspective box, with joints sketched in as spheres. Although no details have yet been drawn, the dynamic pose is just right for this character, who will clearly be engaged in action.

Gear, goggles, and guns have been added, most sketched as basic shapes.

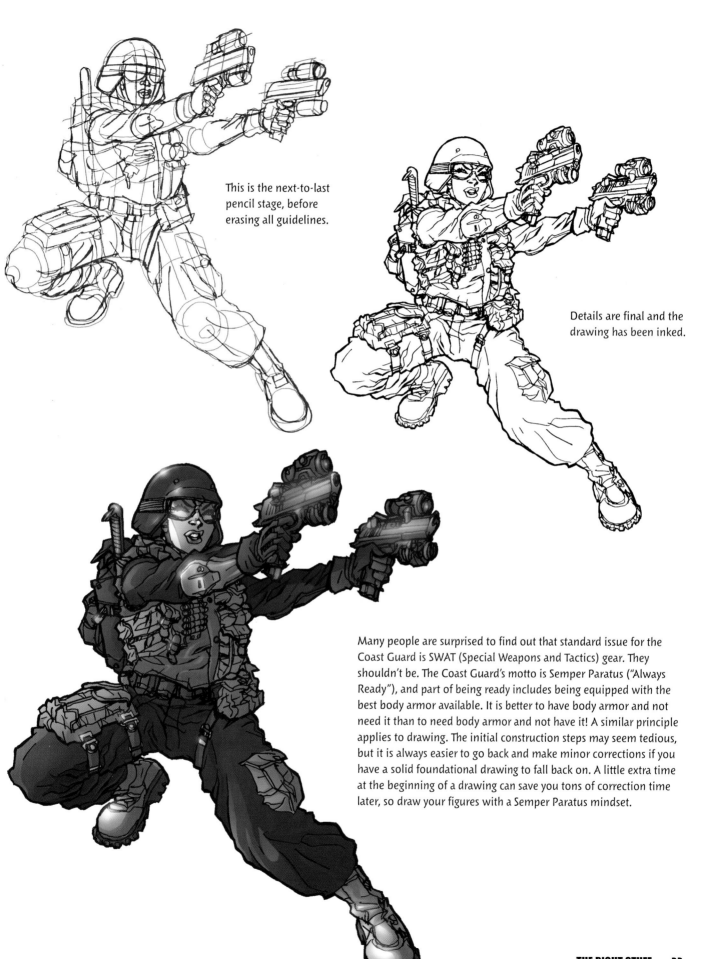

This is the next-to-last pencil stage, before erasing all guidelines.

Details are final and the drawing has been inked.

Many people are surprised to find out that standard issue for the Coast Guard is SWAT (Special Weapons and Tactics) gear. They shouldn't be. The Coast Guard's motto is Semper Paratus ("Always Ready"), and part of being ready includes being equipped with the best body armor available. It is better to have body armor and not need it than to need body armor and not have it! A similar principle applies to drawing. The initial construction steps may seem tedious, but it is always easier to go back and make minor corrections if you have a solid foundational drawing to fall back on. A little extra time at the beginning of a drawing can save you tons of correction time later, so draw your figures with a Semper Paratus mindset.

Marines

There are only 200,000 active and reserve members of the Marine Corps, making them the smallest branch of the U.S. armed forces. Far from being a liability, this is a reflection of the Marines' policy of recruiting and training only the best: "The few. The proud." Leathernecks (a nickname derived from the leather neck collar worn by Marines during the Revolutionary War period to protect against sword strikes) have fought bravely in every war the United States has ever entered, earning a reputation of being "the first to fight, last to leave." (They are sometimes called the military's "911" force [that's "nine-one-one"] because they are known for responding to any crisis as soon as it arises.) The Marines were established in 1775 as an infantry combat force serving aboard naval vessels, but by the time of World War II they were fighting on land, air, and sea. Today, only the U.S. Army, Navy, and Air Force combined boast the variety of training options offered by the Marines.

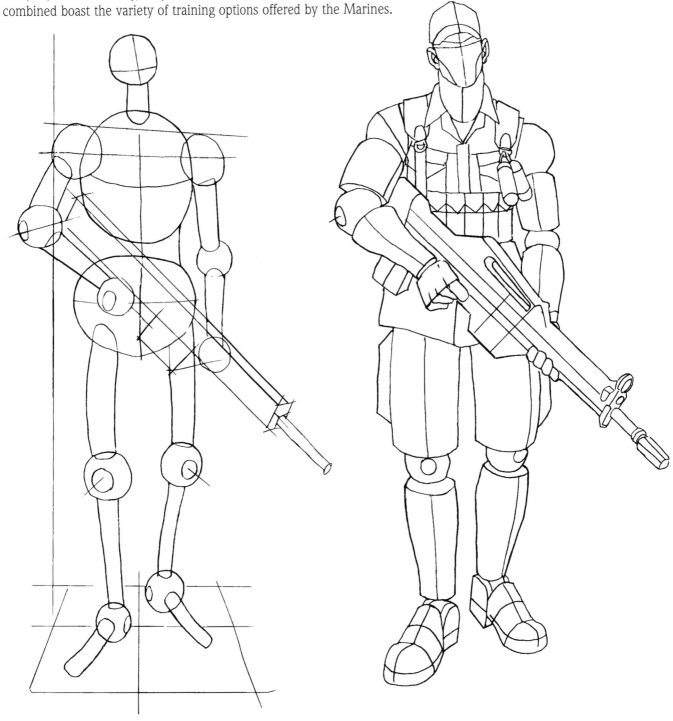

The Marine Corps motto is *Semper Fidelis* ("always faithful"). Voiced by Marines as "Semper Fi" it expresses unswerving loyalty and commitment to their comrades-in-arms and to the Marine credo:

Those who are warriors can master anything.

Those who are driven are bold beyond measure.

Those who belong have the respect of a nation.

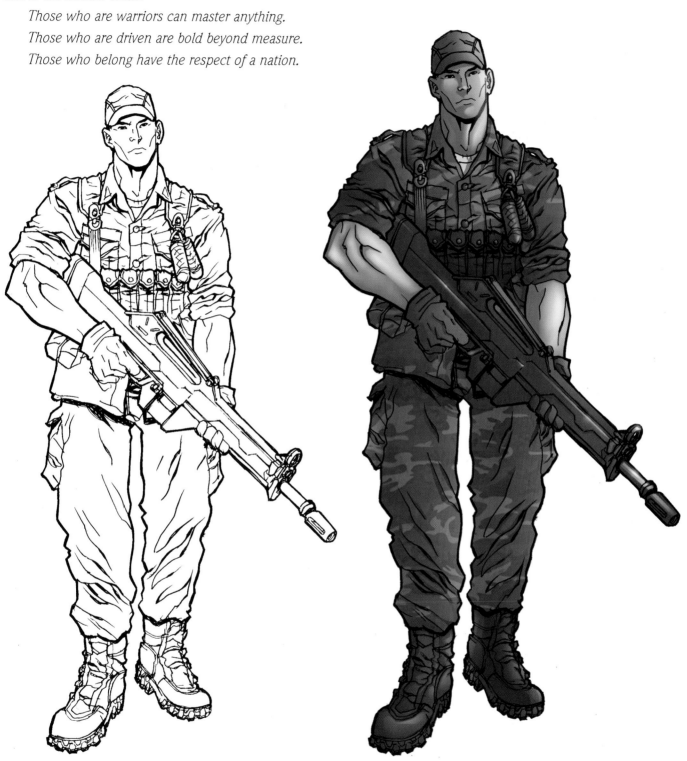

In the first step the artist is establishing the perspective, proportions, and position of all the major anatomical forms; he uses basic shapes—two-dimensional cylinders for thighs and calves, spheres for joints, circles for chest and head, oval for pelvic region, elongated box for rifle. In the next step he has left some of the basic shapes (e.g., the joints), but the leg and arm cylinders have been sort of squared off, indicating what the bulk of the final drawing will be. The final drawing shows all the details in place, right down to the studded boot soles.

Navy

The U.S. Navy was founded in October 1775. The operating forces of today's Department of the Navy include the Marine Corps and, in time of war, the U.S. Coast Guard. The mission of the Navy is to maintain, train, and equip combat-ready naval forces capable of waging war, deterring aggression, and maintaining freedom of the seas. The Navy protects our waters and makes it possible for other nations to ship goods to U.S. ports safely. In times of crisis, the Navy's aircraft carriers serve as mobile landing pads for Air Force planes. Navy ships also pack some serious firepower, which can be directed at land targets while the ships are still several miles out to sea. The Navy and the Marines have historically worked together in many ways. For example, they share many of the same duty stations, the Navy provides transportation for the Marines' foreign missions, and the two branches often work together when working to boost the combat-readiness of foreign troops.

In return for their selfless service, the words these salty seadogs want to hear most from their commanding officer are the congratulatory "Bravo Zulu," which is Navy talk for well done.

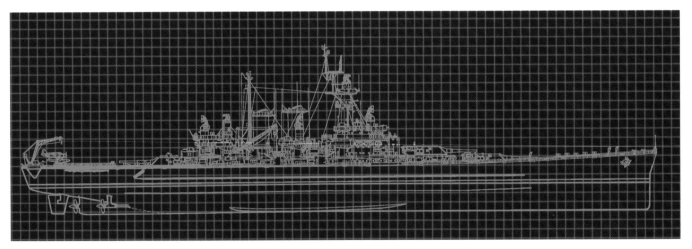

There are no battleships on active duty in the Navy today, but for almost a century, battleships and their crews were the cornerstone of the U.S. naval fleet. This side view of a typical battleship shows what the ship looks like beneath the waterline.

BRAVO ZULU

After NATO was created in 1949, an international signal code that would be recognized by all signatory navies was adopted. (At the time, the U.S. Navy signal for "well done" was TVG—"Tare Victor George.") The B signals were called "administrative" signals, and the last one was BZ, or "well done." The U.S. Navy rendered BZ as "Baker Zebra," which did not become "Bravo Zulu" until 1956, when the International Civil Aviation Organization adopted a "pronounceable" phonetic alphabet, the Alfa, Bravo, Charlie, Delta, etc., series used today. Sources don't say where "Zulu" came from, but the Zulus were incomparable warriors, and the implication is obvious.

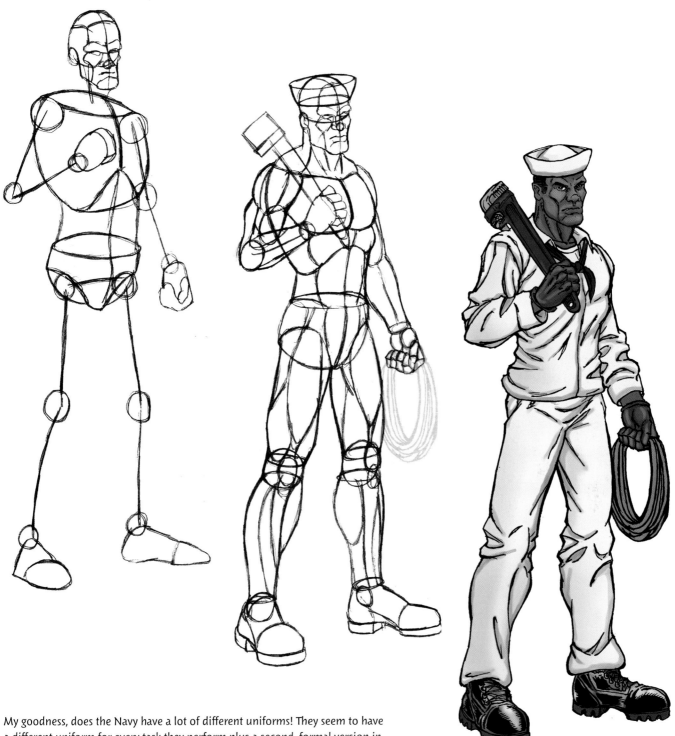

My goodness, does the Navy have a lot of different uniforms! They seem to have a different uniform for every task they perform plus a second, formal version in case they want to look good while doing it! I had more than 20 different designs I could choose from, but went with the familiar seaman's white sailor outfit, which is the one most often associated with the Navy.

Uniforms and Gear

There is nothing more menacing than the image of a skilled warrior decked out head to toe in military gear, but each aspect of the character, including combat and dress uniforms and specialty accessories such as night vision goggles, must be drawn with proficiency for the illustration to work. Even a seemingly simple object, like a belt, needs to be analyzed before you can draw it accurately. A comprehensive reference library—books, printouts from the Internet, magazines, even videos—is a must for drawing believable military equipment.

Tattoos

Tattoos are not, strictly speaking, "gear," but since their use by combat personnel is practically universal, I felt that the subject deserved more than passing mention.
The word *tattoo* comes from the Tahitian "tatu," which means "to mark something." It is believed that tattooing was first practiced in ancient Egypt and eventually spread worldwide as ocean travel became more accessible. Warriors in other early civilizations—for example, the Aztecs and the Celts—were emblazoned with special tribal marks to bring them luck on the hunt and in battles, and many of today's tattoos are based on designs that date back centuries. Soldiers all over the world proclaim their allegiances to countries, loved ones, units, ships, and divisions with brightly colored designs proudly displayed across their bodies. Tattoo shops are located close to every military base and port of call. In the United States, entire units will often get identical tattoos that commemorate shared combat experience or serve as mobile monuments to their fallen comrades.

Granted, this guy is not wearing much in the way of regulation military apparel, but his awesome gun, a squad automatic weapon (SAW) is standard issue for combat units. The SAW, which uses the same type of rounds as the world-famous M16A2 (see page 54), can be bipod-mounted (the bipod can be seen at bottom right of the machine gun) for optimal firing accuracy. It weighs over 15 pounds (7 kg) with bipod and tools and can fire up to 725 rounds per minute. All in all, the SAW is a fitting weapon for this intricately decorated hardcore hombre. Note: Tattoos, like patches (see page 44) can be designed ahead of time and then stored in your computer. Using a program such as Adobe Photoshop, artists can digitally add a variety of predesigned tattoos as a layer during the coloring process.

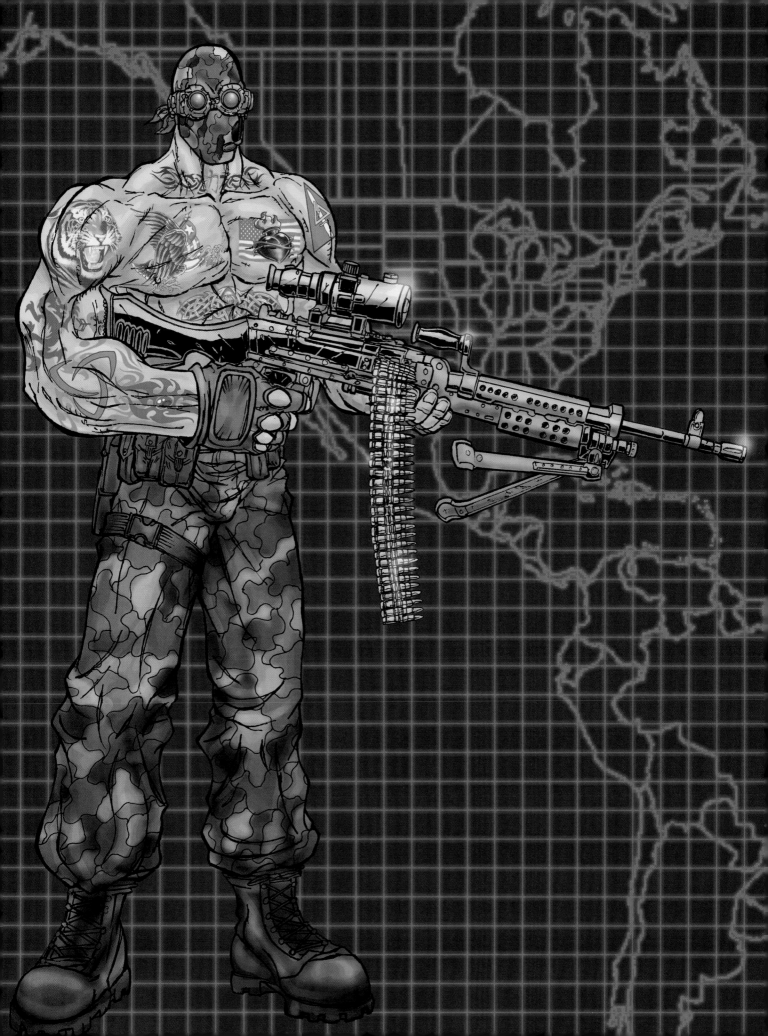

From Brain Bucket to Boots

Once you have the basic frames drawn for your characters, feel free to arm your troops to the teeth with all sorts of military nastiness. I have a stack of mail-order military catalogs I use to find ideas for gear and accessories.

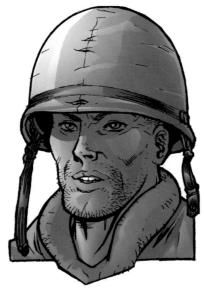

One of the most important components of a soldier's defensive equipment is the helmet. Helmets, nicknamed "brain buckets," used to be made out of metal, but now they are made out of high-impact Kevlar. Note that artist Dan Norton first drew the head and then built the helmet around the soldier's skull. Many people who've never worn a helmet mistakenly draw the helmet as if it fit snugly on the soldier's head, like a hat. This is all wrong and would make for some very uncomfortable troopers! Be sure to allow for space between the top of the soldier's head and where the inside bottom of the helmet shell would be. Note the slight brim, which casts a shadow over the soldier's eyes. Don't draw your soldiers wearing brimless mixing bowls!

Two things all soldiers need in battle are free range of motion and the ability to quickly get at the right pieces of mission-important equipment when they need them. The term for uniform components designed to provide easy-access storage and maximum load-bearing efficiency is web gear. This equipment load carrying system (ELCS) vest may look unwieldy, but it has been designed for maximum usefulness in combat.

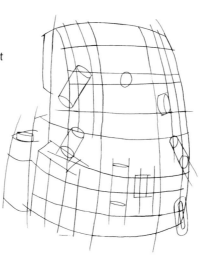
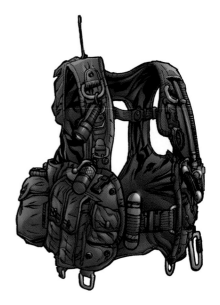

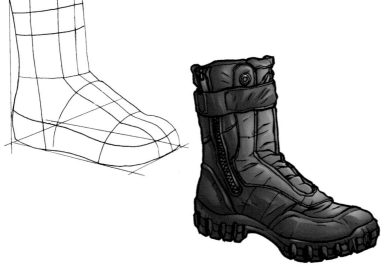

The look of typical combat boots, always designed for extreme durability and for maximum protection of the toes, has changed over the last half-century. The outsize toe box typical of combat boots during the 1950s and 1960s was scaled down somewhat during the 1970s and '80s. Military boots come in all different shapes, sizes, and colors: There are jungle boots, snow boots, tanker boots, infantry boots, desert boots, jump boots, and ranger boots. Regardless of what type of boot you are drawing, it is important to draw it large enough for a soldier's foot to fit inside! Start with the basic shape of the foot and build your boot around it. Military boots have thick soles with treads over an inch thick so don't draw your soldiers flat-footed.

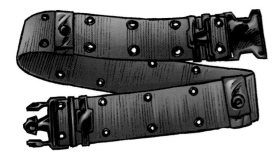

Soldiers wear two different belts, one for their pants and one for their web gear. Web gear belts anchor the harness of web gear straps to soldiers' waists and have nothing to do with keeping their pants up. Web belts are extremely pliable, as shown here.

What night vision goggles are for is obvious: Put them on at night and suddenly the dark can no longer hide your enemy. (Of course if your foe also has a pair, you may be the target.) They are indispensable for covert nighttime combat operations or search-and-rescue missions. One of the great things about drawing military gear is you get to flesh out even the smaller pieces of equipment with tons of details. These goggles, for example, are made up of many parts. As you can see, most of these parts—beyond the basic box shape—are based on circles, ovals, and cylinders.

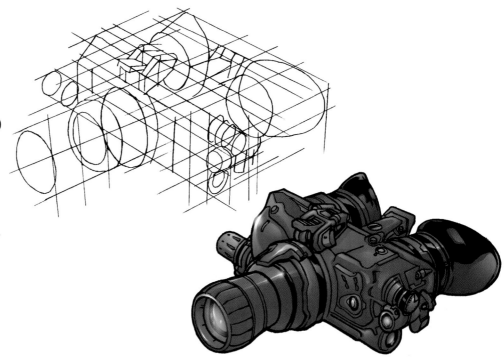

The long-range laser range finder is a lightweight hand-held device that is used to calculate precise range-to-target information, something you want to get right, especially if there are friendly forces in the area. This device, which looks something like a nonsymmetrical pair of binoculars, is based on simple cylinders, but the cylinders themselves are sketched in only after first drawing the ovals, which get progressively smaller toward the front end of the range finder.

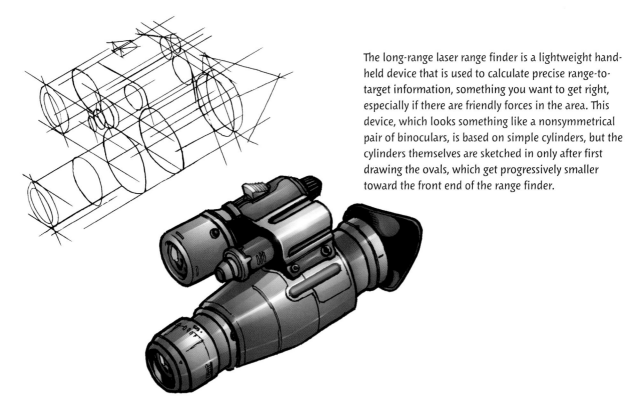

Camouflage

Camouflage patterns—for uniforms, vehicles, and soldiers' faces and hands—are designed to render soldiers and their vehicles as indistinguishable as possible from a terrain's surrounding foliage and natural ground cover.

The first step in applying camouflage is to paint the entire face green.

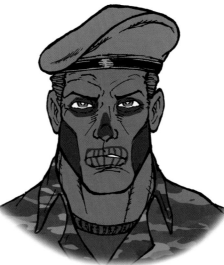

The primary purpose of camouflage paint is to conceal the natural lines, symmetry, and planes of the face. It might seem like a cool idea to paint your character with an olive drab Jolly Roger–type skull with sunken eye sockets, but no real soldier's camouflage would look like that.

Notice how the paint makes otherwise easily recognizable facial features—eyes, chin, cheeks, and forehead—hard to spot.

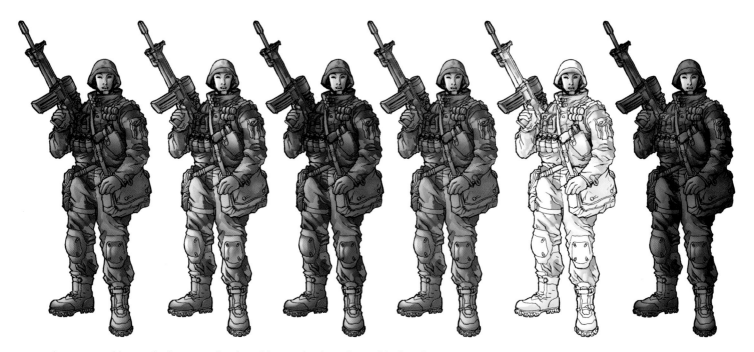

The green and brown leafy pattern developed for combat in regions with abundant bushes and trees may be the most familiar type of camouflage, but there are many other styles and colors around, from plain Arctic white to the tiger-stripe patterns that imitate the sun-streaked look of dense jungle vegetation.

Jetpack

The James Bond jetpack featured in *Thunderball* (1965) was small enough to fit in 007's boot. Since then, various manufacturers have worked on developing a military jetpack, but a working model remains on the drawing board.

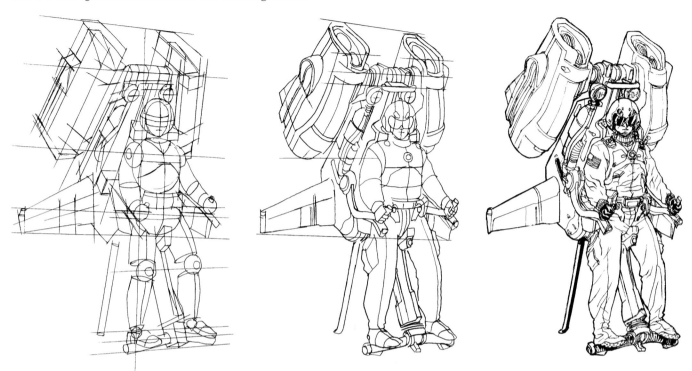

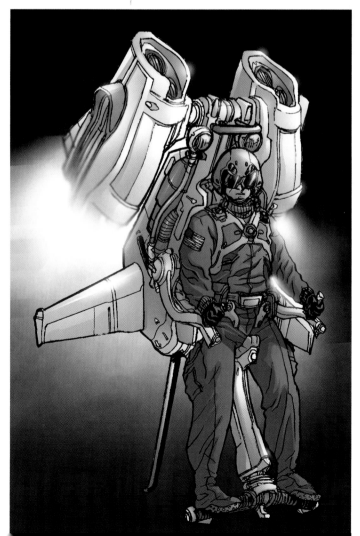

Even though this item as a functioning piece of equipment is currently equal parts fact and fiction, artist Dan Norton's research allowed him to create a jetpack that looks very airworthy. Always look at real-world devices to gain inspiration for creating the fantastic.

Dress Uniforms

After soldiers return from risking their necks on one or more perilous tours of duty, they are often (but unfortunately not always) honored for their valor. For those and other ceremonial or formal occasions, jungle camouflage battle uniforms just don't fit the bill, and every branch of the U.S. Armed Forces has its own unique set of formal dress uniforms. Steeped in tradition and designed to showcase medals and service patches, the soldiers meticulously maintain their formal wear as a visible expression of pride and a tangible way of honoring all who have ever served.

The most eye-catching aspect of dress uniforms is the various medals, awards, and insignia patches they display—it is sort of like wearing a portable trophy shelf. If you want to do some research into the hundreds of available awards and patches from the various military branches, you can go to the library, or you can search the Internet. You may also enjoy creating patches of your own design.

Overall, dress uniforms should have a perfectly maintained, well-pressed look. Draw wrinkles sparingly. Here they can be seen only at the elbows, just above the ceremonial sash, and at the knees and above the shoes. Create a character whose uniform is colorful and whose military career is on proud display.

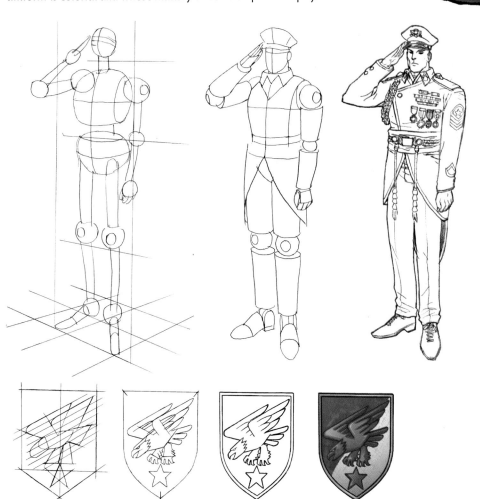

If you do plan on designing patches for your characters' dress uniforms, it's a good idea to practice drawing different patches on a larger scale, and you need to give the patches a three-dimensional look, following the perspective guidelines you would use for any character or object you are drawing. Once you have the designs just the way you want them, you can have them scanned for use in Photoshop, or just photocopy them, for other drawings.

Body Armor

Body armor has come a long way since the 45- to 55-lb (20.4- to 25-kg) plate or chain mail armor worn by medieval knights and their horses. Until the 1990s, Kevlar, a flexible synthetic fiber invented by Stephanie Kwolek, a researcher at DuPont, was the material of choice for so-called "bulletproof vests." Kevlar is 5 times stronger, ounce for ounce, than steel; does not rust or corrode; and is extremely heat-resistant, withstanding temperatures up to 675K (755.3°F) without melting. From the beginning, however, the term "bulletproof" was a misnomer, as Kevlar vests were never able to stop projectiles fired from rifles. In the 1990s, the military began augmenting their Kevlar-based body armor by adding small-arms protective plates to the front and back of Kevlar vests. The plates are made of boron carbide ceramic with a spectra shield backing, and each plate is designed to stop up to three 7.62-mm rounds with a muzzle velocity of 2,750 ft/s (838 m/s).

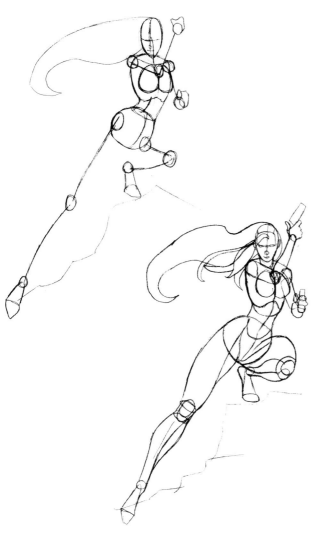

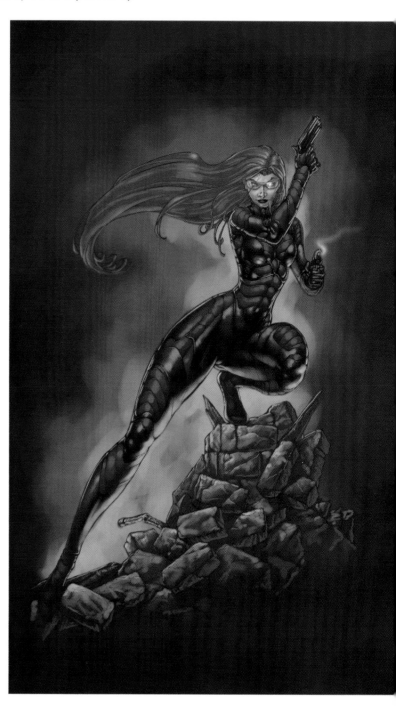

The next generation in personal stealth technology—a "second skin" armor system—is still on the drawing board, so you can use your imagination to develop the details. This futuristic skin-tight body armor may be made of Kevlar, titanium, and Neoprene, or a combination of yet-to-be invented materials. The yellowish aura surrounding this female fighting machine is evidence of a controlled heat-diffusion system, effectively making our warrior invisible to thermo-optic and motion detectors. Artist Brett Booth has drawn this femme fatale as all curves and attitude.

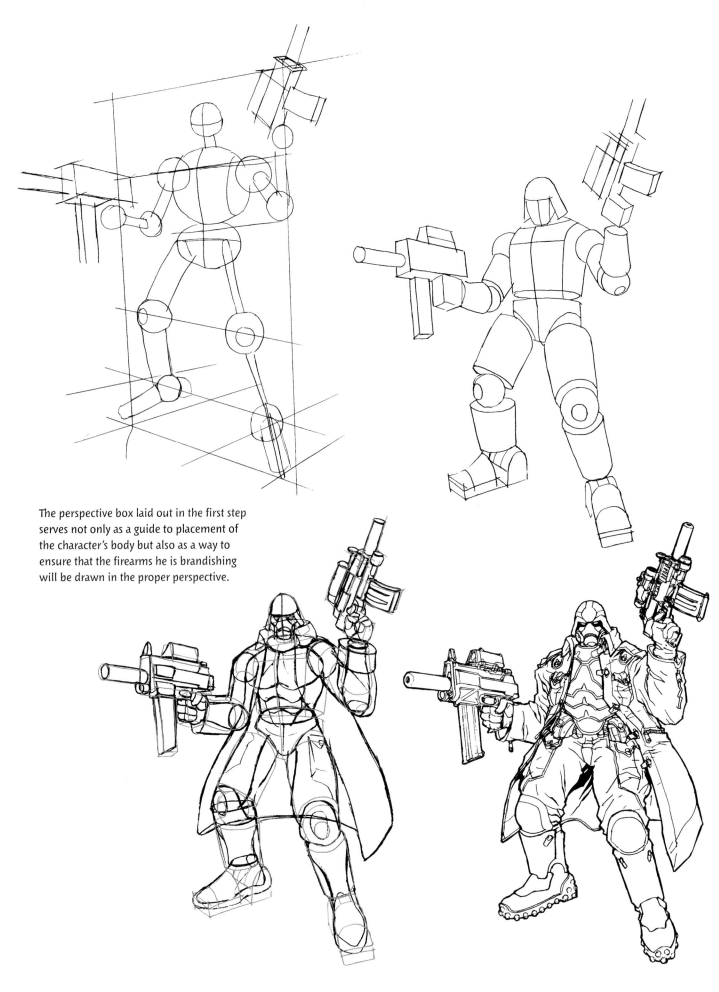

The perspective box laid out in the first step serves not only as a guide to placement of the character's body but also as a way to ensure that the firearms he is brandishing will be drawn in the proper perspective.

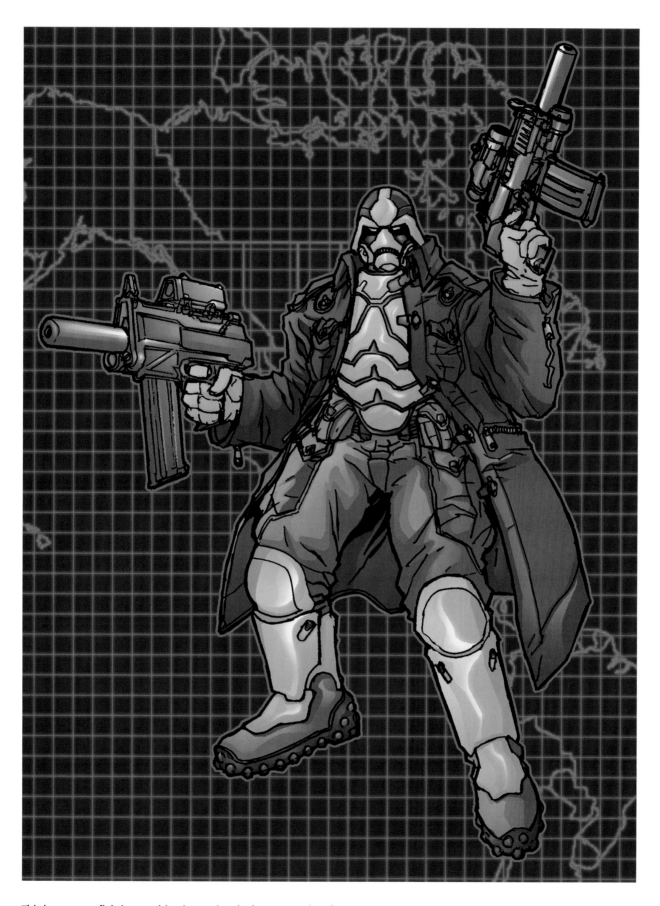

This lean, mean fighting machine is wearing the best protection that
Bad Guy Gear Inc. has to offer.

Weapons

The capabilities and types of weapons used by the U.S. military have changed dramatically over the last century. The awesome arsenal available to today's military includes the M107 long-range semiautomatic sniper rifle, which can engage multiple targets from as far away as 1.2 mi (2,000 m); the laser-aiming model Heckler/Koch Mark 23 SOCOM handgun; the FIM-92 Stinger weapons system; and the Barretta M82A1, a .50-caliber semiautomatic rifle that has the recoil of a 12-gauge shotgun.

Flamethrowers

A flamethrower consists of a special gun fitted to a fuel tube with a fuel regulation valve attached to a fuel tank. When the trigger is pressed, a stream of oil, gas, or napalm is released, spraying up to 150 feet (46 m). Originally used by the infantry to clear out troublesome pillboxes, which are small concrete bunkers, flamethrowers today are used mainly to clear vegetation or cause significant incendiary damage to enemy camps and storehouses.

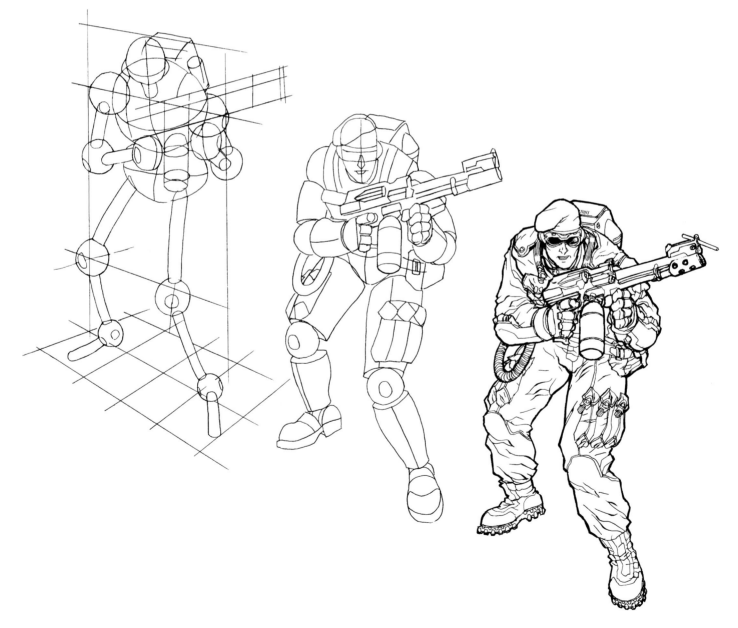

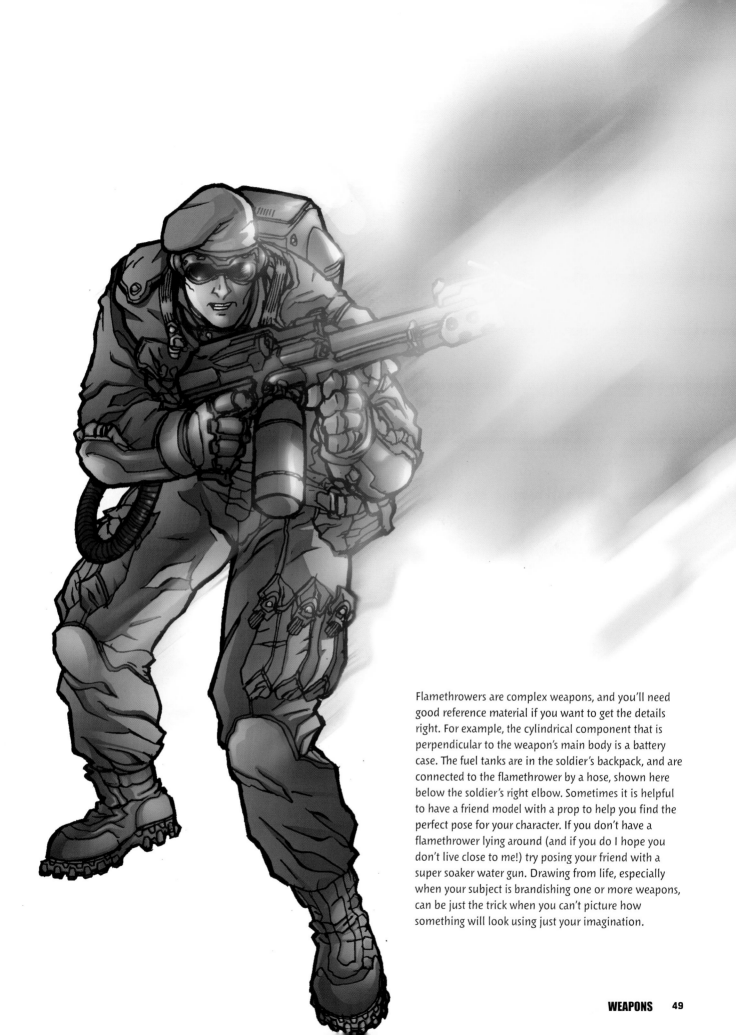

Flamethrowers are complex weapons, and you'll need good reference material if you want to get the details right. For example, the cylindrical component that is perpendicular to the weapon's main body is a battery case. The fuel tanks are in the soldier's backpack, and are connected to the flamethrower by a hose, shown here below the soldier's right elbow. Sometimes it is helpful to have a friend model with a prop to help you find the perfect pose for your character. If you don't have a flamethrower lying around (and if you do I hope you don't live close to me!) try posing your friend with a super soaker water gun. Drawing from life, especially when your subject is brandishing one or more weapons, can be just the trick when you can't picture how something will look using just your imagination.

Antiaircraft/Antitank Guns

The first antitank weapons were high-caliber rifles. Later, antitank vehicles carrying large-bore cannons were introduced, but these were so heavy as to be almost immobile and no more were developed after World War II.

The first primitive antiaircraft weapons appeared during World War I. Since then, antiaircraft guns have undergone a series of major modifications to adapt them to fit the needs of modern warfare. Today, one of the most effective mobile antiaircraft weapons is the surface-to-air FIM-92 Stinger, which employs its infrared seek capacity to attack aircraft at heights up to 12,500 feet (3,800 m). Production on a Stinger effective at distances up to 25,000 feet (7,600 m) began in 2004.

The "88"

In WWII Germany unveiled the feared "88" series of antitank guns, the first of which, the Flak 18, could shoot 3½-inch projectiles 5 miles into the sky. A high muzzle velocity, excellent accuracy, and hard-hitting ammunition made the German 88 a multipurpose gun that could double as an antitank gun. Allied forces learned to give it a wide berth.

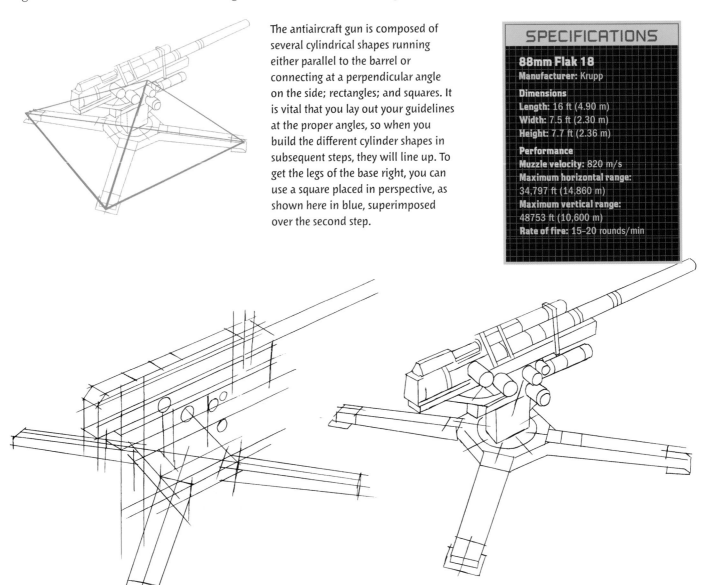

The antiaircraft gun is composed of several cylindrical shapes running either parallel to the barrel or connecting at a perpendicular angle on the side; rectangles; and squares. It is vital that you lay out your guidelines at the proper angles, so when you build the different cylinder shapes in subsequent steps, they will line up. To get the legs of the base right, you can use a square placed in perspective, as shown here in blue, superimposed over the second step.

SPECIFICATIONS

88mm Flak 18
Manufacturer: Krupp

Dimensions
Length: 16 ft (4.90 m)
Width: 7.5 ft (2.30 m)
Height: 7.7 ft (2.36 m)

Performance
Muzzle velocity: 820 m/s
Maximum horizontal range:
34,797 ft (14,860 m)
Maximum vertical range:
48753 ft (10,600 m)
Rate of fire: 15–20 rounds/min

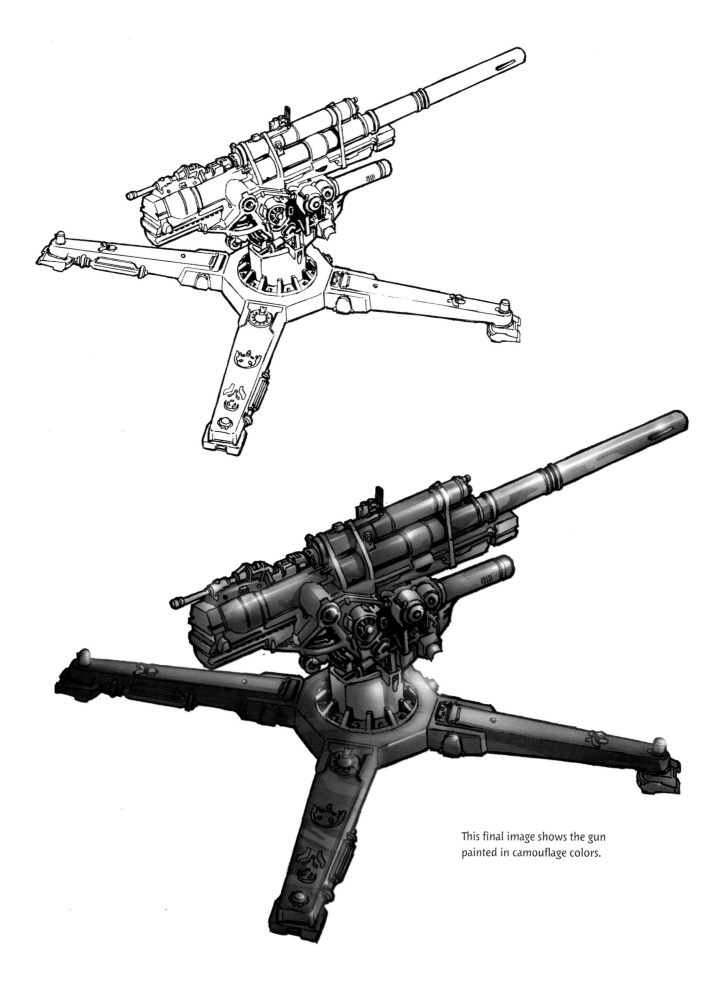

This final image shows the gun painted in camouflage colors.

Bazooka

Experiments in rocketry carried out by U.S. physicist Robert H. Goddard in the second decade of the 20th century laid the foundation for development of all later bazooka-type weapons. In the 1920s, Goddard refined his ideas, and in March of 1926 the first rocket using liquid propellants was launched. During World War II the U.S. Army developed a shaped-charge hand grenade for antitank use—the M10—that was effective at penetrating enemy tank armor, but the M10 weighed 3.5 pounds (1.6 kg) and could only be launched by hand. Army Colonel Leslie A. Skinner suggested placing the grenade on the front of an experimental rocket launcher similar to the one Goddard had created. This proved to be successful and in late 1942, the U.S. launched what was to be the first of many HEAT (high-explosive antitank) 60-mm (2.36-in) rounds from a 4-ft-long (1.2-mm-long) tube. The system, officially RPG (rocket-propelled grenade) M1A1, was soon nicknamed the bazooka. (The name derives from its physical resemblance to an instrument invented by 1930s and '40s radio comedian Bob Burns; Burns dubbed his tubular wind instrument "bazooka," after "bazoo," a slang term for "big mouth.") Bazookas were used effectively during World War II and the Korean War.

As more sophisticated armor rendered the older-model bazookas ineffective, lightweight-antitank weapons (LAWs) were developed—the M72s—but these could not keep pace with technological developments in modern tank armor, and are used only against unarmored buildings and vehicles. Currently, a next-generation, high-penetration LAW is under development.

SPECIFICATIONS

60-mm M72A3 LAW Rocket
Manufacturer: Talley Defense Systems

Dimensions/Weight
Length: 20 in (50.8 cm)
Weight: 2.2 lb (1 kg)
Diameter: 2.6 in (66 mm)

Performance
Velocity: 500 ft/s (150 m/s)
Range: 3,300 ft (1,000 m)

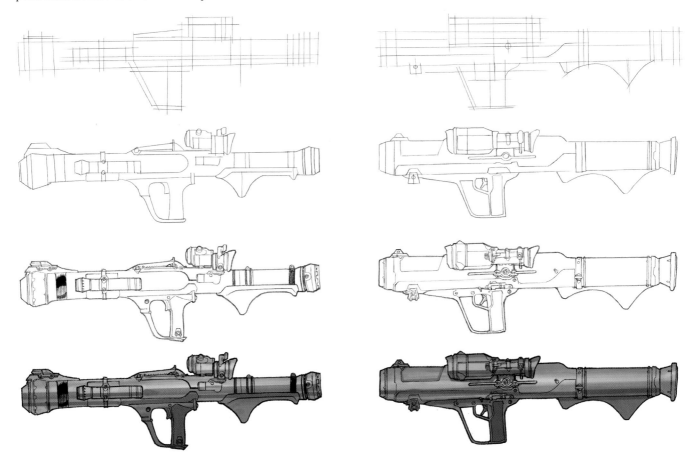

There isn't a whole lot to drawing a realistic bazooka-type weapon beyond sketching a cylinder for the main shaft. Add another cylinder for the targeting system and be sure to draw a rear blast port. A considerable amount of energy is released when one of these bad boys fires and for a soldier it was only slightly less lethal to be standing behind a bazooka as it was to be standing in front of one.

Submachine Guns

Submachine guns were used extensively in World War II, but by the end of the 20th century their use had become limited. Today's submachine guns—the most popular models being the Uzi, the H&K MP5, and the Beretta M12—are shorter than earlier models, have closed-bolt operation, and are made of aluminum or polymer.

Uzi

The Uzi submachine gun—which is instantly recognizable because of its distinct magazine/grip component—has a long and illustrious history, both in real-world battle, on film (notably, *The Terminator*, where the Uzi was one of the weapons of choice of costar Linda Hamilton), and in countless video games. Designed in the late 1940s by Israeli army officer and inventor Uziel Gal, the Uzi was used by the Israeli military until December 2003, when an official phase-out began. Several smaller variations of the original Uzi are in use by special forces and law enforcement agencies around the world, including the Micro Uzi, which is about the same size as a standard pistol, and the Para Micro Uzi, which is standard issue for Israeli counterterrorism units.

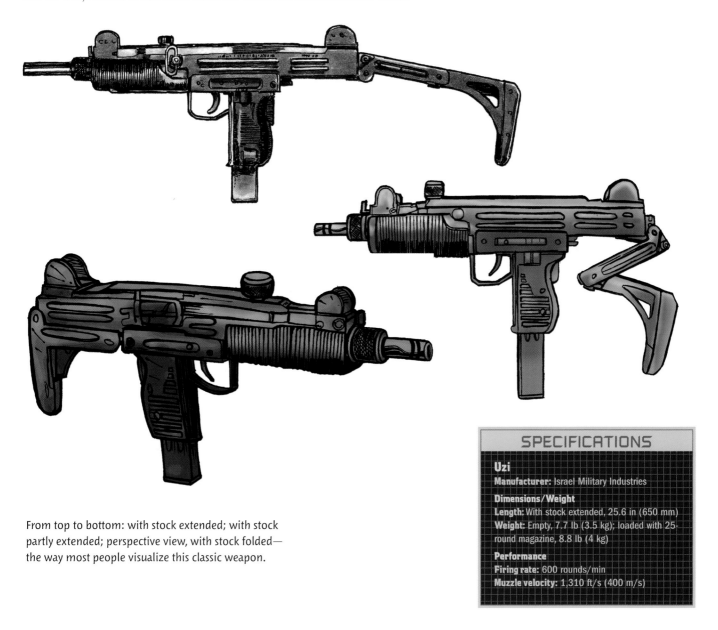

From top to bottom: with stock extended; with stock partly extended; perspective view, with stock folded— the way most people visualize this classic weapon.

SPECIFICATIONS

Uzi
Manufacturer: Israel Military Industries
Dimensions/Weight
Length: With stock extended, 25.6 in (650 mm)
Weight: Empty, 7.7 lb (3.5 kg); loaded with 25-round magazine, 8.8 lb (4 kg)
Performance
Firing rate: 600 rounds/min
Muzzle velocity: 1,310 ft/s (400 m/s)

Shooting Gallery

All of the weapons in this gallery of guns
are the work of artist Robert Burrows.

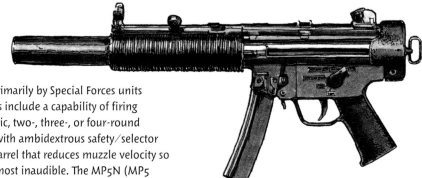

The Heckler & Koch MP5 submachine gun is used primarily by Special Forces units
around the world for close-quarter combat. Features include a capability of firing
various different pistol cartridges; and semiautomatic, two-, three-, or four-round
bursts, or sustained firing modes; and a pistol grip with ambidextrous safety/selector
lever. The H&K MP5SD, shown here, has a custom barrel that reduces muzzle velocity so
that at distances of more than 49 feet (15 m) it is almost inaudible. The MP5N (MP5
"Navy") has a tough, corrosion-resistant finish, making it ideal for use by Navy SEALs.

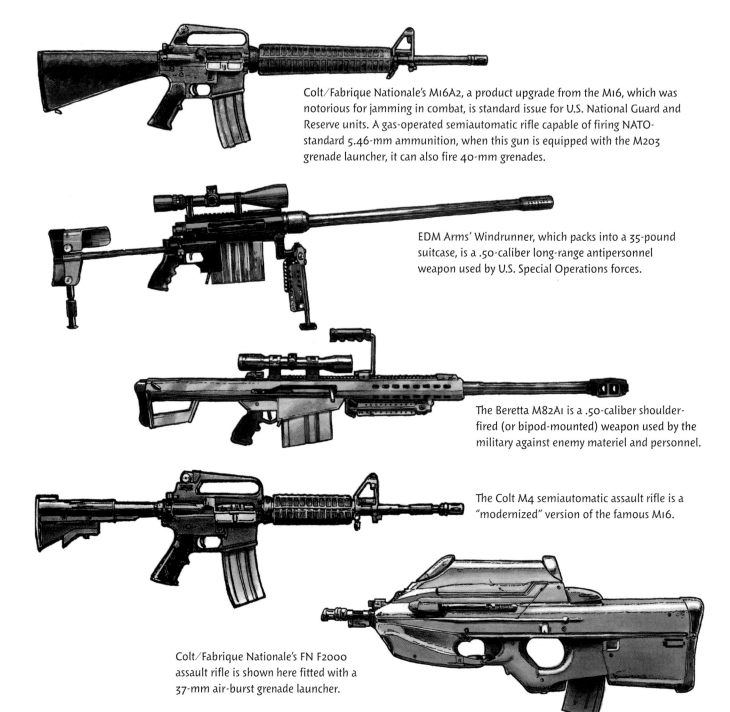

Colt/Fabrique Nationale's M16A2, a product upgrade from the M16, which was
notorious for jamming in combat, is standard issue for U.S. National Guard and
Reserve units. A gas-operated semiautomatic rifle capable of firing NATO-
standard 5.46-mm ammunition, when this gun is equipped with the M203
grenade launcher, it can also fire 40-mm grenades.

EDM Arms' Windrunner, which packs into a 35-pound
suitcase, is a .50-caliber long-range antipersonnel
weapon used by U.S. Special Operations forces.

The Beretta M82A1 is a .50-caliber shoulder-
fired (or bipod-mounted) weapon used by the
military against enemy materiel and personnel.

The Colt M4 semiautomatic assault rifle is a
"modernized" version of the famous M16.

Colt/Fabrique Nationale's FN F2000
assault rifle is shown here fitted with a
37-mm air-burst grenade launcher.

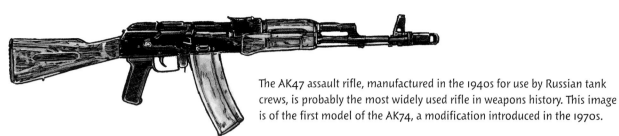

The AK47 assault rifle, manufactured in the 1940s for use by Russian tank crews, is probably the most widely used rifle in weapons history. This image is of the first model of the AK74, a modification introduced in the 1970s.

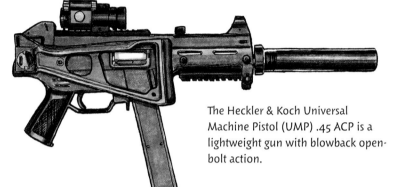

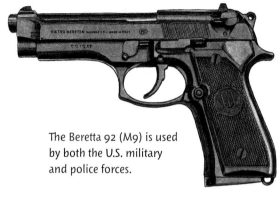

The Heckler & Koch Universal Machine Pistol (UMP) .45 ACP is a lightweight gun with blowback open-bolt action.

The Beretta 92 (M9) is used by both the U.S. military and police forces.

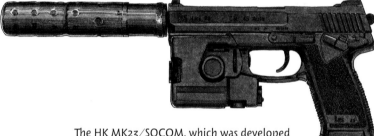

The HK MK23/SOCOM, which was developed in the early 1990s for use by the U.S. Special Operations Command, is also popular with some law enforcement agencies.

The Walther PPK-S is a compact, easily concealed double-action pistol that was Jame's Bond's weapon of choice through 17 films, beginning with Dr. No. (In 1997's Tomorrow Never Dies 007 finally makes a switch, from the PPK to a Walther P99.)

Brett Booth has drawn his international arms dealer in full tough-guy regalia. In reality, arms dealers are more likely to look like the Nicolas Cage character, Yuri Orlov, in Lord of War, but it isn't a stretch to visualize Booth's version wielding any (or all) of the deadly weapons pictured in this gallery of guns.

Military Working Dogs (MWDs)

Working dogs have been used in military campaigns for centuries. There are recorded accounts of dogs being sent out by the ancient Egyptians and by Roman legions on combat attacks, and Attila the Hun used dogs as sentries. In the late 18th century, the U.S. Army used bloodhounds as trackers; during the Civil War, dogs were used as messengers and scouts; and Teddy Roosevelt's Rough Rider patrols rode alongside scout dogs. The German army established the first official military training school for dogs in Lechernich, near Berlin, in 1884.

The first extensive use of dogs in modern armies was in World War I; radio equipment was often broken, and messenger dogs were an important means of communication. During World II, over 1 million dogs served with the armies of the Allied and Axis powers. In 1942, the U.S. Secretary of War directed the Quartermaster General (the equivalent of today's Secretary of Defense) to expand the then-fledgling War Dog Program (later the Military Working Dog Program), leading to the formation of the first K-9 (get it?) Corps. Experimentation during and after the war with different breeds led to the inescapable conclusion that the best choice for military dogs is the German shepherd, although the Marines also made extensive use of Doberman pinschers.

Today, the branch of the U.S. armed forces responsible for the MWD Program is the Air Force. Most of the trained K-9 Corps do drug- and/or bomb-detection duty and sentry duty, but about 20 percent of them do patrol duty, which involves scouting, searching, and, on command of handler, attacking. Military dog units patrol our borders and are assigned to all major airports to keep our citizens safe from threats foreign and domestic. Loyal, protective, intelligent, strong, and courageous, dogs will continue to exemplify the self-sacrificing traits of a good soldier as long as their assistance in warfare is needed.

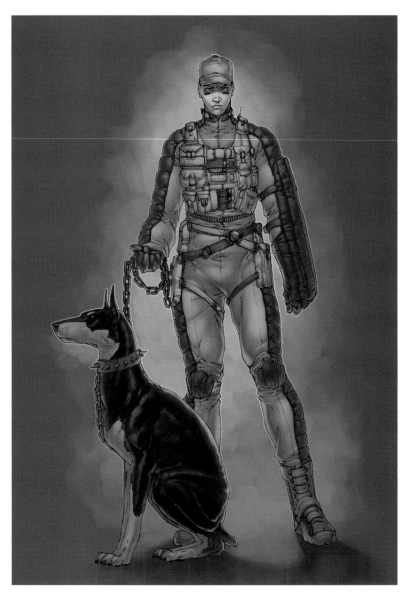

Just as their canine companions need special training, dog handlers need to be specially trained so they can work effectively together, with their dogs, as a team. Whatever the situation—sentry or patrol duty, mine, drug, or explosive detection, searching for armed suspects, or locating a wounded soldier—it takes a highly attentive handler to properly interpret the feedback the dog is giving. The soldier depends on the dog's keen senses of hearing and smell, while the dog depends on the soldier to make split-second decisions and to take the correct course of action.

Doberman Pinscher

The Doberman pinscher was developed in Germany in the 1860s by cross-breeding German pinschers with Rottweilers, Beauceron pinschers, greyhounds, and English greyhounds: The result was a highly intelligent, specialized breed with a sleek physique. The innovator credited with first combining these breeds was a German tax collector named Louis Doberman. Doberman wanted to design a watchdog and bodyguard capable of handling any situation that might arise as he traveled through crime-ridden areas while collecting taxes. Faster than a German shepherd and better suited for high-humidity and high-temperature zones, Dobermans were immediately recognized as an asset in both the civilian and military arenas. Thanks to one ingenious tax collector the Doberman has become a fixture wherever swiftness of foot and acute senses are demanded to protect life and property.

Dobermans, classified as working dogs, weigh from 65 to 90 pounds (29.5 to 40.8 kg), and are 2 feet (0.6 m) to 2 feet 4 inches (0.75 m) in height. Their short, thick coats are smooth and glossy. Colors are black, red, "blue," or fawn, with sharply defined patches of rust.

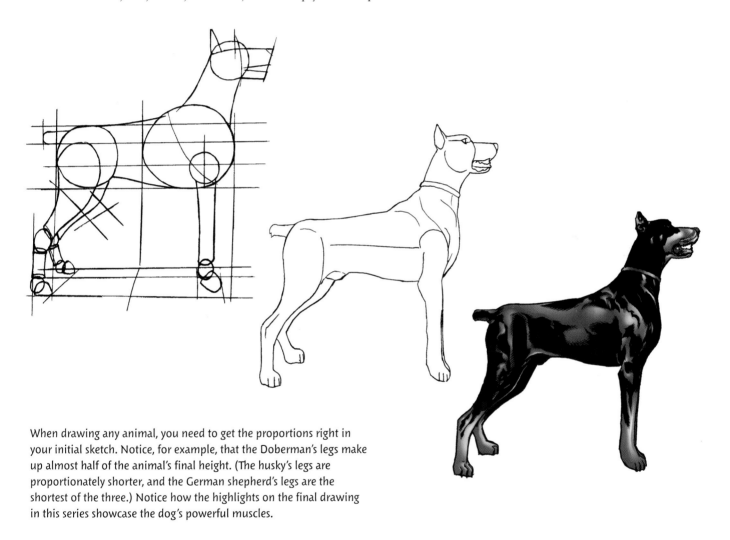

When drawing any animal, you need to get the proportions right in your initial sketch. Notice, for example, that the Doberman's legs make up almost half of the animal's final height. (The husky's legs are proportionately shorter, and the German shepherd's legs are the shortest of the three.) Notice how the highlights on the final drawing in this series showcase the dog's powerful muscles.

Siberian Husky

The Siberian husky is a medium-sized dog especially adapted to performing well in cold environments. The ancestors of the Siberian husky originated with the Chukchi of northeastern Siberia, who bred them over hundreds of years for herding reindeer and pulling loads of lumber or rocks. By the end of the 19th century, Alaskan traders were using Chukchi dogs, which they renamed the Siberian husky, to pull their sleds. Siberian huskies are natural athletes with a trim muscular body and a level of endurance that outclasses even elite marathoners or pentathletes. Teams of huskies take part in the annual Iditarod race in Alaska, which is over 1,100 miles (1,770 km) long and lasts 9 to 14 days, with some individual dogs running over 300 miles (483 km) of the course. Today, huskies are still used by the military in cold-weather environments for sled teams and as guard dogs.

Huskies, like Dobermans, are working dogs. Female huskies weigh from 35 to 50 pounds (15.9 to 22.7 kg); males, from 45 to 60 pounds (20.4 to 27.2 kg). They have medium to long coats; their outer coats are straight and coarse, and they have soft, dense undercoats. Their basic coats are white, with silver, black, gray, copper, and brown markings.

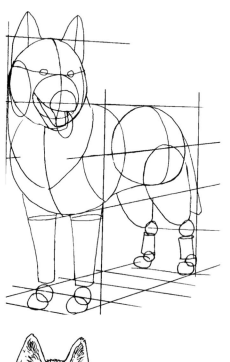

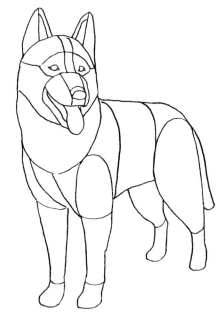

It can be tricky to draw a husky's anatomy correctly since it is hidden under so much fur. In the initial steps you should ignore the fur and just concentrate on building the dog as if it were hairless (not a pretty sight, but an effective artistic method.) Artist Dan Norton has built this dog mostly from basic shapes—cylinders, ovals, and spheres—and sketched in lines for the fur in only a few key spots.

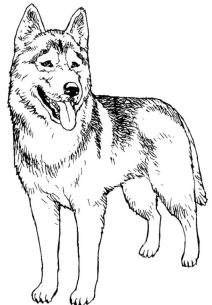

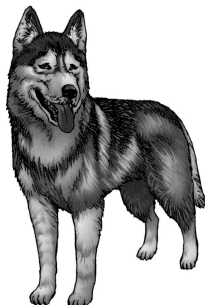

German Shepherd

When German shepherds were originally introduced as part of the German police force, they were known in Germany primarily as a herding dog, and many observers thought they were a poor choice for police duty. Thanks to the tireless work of Max von Stephanitz, the original breeder of German shepherds, the public was eventually convinced that the breed was indeed fit for police— and military—work and, beyond that, could be used as seeing-eye dogs.

German shepherds first became popular in the United States when many GIs brought them back following World War I. Among the many characteristics of German shepherds that make them ideal as service dogs are keen eyesight, physical stamina, and courage. As a group, they can be relied on to perform their duties without becoming distracted by disturbances unrelated to their tasks. They are highly trainable, and have a strong desire to please their handlers.

German shepherds weigh from 75 to 95 pounds (34 to 42.6 kg). Females are from 22 to 24 inches tall (55.8 to 61 cm); males from 24 to 26 inches tall (55.8 to 66 cm). Their dense, medium-length coats may be straight or slightly wavy, with varied markings (black, gray, brown, yellow brown).

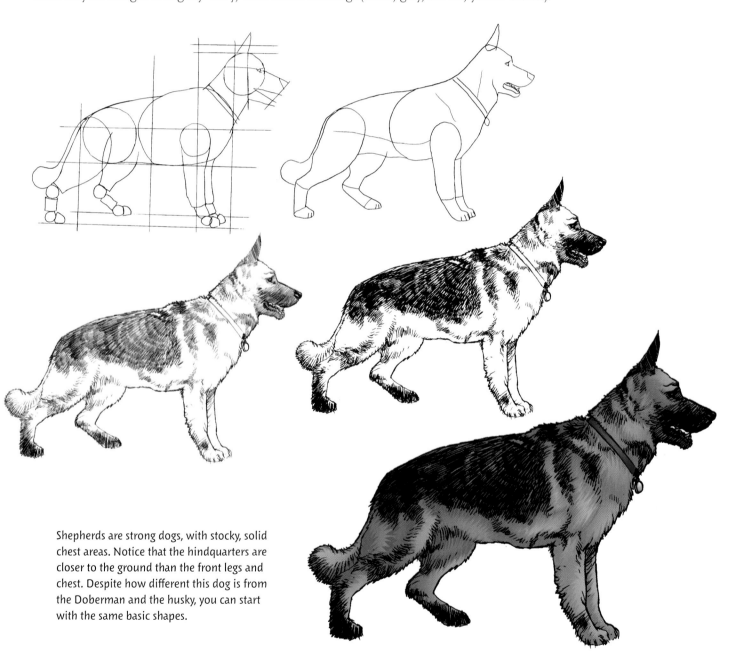

Shepherds are strong dogs, with stocky, solid chest areas. Notice that the hindquarters are closer to the ground than the front legs and chest. Despite how different this dog is from the Doberman and the husky, you can start with the same basic shapes.

Enlisted Personnel Job Categories

In the Army and Marines, a given enlisted job is known as a Military Occupational Specialty (MOS); in the Air Force, as an Air Force Specialty Code (AFSC); and in the Navy and Coast Guard, as a Rating. These jobs—some of which are unique to the branch and some of which are common to all branches—are identified by assigned numbers, a combination of numbers and letters, and, for the Navy and Coast Guard, by letters. Here, for example, are three different IDs for enlistees trained in intelligence/counterintelligence operations: Navy/Coast Guard, IS (intelligence specialist); Army, 97Z (counterintelligence/human intelligence, senior); Air Force, AFSC, intelligence officer.

Typical categories are aerography/metereology, armor, artillery, intelligence (ground, air, and signals), engineer, ground supply, flight officer, and medic, and most of these specialties have equivalent or similar occupations in the civilian world. Many of these job skills overlap with skills that soldiers in the U.S. Special Operations Forces (SOF) must have (see the next chapter), but SOF soldiers and officers undergo much more rigorous training and are usually experts in two, three, or more areas.

Bomb Squad

Time was, members of military bomb squads didn't need to know much beyond how to deal with TNT-based explosive devices. Today, things are much more complicated. Soldiers need to know how to handle situations involving CBRN (chemical, biological, radiological, and nuclear) threats. They are trained in what is known as IEDD (improvised explosive device disposal), and "improvised" means just that: IEDs may indeed be bombs, but they may also be incendiary devices or contain chemical or biological agents, and are likely to involve electronic/remote firing systems. Bomb squad teams are charged with identifying the level of threat, selecting equipment appropriate to the threat, putting into place electronic countermeasures (which may themselves have to be improvised), and offering "tactical explosive breaching support." In other words, they are responsible for making sure things don't go boom in stressful situations.

Teams may deal with a bomb threat by suiting up in traditional full-body padded Kevlar armor, taking "the long walk" (that nerve-wracking approach to a possible explosive or incendiary device, and containing the device in specialized TCVs (total containment vessels). They also operate BFE (back from everyone) lab areas, which are usually a good distance from the other troops and where state-of-the-art dispersal devices are developed and deployed.

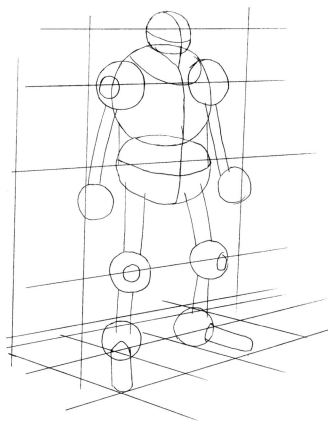

When drawing characters with several layers of clothes, remember that the range of motion is going to be greatly hampered by all that padding. It is all too easy to lose track of knees and elbows, and if you incorrectly position the limbs, your character is likely to look awkward or, worse, in need of medical attention. Here the artist has started with the usual perspective box, with exaggerated circles (chest area, shoulders, knees) and cylinders (lower trunk, legs).

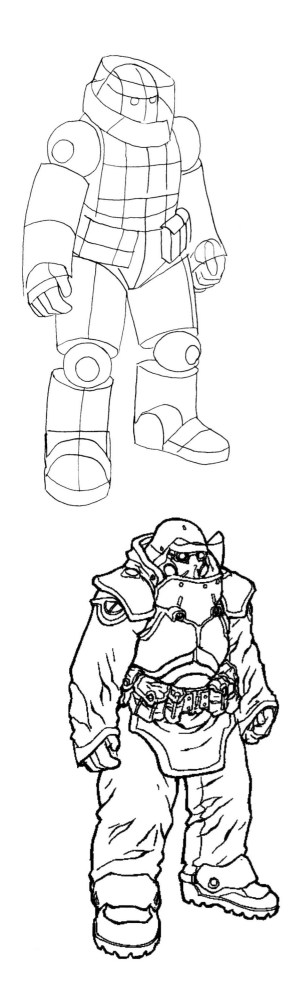

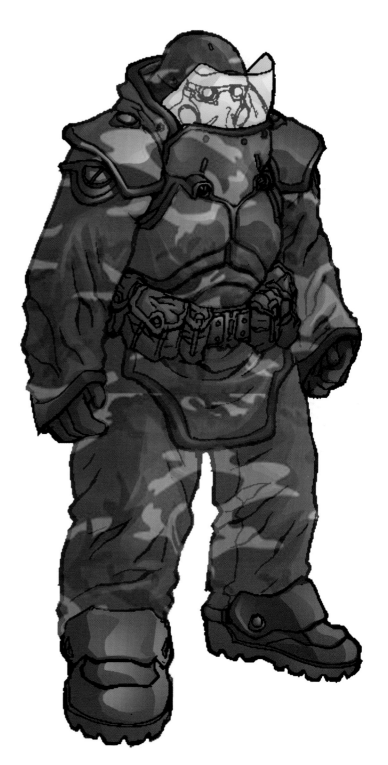

At close range no amount of armor will protect you from a powerful explosion, but this armor—a type that would most likely be worn during initial inspection of a potential bomb—is designed to protect the wearer from harm against smaller bombs and secondary fallout.

The Hazmat Teams

Every time a hazmat team rolls into action they know it is a WCS (worst case scenario).
Specially trained to deal with hazardous material, aka *hazmat*, these soldiers have the
equipment and the nerves to detect, neutralize, and contain potentially lethal agents.
Hazmat teams can be called on to assess a possibly contaminated zone on friendly soil,
accomplish a rescue mission in infected regions, or be dropped into the thick of an already
contaminated battlefield and complete a mission where no one else has dared to tread.

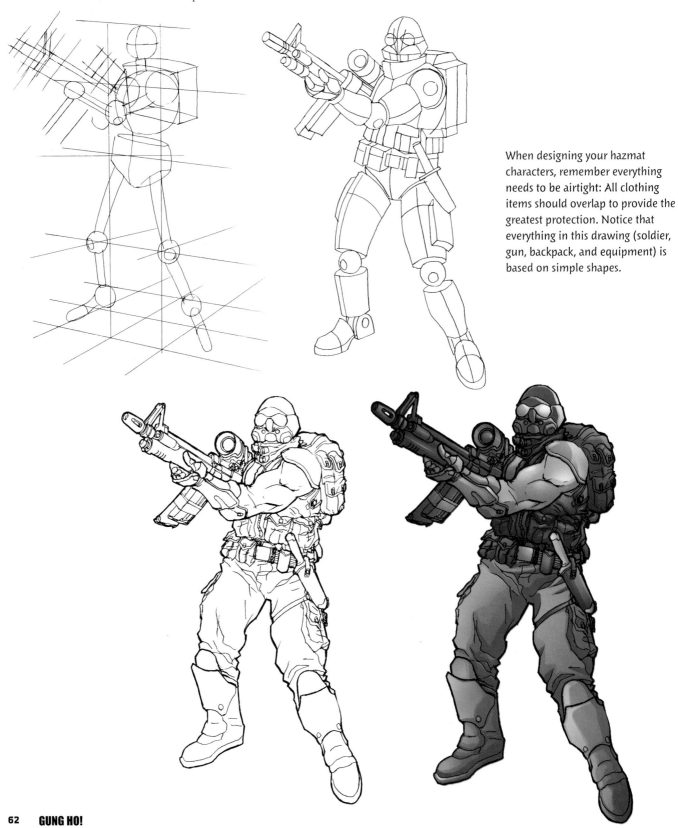

When designing your hazmat
characters, remember everything
needs to be airtight: All clothing
items should overlap to provide the
greatest protection. Notice that
everything in this drawing (soldier,
gun, backpack, and equipment) is
based on simple shapes.

Gas Masks

One basic training event that no soldier ever forgets is the gas chamber exercise. During this exercise, which is designed to teach soldiers the importance of proper masking techniques and to instill in them trust in their equipment, soldiers must enter a room full of actual tear gas, then remove their protective masks so they will feel the terrible burning sensation of the gas blinding their eyes as their throats involuntarily constrict. Despite the pain, they must then put the masks back in place before leaving the room. Today's protective masks come in a variety of different shapes and sizes, but they all work on the same basic principle. A vacuum seal around the wearer's face prevents gas from irritating the soldier's eyes and airways while a series of filters—micromeshes and chemical neutralizing agents such as charcoal—prevent airborne contaminant from entering the lungs.

Different masks are rated for different toxins and contaminants, with some affording protection against riot-control chemicals and others modified to provide specialized protection against nuclear, biological, and chemical (NBC) agents. In the 1990s masks were developed with night-vision capabilities. Currently, all U.S. armed forces branches are cosponsoring development of a mask that will offer protection from a variety of chemical warfare agents as well as improved vision and communications capabilities. Providing maximum vision capabilities is no easy task. As anyone who has qualified with an M16 while in full NBC MOPP Level 4 knows, it can be a little tricky. (MOPP is an acronym for mission-oriented protective posture; Level 4 means that the wearer is fitted with overgarment, helmet, overboots, protective mask and hood, and butyl rubber gloves.)

Here are two masks which perform similar functions but are constructed totally differently. As always, the key to drawing successful military characters, weapons, vehicles, accessories, etc., is authenticity. You don't have to limit yourself to real-world examples of equipment, but you better learn to draw things in a way which makes them look like they could work. Before you draw a soldier with full NBC MOPP Level 4 protection, you should practice drawing the mask by itself. In any case, you'll want to lightly sketch in a correctly proportioned head first, because all masks must fit snugly. The top of the mask will be over the soldier's forehead, and the bottom of the mask will cover the area under the chin.

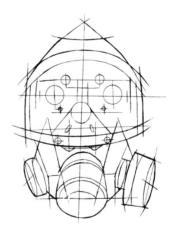
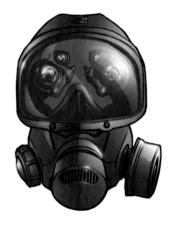
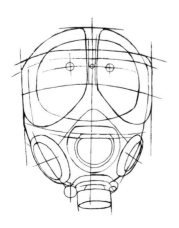
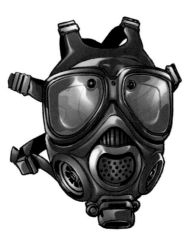

Communications

Gone are the days when all the radio operator had to worry about was calling in an air strike from HQ. Today's communications specialist is in charge of monitoring all airwaves and radio waves, the Internet, satellite uplinks, and cell phone towers. In combat, if you need someone to break a code, hack a system, or monitor a satellite tracking system the communications specialist is the person to call.

Remember, in the field nothing is as vitally important as keeping the communications lines open. If communications between headquarters and field troops are cut off, the field personnel are effectively rendered blind and deaf to what is happening elsewhere on the battlefield and they will be stranded with no possibility of an evac, or the arrival of reinforcements.

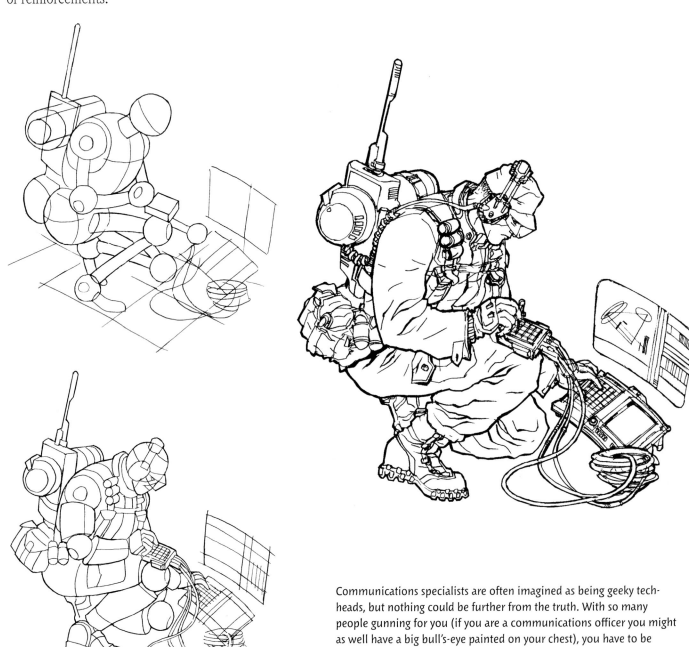

Communications specialists are often imagined as being geeky tech-heads, but nothing could be further from the truth. With so many people gunning for you (if you are a communications officer you might as well have a big bull's-eye painted on your chest), you have to be equal parts brains and combat savvy.

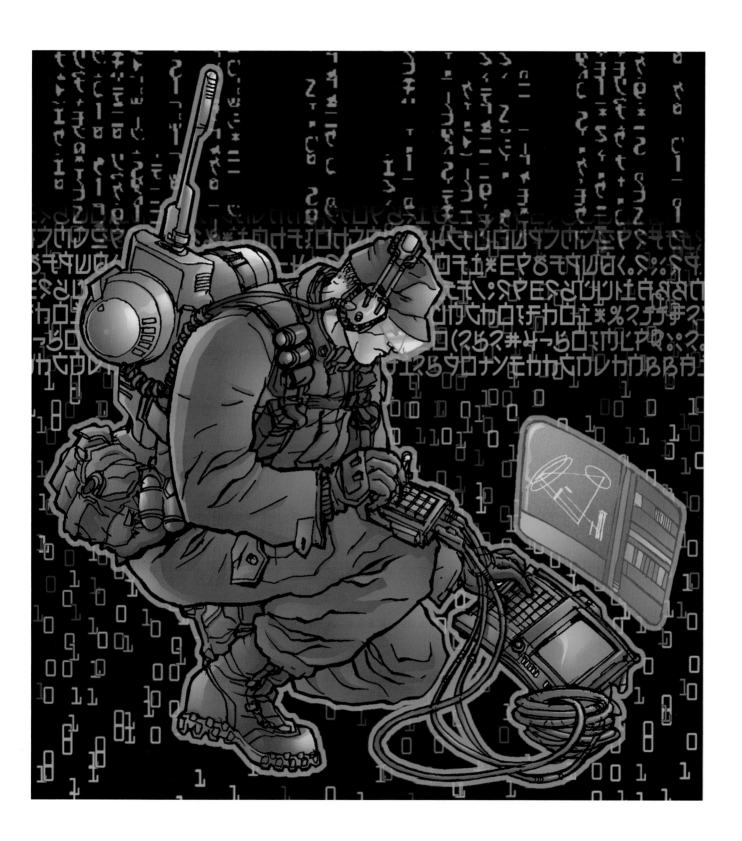

Diver

Some of the duties of a military diver include routine underwater ship maintenance, salvage operations, rescuing a crew stranded in a submarine, recovering a sunken warhead, demolition, construction of piers and harbor facilities, and waterway infiltration. Military scuba divers do their work just beneath the surface of the water. Deep-sea divers work far beneath the surface, in an airless environment in which constant and strict attention must be given to the breathing apparatus. (For information on Navy SEALs, easily the most famous military divers in the world, see the next chapter.)

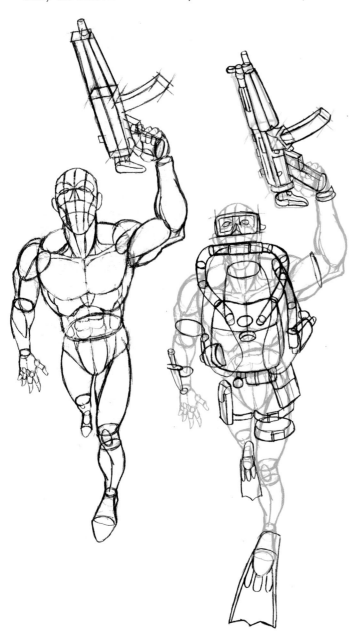

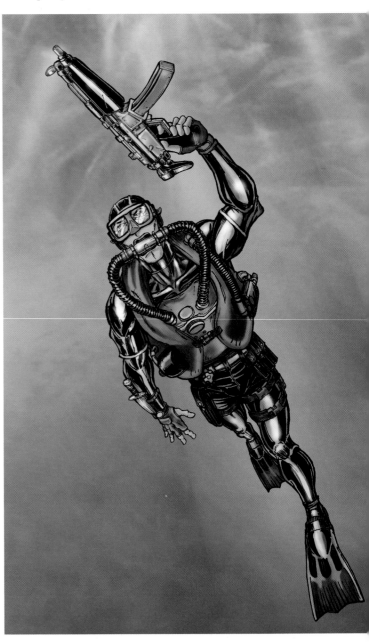

Divers wear a lot of specialized equipment, but you will want to draw the basic figure first. You need to be sure you have nailed the anatomy and perspective before adding the aquatic gear. Once you have a good grasp of the basic figure, go back and add simple shapes for the various tanks and hoses. Finish the drawing by adding details and erasing any unneeded construction lines, shown here in green.

Intelligence/Counterintelligence

Intelligence/counterintelligence operations are mounted by all branches and by all SOF units. (For a description of SOF intelligence/counterintelligence personnel, see the next chapter.) At the MOS/ASFC/Rating level, a counterintelligence agent's job is to assist in surveys and investigations of individuals, organizations, and installations in order to detect, identify, and counter or neutralize threats to national security. Down the line, a counterintelligence officer must be able to supervise the collection, processing, filtering, and dissemination of data from multiple sources simultaneously and then advise commanding officers on the best advisable course of action.

Depending on the service branch, a counterintelligence officer may be trained in counterespionage operations, psychological operations (PSYOPS), interrogation techniques, image intelligence (IMINT), electronic warfare (EW), and counter–human intelligence (C-HUMINT). Whatever the particulars of an individual's job skills, intelligence agents as a group maintain a protective shield around the military's critical technology from all threats foreign and domestic, and they are the first line of defense against espionage.

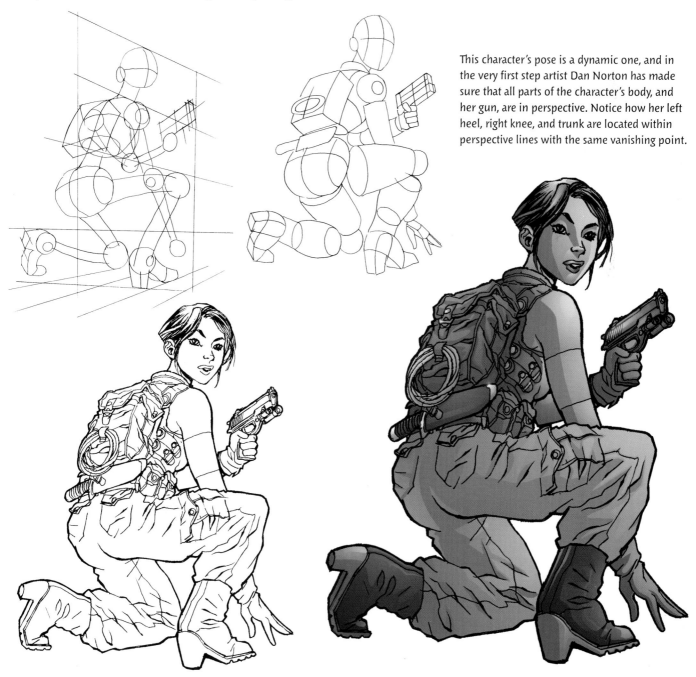

This character's pose is a dynamic one, and in the very first step artist Dan Norton has made sure that all parts of the character's body, and her gun, are in perspective. Notice how her left heel, right knee, and trunk are located within perspective lines with the same vanishing point.

Medic

It takes a special kind of guts to go into battle with a medical bag instead of a rifle. Everyone has seen those war movies where a soldier in a foxhole screams "Medic!" and then some brave soul comes zipping across the battlefield as bullets whiz overhead. Often the field medic is the only hope soldiers wounded in battle have of not becoming a casualty.

Many soldiers have a strong desire to serve their country, but are morally opposed to using firearms. They find the Medical Corps to be an acceptable way to carry out their active service requirements.

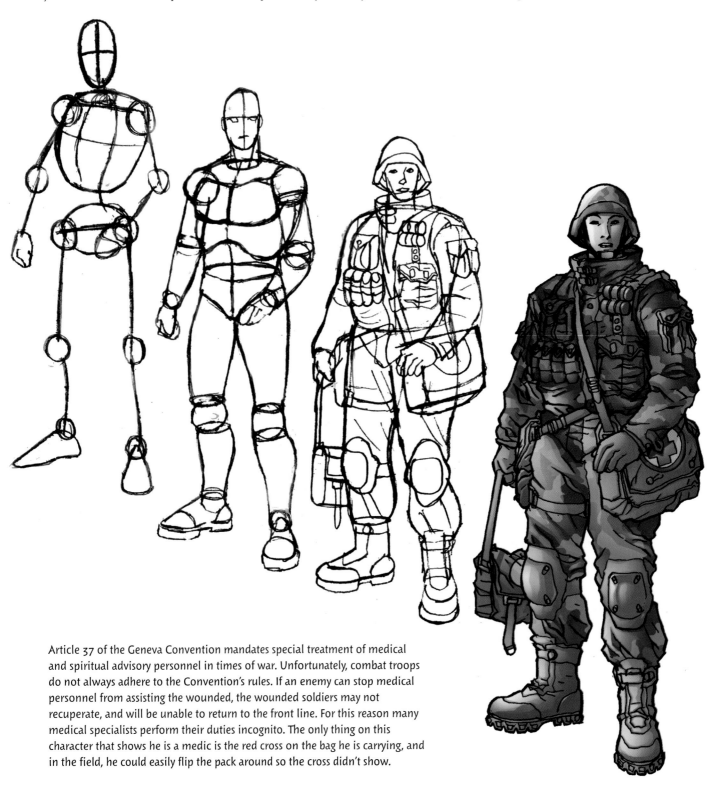

Article 37 of the Geneva Convention mandates special treatment of medical and spiritual advisory personnel in times of war. Unfortunately, combat troops do not always adhere to the Convention's rules. If an enemy can stop medical personnel from assisting the wounded, the wounded soldiers may not recuperate, and will be unable to return to the front line. For this reason many medical specialists perform their duties incognito. The only thing on this character that shows he is a medic is the red cross on the bag he is carrying, and in the field, he could easily flip the pack around so the cross didn't show.

Sniper

Snipers are often thought of only as highly trained sharpshooters who can hit targets from incredibly long distances, but they do much more than just that. They are also experts in stealth, camouflage, infiltration, and reconnaissance techniques. Snipers are classified as *force multipliers*, or those capable of inflicting damage disproportionate to the actual size of the team or individual. Nothing scares an enemy more than to know that out there somewhere is a crack shot lining up a bullet with his name on it.

The image of a lone sharpshooter has a certain legendary cachet, but in fact military snipers usually work as part of a team. These elite shooters must be able to move into position undetected and stay concealed for hours at a time, patiently waiting for either a specific target or a "target of opportunity," someone or thing that presents itself as a mission-enhancing mark. A sniper must be schooled on countless variables before squeezing the trigger; he or she must take into account the weapon's characteristics, range, target movement, wind speed, wind direction, heat shimmers, light source, temperature, barometric pressure, and how the bullet's flight pattern will alter over distance.

The weapon this sniper is shouldering looks very much like one of the rifles used during World War II and Korea. (The size of the weapon has been deliberately exaggerated—the rifle is seemingly longer than the slightly built sharpshooter who is wielding it—for effect.) Today's sniper rifles, such as the EDM Windrunner (see page 54), with over 4 times the range of many earlier sniper rifles and firing .50-caliber ammunition, have a very different look.

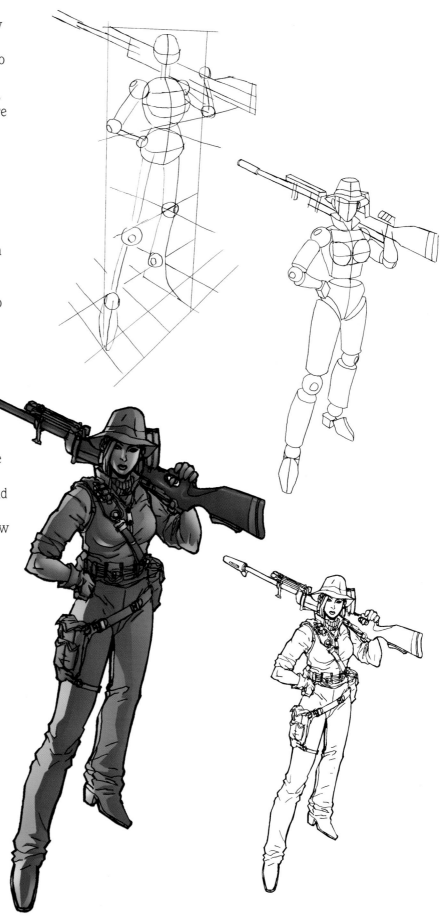

Special Operations

Every Special Operations Forces (SOF) operative in the armed forces has gone through intensive preparation. The training regimens vary, depending on which SOF the would-be operative wants to become part of, but all go far beyond even the most rigorous of basic training schedules. Basic training gives recruits the fundamentals of being a soldier. SOF training teaches the complex set of skills needed to carry out the highly dangerous and specialized missions involved in unconventional warfare.

United States SOF forces have been involved, on an unprecedented scale, in every phase of the war in Iraq. The Green Berets carried out "hearts and minds" PSYOPS operations, Delta teams and black ops worked together to hunt down and capture Saddam Hussein, Rangers concentrated on recon missions, SEALs cleared mines from waterways, and Air Force SOF teams chuted into enemy territory to pinpoint air strike targets for U.S. planes.

This chapter features soldiers in the best-known SOF units; SOF intelligence/counter-intelligence personnel; and those operatives who are part of the so-called "black world," comprised of units whose top-secret operations are known only to a limited number of people in the military intelligence community.

Army Ranger

The mission of the U.S. Army Rangers (75th Ranger Regiment) is to provide forward recon for regular Army units as well as take out the enemy using counter-guerilla fighting tactics. Considered the finest light infantry force in the world, the 75th personifies the best of what the Army has to offer. All three Ranger battalions are quick-response elite teams prepared to meet all A3 ("anytime, anywhere, anything") threats and are trained extensively in airborne insertion techniques, including parachuting and rappelling from helicopters, for Arctic, jungle, desert, and mountain conditions.

When you absolutely, positively need something blown up overnight, this is the guy to call. He is all about stealth, so he dresses accordingly, from his infrared-blocking night fatigues to his midnight blue steel weapons. To be as silent as a mouse, he can't have too many accessories swinging around so he carries most of his gear in a hard plastic watertight backpack nicknamed a "turtle shell." Forget about a holster; his magnetized pistol sticks directly to the hard shell's exterior. His mission is a success if the only way you know he was there is something goes ka-blooey!

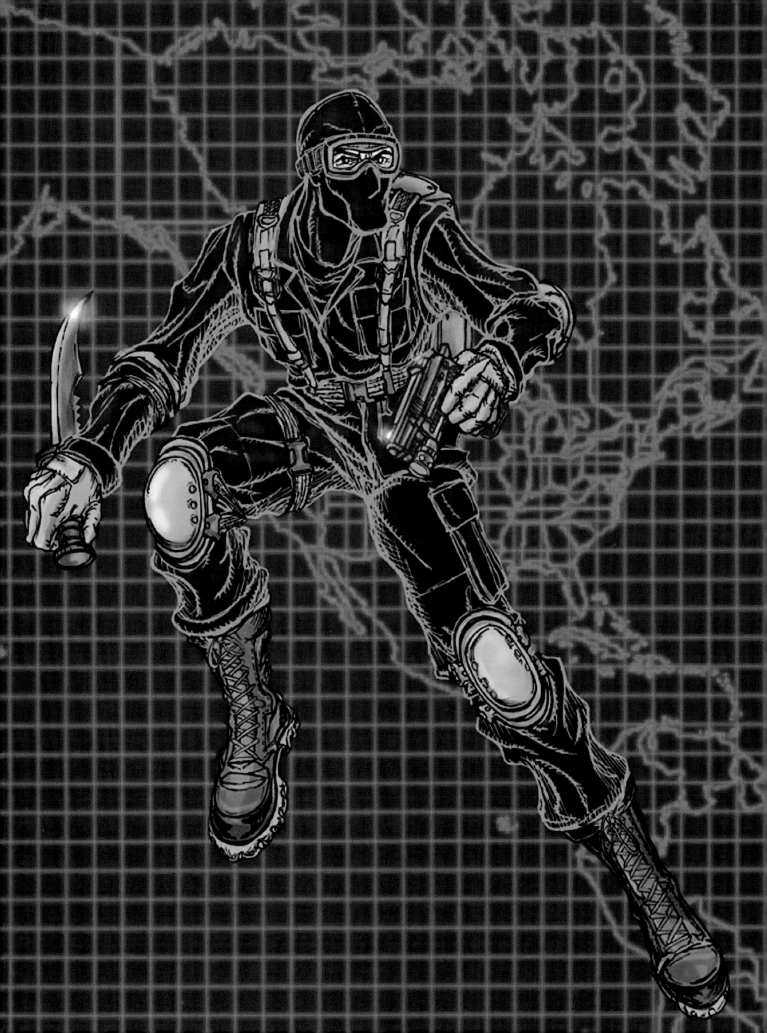

Here the artist has chosen to depict a Ranger performing one of the 75th Regiment's favorite modes of insertion, by air. Draw the basic figure first, then add the gear and chute.

THE RANGER CREED

Recognizing that I volunteered as a Ranger, fully knowing the hazards of my chosen profession, I will always endeavor to uphold the prestige, honor, and high esprit de corps of my Ranger Regiment.

Acknowledging the fact that a Ranger is a more elite soldier who arrives at the cutting edge of battle by land, sea, or air, I accept the fact that as a Ranger my country expects me to move farther, faster and fight harder than any other soldier.

Never shall I fail my comrades. I will always keep myself mentally alert, physically strong and morally straight and I will shoulder more than my share of the task whatever it may be. One-hundred-percent and then some.

Gallantly will I show the world that I am a specially selected and well-trained soldier. My courtesy to superior officers, neatness of dress and care of equipment shall set the example for others to follow.

Energetically will I meet the enemies of my country. I shall defeat them on the field of battle for I am better trained and will fight with all my might. Surrender is not a Ranger word. I will never leave a fallen comrade to fall into the hands of the enemy and under no circumstances will I ever embarrass my country.

Readily will I display the intestinal fortitude required to fight on to the Ranger objective and complete the mission though I be the lone survivor.

RANGERS LEAD THE WAY!

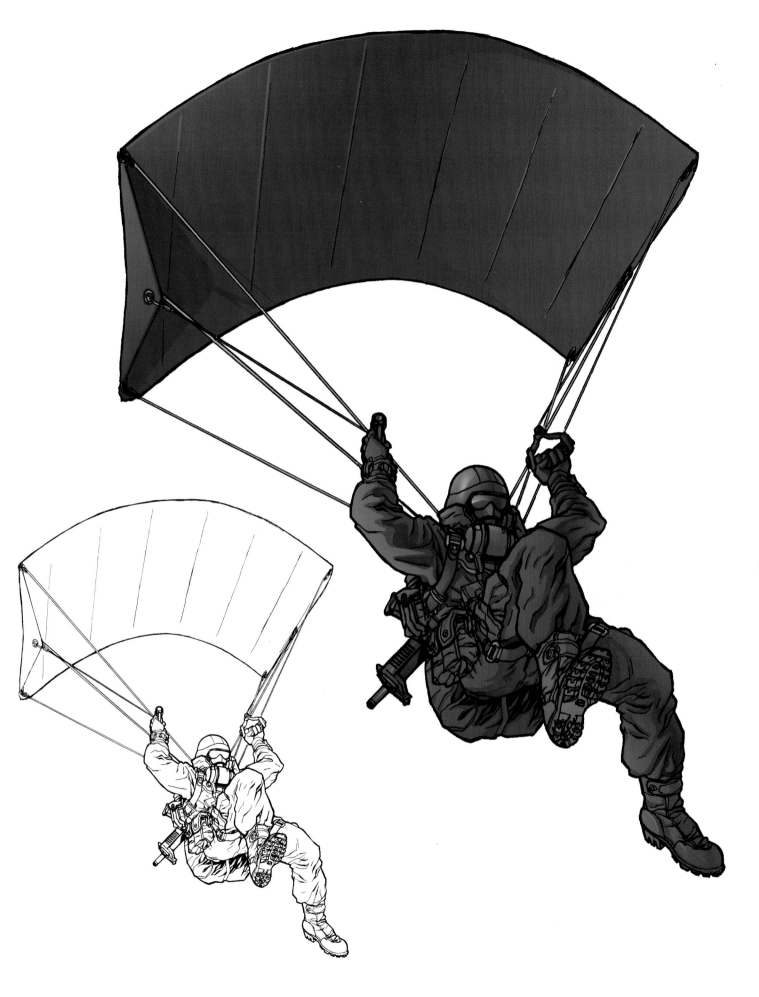

Air Force Special Operations Command

The Air Force Special Operations Command (AFSOC), which is headquartered at Hulburt Field in Florida, includes 20,000 active-duty, reserve, Air National Guard, and civilian personnel. Air Force air commandos provide combat control, combat weather, and pararescue personnel to support both SOF and conventional force operations; conduct PSYOPS broadcasts; supply combat aviation advisors to the military forces of other countries; and have responsibility for Air Force combat search and rescue operations.

Currently the AFSOC plans to buy over 100 new personnel-recovery helicopters, which will replace aging HH-60G Pave Hawks. It will also acquire 14 C-130s (see page 121) from other Air Force units, and these will be equipped either to insert, extract, and resupply SOFs in hostile territory or as gunships for use in ground combat missions.

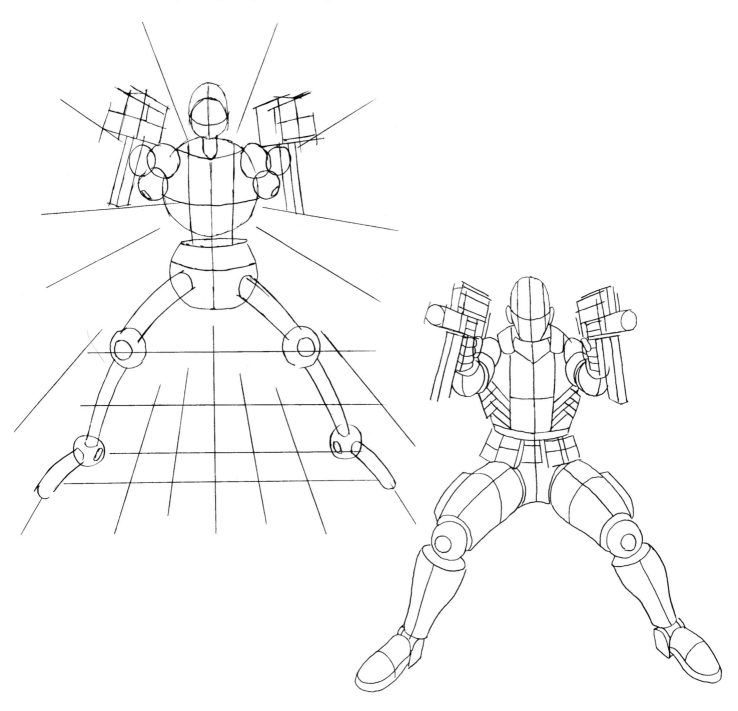

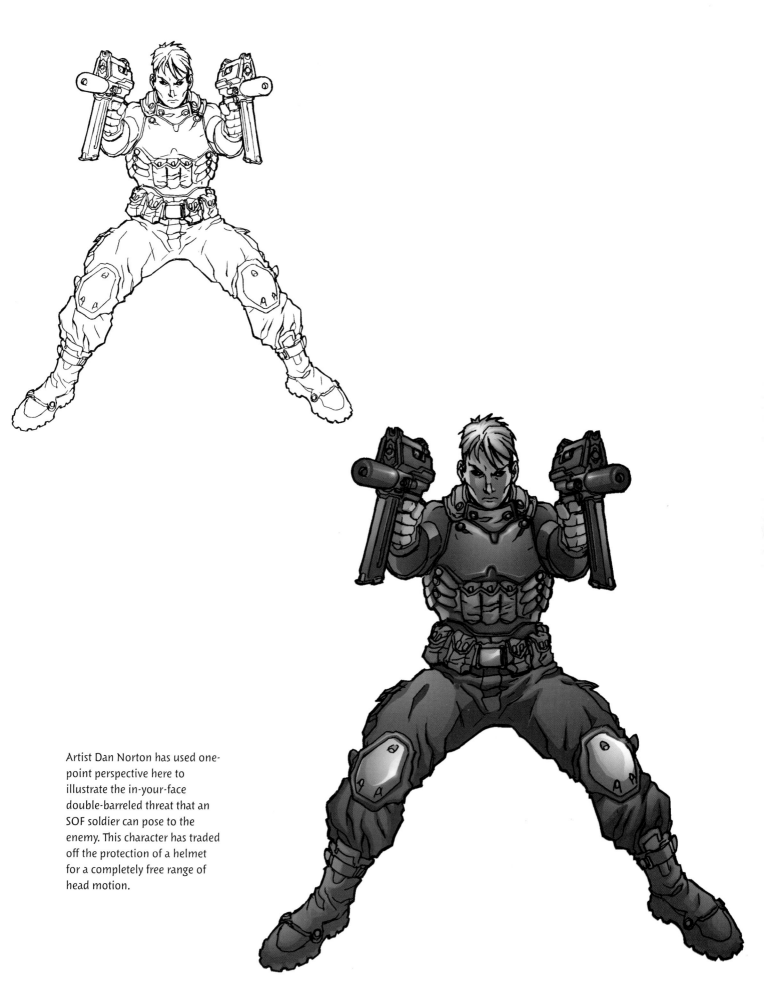

Artist Dan Norton has used one-point perspective here to illustrate the in-your-face double-barreled threat that an SOF soldier can pose to the enemy. This character has traded off the protection of a helmet for a completely free range of head motion.

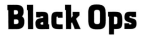

Black Ops

You ever get that funny feeling someone is watching you, but you turn around and no one is there? You may have just had an encounter with a black operations agent. The Department of Defense is reluctant to admit the very existence of black ops, but they are most definitely out there. Black ops missions depend on circumstances, but many probably involve "putting out fires" by squelching potential leaks—by any means necessary—of ultra-secret matters the revelation of which would threaten national security. These covert operatives sometimes look like ordinary citizens, but you can be sure that in the field they pack the latest in high-tech firepower and have access to cutting-edge body armor and stealth equipment. Their identities are secret, as are their internal operating structure and base of operations.

SOF intelligence/counterintelligence agents—aka spies—operate under flexible rules, are likely to be suave and debonair—and are deadlier than two-headed cobras. SOF spies must be able to infiltrate deep, deep into an enemy's territory. To be effective they need to spend months and sometimes years living a charade, operating under false aliases with intricate cover stories they must memorize. It's not all sports cars and fantastic gadgets for these brave soldiers; they know the risks. If they get caught they have to depend on lightning-fast reflexes and a lot of luck to avoid being interrogated by some psychopath with a penchant for power tools.

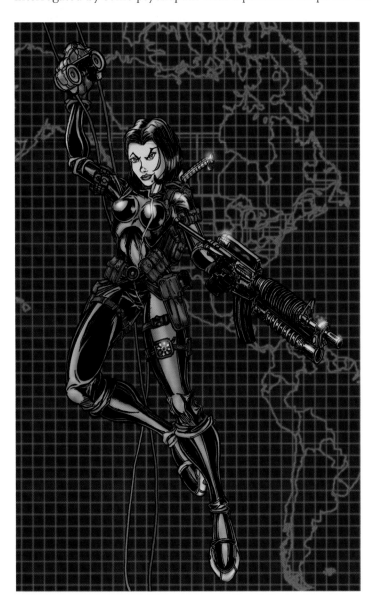

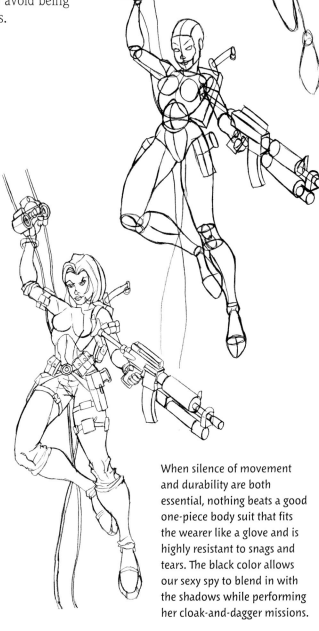

When silence of movement and durability are both essential, nothing beats a good one-piece body suit that fits the wearer like a glove and is highly resistant to snags and tears. The black color allows our sexy spy to blend in with the shadows while performing her cloak-and-dagger missions.

Delta Force

Delta Force (The U.S. Army's 1st Special Forces Operational Detachment—Delta) is an elite counterterrorist team that can be deployed to eliminate terrorist threats, free hostages, and provide important reconnaissance information on enemy troop size and location. Patterned after the British SAS, Delta Force, which operates out of Fort Bragg, North Carolina, consists of several units, including a support squadron, a signal squadron, and an aviation platoon, as well as a platoon that reportedly includes female operatives. The ultra-rigorous training involves runs through CQB (close quarters battle) simulations designed to teach individuals and teams how to assault buildings that have been captured by terrorists.

Utilizing traditional Ninja-style stealth tactics to gather intelligence, Delta Force operatives strike swiftly and silently, carrying out their missions with surgical precision before melting back into the general population.

Demolition

Mix a knack for high-tech toys and a love of blowing things up and you get a demolitions specialist. These SOF combat technicians are responsible for taking out enemy fortifications such as railways, bridges, bunkers, and storage depots. As the modern military becomes more sophisticated in its method of bomb detection, demolition engineers must come up with new and ingenious techniques for making things go boom.

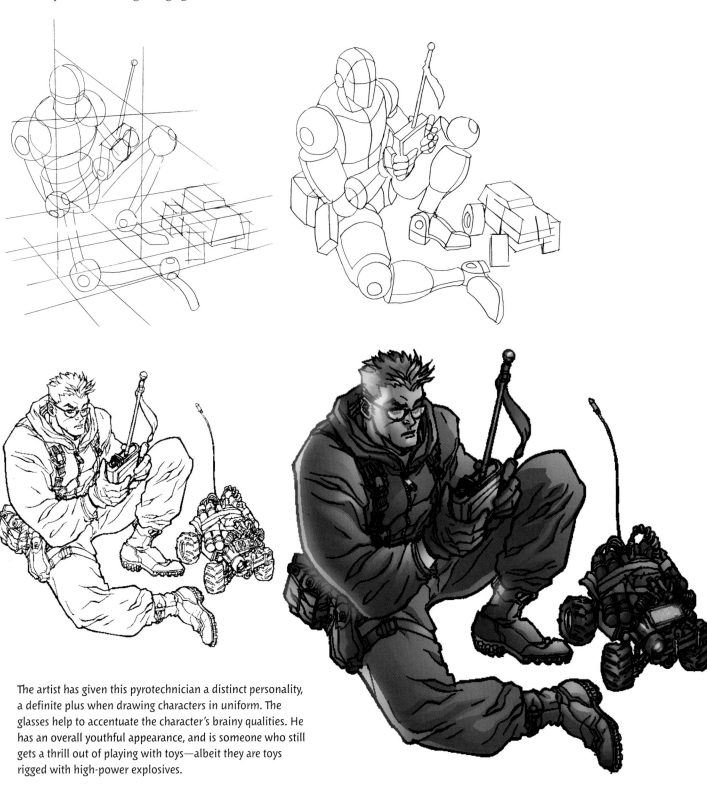

The artist has given this pyrotechnician a distinct personality, a definite plus when drawing characters in uniform. The glasses help to accentuate the character's brainy qualities. He has an overall youthful appearance, and is someone who still gets a thrill out of playing with toys—albeit they are toys rigged with high-power explosives.

Green Berets

The Army's Special Forces members, known popularly as the Green Berets, are double volunteers: The Green Berets, whose motto is *De Oppresso Liber* ("liberate the oppressed"), first volunteer for airborne training and then for SOF training in advanced military skills; at least two occupational specialties (e.g., engineering, weapons, medicine, explosives, interrogation and interrogation-evasion techniques, disguise, and the latest in telecommunications and computer reconnaissance); and simulated missions in which they must train and organize indigenous forces to bring the war to their adversaries where they least expect it, deep inside enemy-held territory.

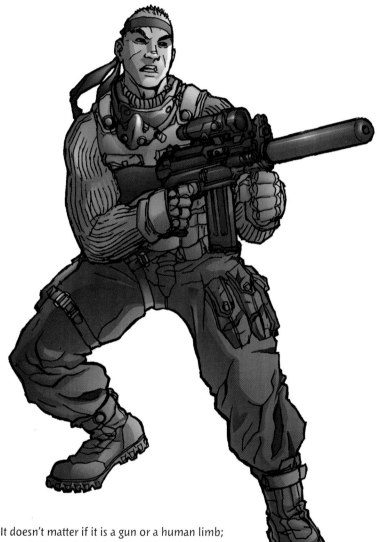

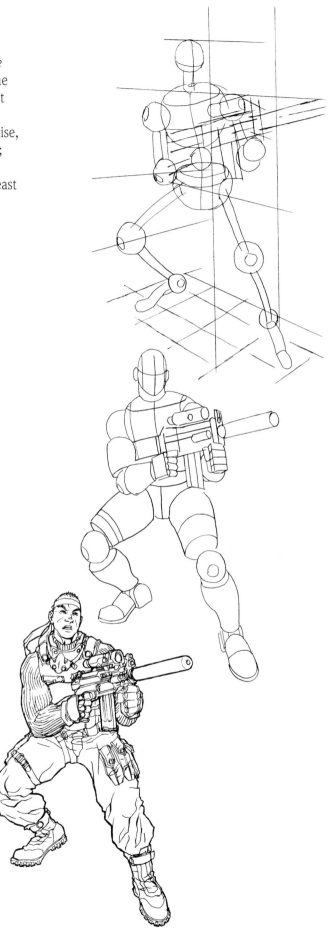

It doesn't matter if it is a gun or a human limb; everything can be broken down into simple shapes to provide quick and accurate positioning. If you are drawing subject matter that is new to you, first try to copy your reference (the example shown here, or an image from your reference library) exactly. Then draw the subject again, this time slightly altering the position of the figure and weapon. Repeat several times in a row, each time changing some other aspect of the subject. Through this process, you will be giving yourself step-by-step lessons in how to mentally visualize the pose and weapon position you want before putting pencil (or pen) to paper.

Marine Corps Force Recon

Reconnaissance specialists, whether or not they are members of regular or SOF units, collect surveillance information by observing, identifying, and reporting enemy activity. Data pertaining to the size, number, fortifications, armaments, and vehicles of enemy forces are recorded and forwarded to command headquarters. A skilled recon expert can not only determine when enemy troops have been deployed, where they have been, and where they are going, but also provide detailed facts about the terrain, hydrography (the science of surveying the seafloor and coastlines, an indispensable part of preparation for beachhead landings), beaches, roads, bridges, routes, urban areas, possible helicopter landing zones (HLZ)or airborne drop zones (DZ), and the best methods of incursion, including aquatic landings and HALO (high-altitude low-opening) parachute drops.

The members of Marine Corps Force Recon are a super-elite group of reconnaissance specialists whose history goes back to World War II, when the U.S. Marines formed a Raider Battalion modeled after the British Royal Marine Commandos. During the Korean War, the Marine Amphibious Recon Company operated missions as far as 40 miles into North Korean territory, and Marine Recon teams played a crucial intelligence-gathering role in Vietnam. Currently, the USMC recon battalions perform a number of different types of operations in addition to long-range reconnaissance and surveillance, including tactical recovery of aircraft personnel, harbor reconnaissance, small unit raids, and prisoner snatches.

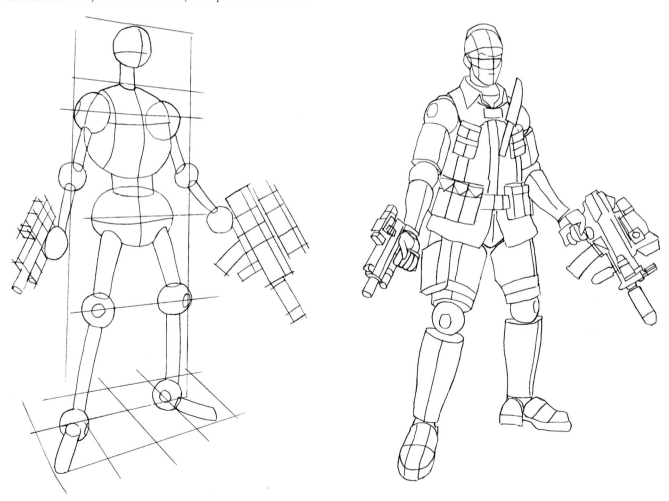

Recon soldiers are usually the first to invade hostile territories so they can place beacons to guide troops to rendezvous points. They can also laser-paint targets for precision guided munition (PGM) strikes. This Dan Norton character is prepared for whatever task a recon mission might require.

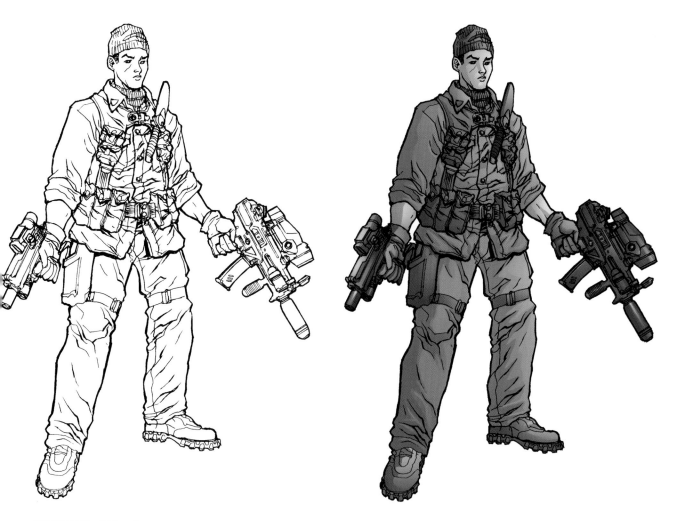

Super-stealth recon is a military art form, and there is no doubt that this tracker has at least a master's degree.

Navy SEALs

"Gen-u-wine, shockproof, waterproof, chrome plated, antimagnetic, barrel chested, rootin' tootin', parachutin', fightin' frogman, that never eats, sleeps and takes forty men forty days and forty nights to track down, can see in the dark, breathe underwater, and fly," is how former SEAL Dwight Daigle described his fellow SEALs. This description is only slightly exaggerated, if at all. The SEALs (sea, air, and land), an SOF unit that is the foundation of the Navy's Naval Special Warfare (NSW) combat forces, traces its history back to the famous frogmen of World War II. They are a highly adaptable group of elite soldiers who time and again accomplish seemingly impossible mission objectives. SEALs undergo intense physical and psychological training to hone their skills as individual soldiers, but, more importantly, they are taught to rely unquestioningly on every member of their teams. It is this unshakeable loyalty to one another, combined with courage, valor, commitment, and integrity, that has won them the respect of soldiers all over the world. SEAL operations cover a wide range of hazardous missions, including advanced land and hydrographic reconnaissance, sabotage, antidrug actions, disinformation, and rescue and recovery. If dictionary definitions of "butt kicker" aren't accompanied by a picture of a Navy SEAL, they should be!

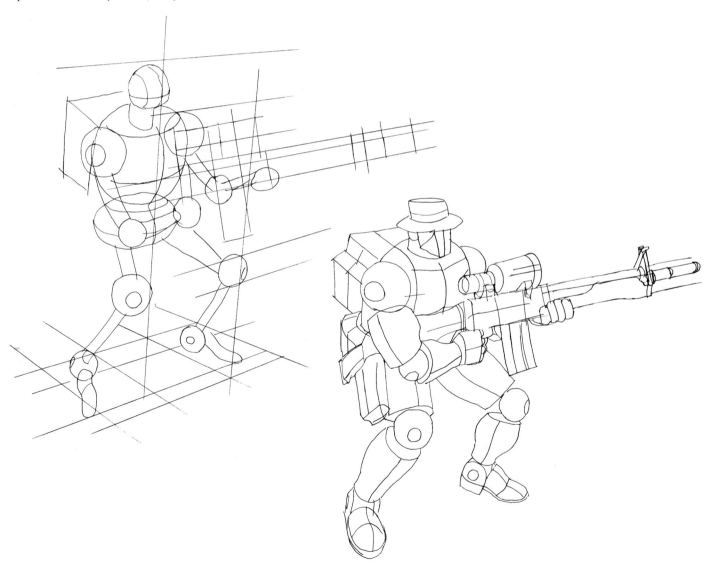

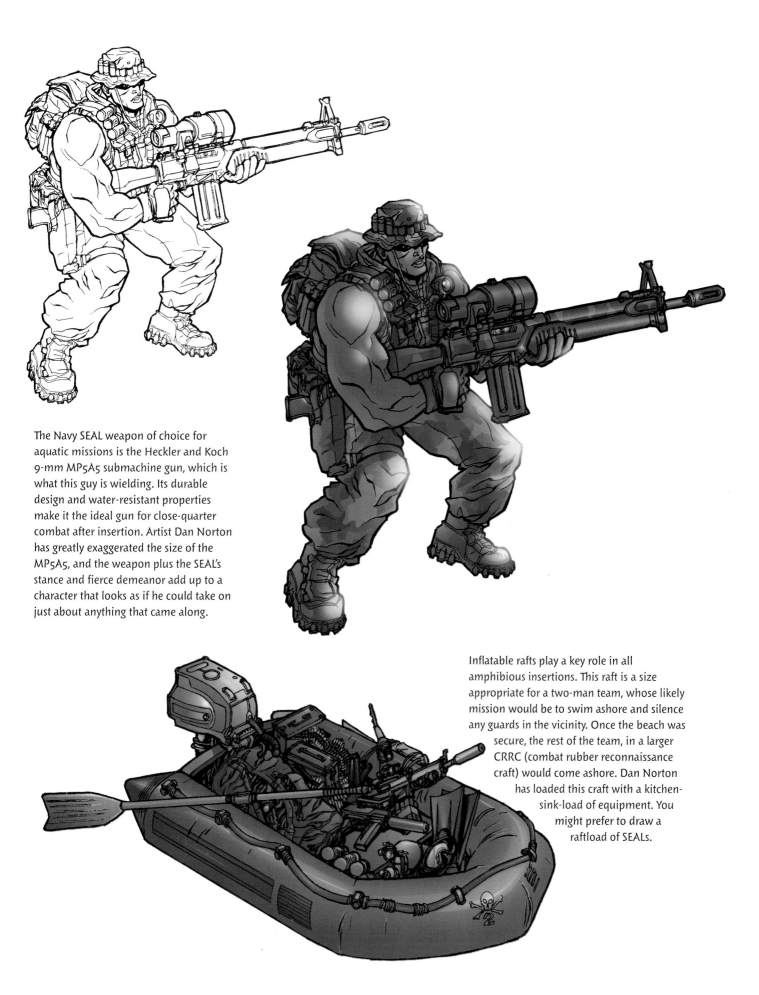

The Navy SEAL weapon of choice for aquatic missions is the Heckler and Koch 9-mm MP5A5 submachine gun, which is what this guy is wielding. Its durable design and water-resistant properties make it the ideal gun for close-quarter combat after insertion. Artist Dan Norton has greatly exaggerated the size of the MP5A5, and the weapon plus the SEAL's stance and fierce demeanor add up to a character that looks as if he could take on just about anything that came along.

Inflatable rafts play a key role in all amphibious insertions. This raft is a size appropriate for a two-man team, whose likely mission would be to swim ashore and silence any guards in the vicinity. Once the beach was secure, the rest of the team, in a larger CRRC (combat rubber reconnaissance craft) would come ashore. Dan Norton has loaded this craft with a kitchen-sink-load of equipment. You might prefer to draw a raftload of SEALs.

SAS

The U.K.'s Special Air Service (SAS) is the prototypical Special Forces team. "Who Dares Wins" is their motto, and they live up to it time and time again. Like soldiers in U.S. SOF units, SAS officers and men are highly intelligent, dedicated professional warriors who are motivated to trust in their comrades and their training to accomplish the most difficult missions. SAS agents are subjected to an exhaustive selection process (there are only 400 troops at any given time), followed by intense training to prepare them for a wide range of missions from intense and dangerous counterterrorist operations and sabotage to training foreign forces in advanced SAS techniques.

Sometimes the climate is more ruthless than the enemy. Soldiers must be ready to assault those who stand in the way of freedom in any environment. Training for missions in extreme cold involves everything from frostbite prevention to mountain climbing, from how to build a shelter out of ice to the best ways to move across snowy terrain using snowshoes, skis, and snowboards. The SAS literally "wrote the book" on survival under the most adverse conditions (*SAS Arctic and Mountain Survival Handbook*).

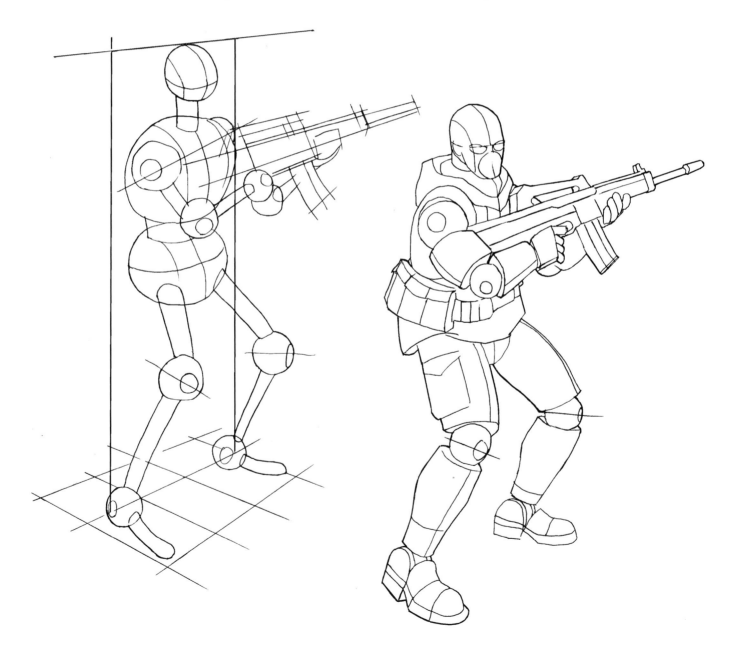

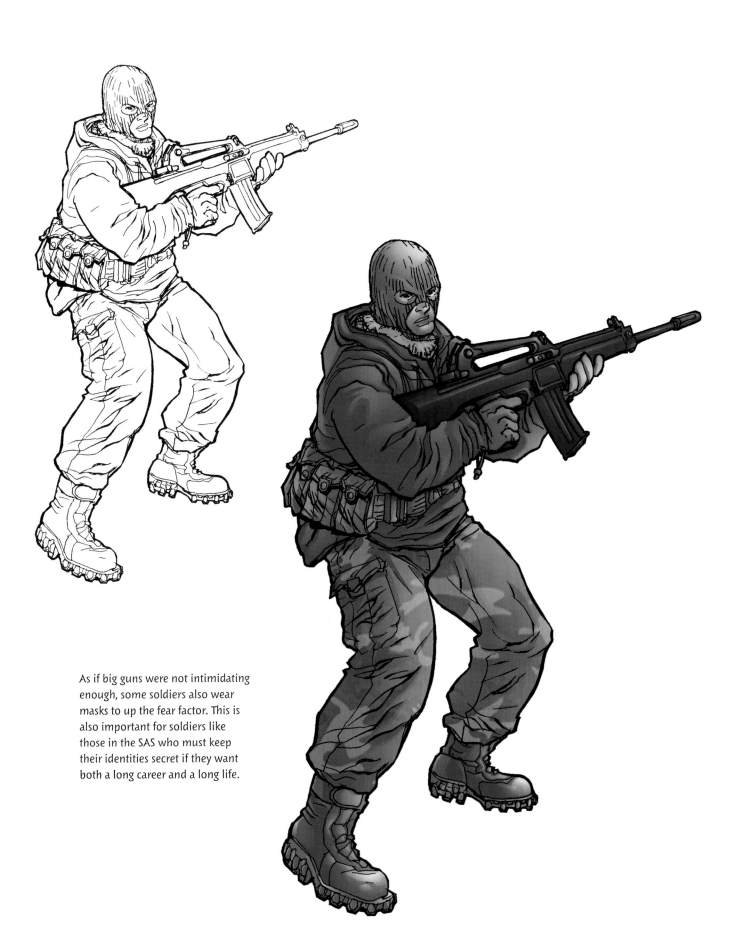

As if big guns were not intimidating enough, some soldiers also wear masks to up the fear factor. This is also important for soldiers like those in the SAS who must keep their identities secret if they want both a long career and a long life.

The Motor Pool

Armored tanks—from the clumsy and sporadically effective Mark series used in World War II to the cutting-edge Abrams M1A2 SEP (system enhancement program)—have been used in combat for almost a century. But tanks are only one example of the many combat vehicles employed by armed forces in the United States and around the world. The letters PMCS stand for *preventive maintenance checks and service*, the program by which every vehicle in the motor pool, from armored amphibious tanks to all-terrain 4- and 6-wheelers to motorcycles, is kept well maintained and roadworthy. But listen up. From now on we are going to use PMCS to mean *pencil motor control skills*. I want to see you practice your PMCS on every one of the vehicles featured on the following pages. I want those pencils moving so fast I see smoke coming off your pages, so jump to it!

Heavy Equipment Recovery

What happens in a battle when it is necessary for troops—and heavy equipment— to get out fast? In the past, officers would call for one of the original M88 series of monster tow trucks, but as tanks became heavier, it was clear that major modifications would be necessary to make the M88 Hercules (*heavy equipment recovery combat utility lift and evacuation system*) series adequate to their recovery tasks. In 1997 the M88A2 Hercules entered the armed services. The M88A2, which can tow 25 percent heavier loads and lift 40 percent heavier loads, and has a 50 percent higher winching capacity than previous models, is now the primary recovery support for all branches of the U.S. military.

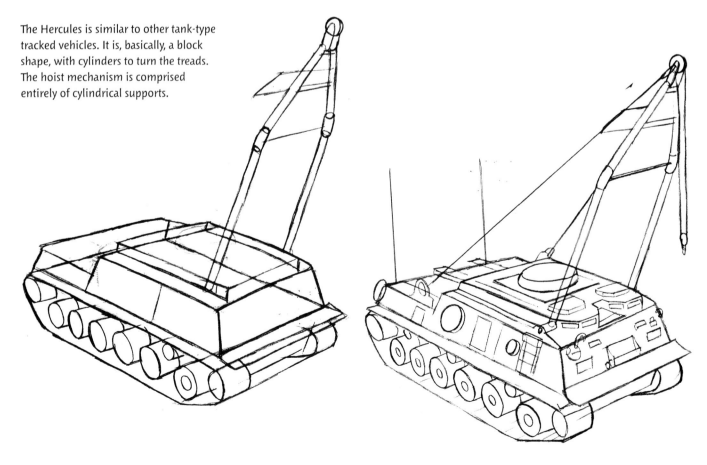

The Hercules is similar to other tank-type tracked vehicles. It is, basically, a block shape, with cylinders to turn the treads. The hoist mechanism is comprised entirely of cylindrical supports.

POWER AND WEIGHT

In the specifications lists for some of the land and air vehicles in this book, the term *power-to-weight ratio* is used. This ratio expresses the relationship between a machine's horsepower and its weight. The higher that number, the less time it takes for a vehicle to reach its cruising speed. One vehicle may have more power than another, but if it is significantly heavier than the less-powerful vehicle, its performance will be inferior.

With regard to weight, there is a certain amount of confusion surrounding the correct unit of measure to use for the weight of heavy objects. For this book, we entered the unit as listed in the source, without attempting to convert it. *Note*: One tonne, or metric tonne (mt), is equal to 2,204.622 pounds (lb) (10,000 kilograms [kg]). The U.S. Customary unit, the ton, is equal to 2,000 pounds (907.2 kg).

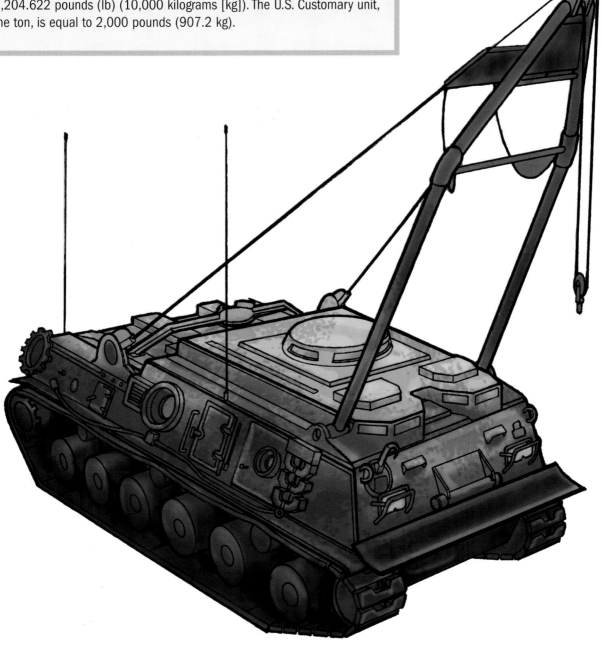

Armored Combat Vehicles

Abrams Main Battle Tanks (MBTs)

The Abrams M1 tanks, which were designed to have superior firepower, protection, and mobility, rolled off the assembly line in 1978; the M1A1s in 1985; and the M1A2s in 1986. Improvements in the M1A1 and M1A2 tanks over the M1s included special armor, heavy-duty suspension, enhanced thermal control systems (to a second-generation forward-looking infrared sight [FLIR]), color and high-resolution flat-panel displays, a user-friendly soldier-machine interface, and a nuclear, biological, and chemical (NBC) protection system.

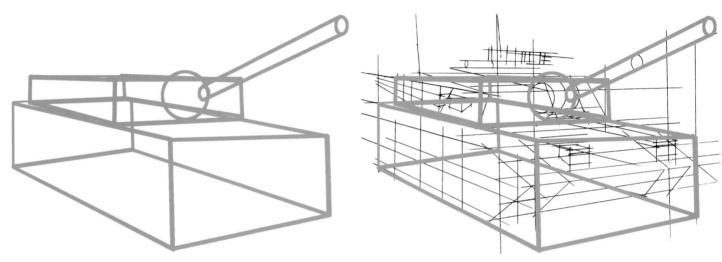

Left: The basic shapes for the tank are two stacked rectangular boxes, a circle (the gun mount), and a cylinder. Use a ruler to make sure the outlines of the shapes are true to the rules of perspective.
Right: The basic shapes superimposed on an early-stage sketch of the tank. The outlines are shown here much heavier than they would be for an actual drawing.

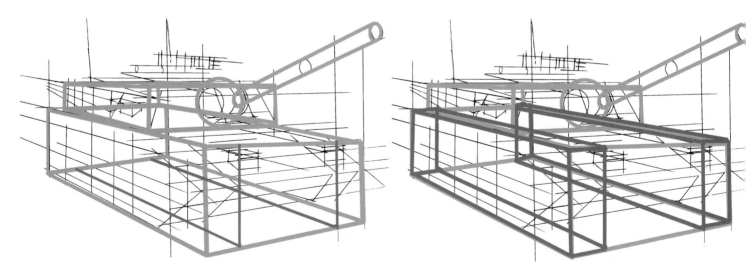

Land vehicles are basically symmetrical, and the red lines in these drawings, which further subdivide the tank-body rectangle, serve as a guide for the correct placement of the tank treads. It is possible to use a grid system, whereby you divide a reference photo (or an enlarged version of the inked Abrams tank on page 89) into boxes, then divide your paper in corresponding, smaller boxes, then draw in the details. However, that is too time-consuming for practical cartooning. Rather, you need to practice until you get a feel for how things exist in space, and then you will be able to "eyeball" where the lines should go. This is where many students lose heart. It is a tough skill to develop, and takes a lot of work, but those who stick it out will reap the rewards.

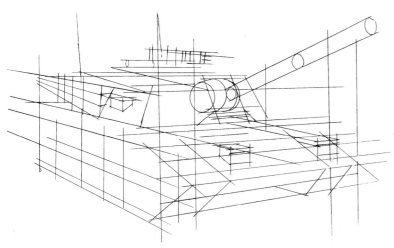

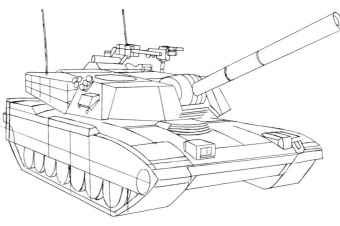

Draw in as many guidelines as you need to have a good idea of where everything is going to go. Guidelines are the temporary scaffolding you build your final drawing around.

All the important shapes should be fully formed, and by this time only a few guidelines are left to help place details correctly. Now you can start rendering details and shading.

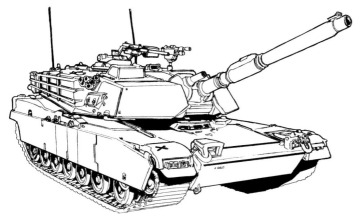

Depending on the look you are going for, you can choose between finishing your drawing by scanning it into a computer and digitally inking it (see page 138) or doing it by hand using a technical pen or a dip pen. This drawing was digitally inked. The lines are crisp and solid, and most of them have the same weight. If you do this by hand, you can vary the line weights more.

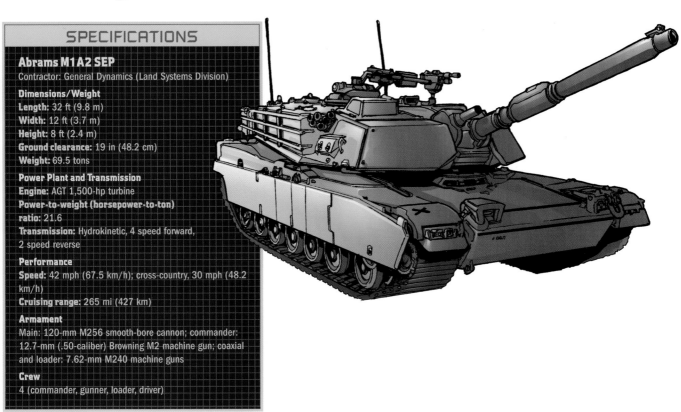

SPECIFICATIONS

Abrams M1A2 SEP
Contractor: General Dynamics (Land Systems Division)

Dimensions/Weight
Length: 32 ft (9.8 m)
Width: 12 ft (3.7 m)
Height: 8 ft (2.4 m)
Ground clearance: 19 in (48.2 cm)
Weight: 69.5 tons

Power Plant and Transmission
Engine: AGT 1,500-hp turbine
Power-to-weight (horsepower-to-ton) ratio: 21.6
Transmission: Hydrokinetic, 4 speed forward, 2 speed reverse

Performance
Speed: 42 mph (67.5 km/h); cross-country, 30 mph (48.2 km/h)
Cruising range: 265 mi (427 km)

Armament
Main: 120-mm M256 smooth-bore cannon; commander: 12.7-mm (.50-caliber) Browning M2 machine gun; coaxial and loader: 7.62-mm M240 machine guns

Crew
4 (commander, gunner, loader, driver)

Amphibious Assault Vehicles (AAVs)

Amphibious assault vehicles have been manufactured in various shapes and sizes over the years, but they are all designed to perform the same task: Get squads of soldiers safely into combat zones. They are not as heavily gunned as tanks, but they don't need to be. They aren't sticking around for the fight. As soon as they deliver their payload they are off to retrieve more troops. AAVs are basically large, heavily armored boxes with plenty of interior storage space.

The Marine Corps has announced plans to replace its AAVs with advanced amphibious fighting vehicles [AAAVs, aka expeditionary fighting vehicles (EFVs)] by 2008. The EFVs will be faster (water speed of 23–29 mph [37–46.7 km/h] and land speed of up to 45 mph [72.4 km/h]) and better protected than the AAVs and will feature an automatic transfer of power from the high-speed water jets to the tracks, effecting a smooth transition from water to land.

Above: The basic shapes used for this AAV are squares and an upside-down prism. Right: The hubs, which are drawn in next, are circles, seen at a slight angle. Notice that although the three hubs on the right side of the vehicle will not be seen in the final drawing, they are sketched in, so the parallelism will be exactly right. For clarity, the right-side hubs are shown in solid blue, but if you use this method, you would draw only the outlines.

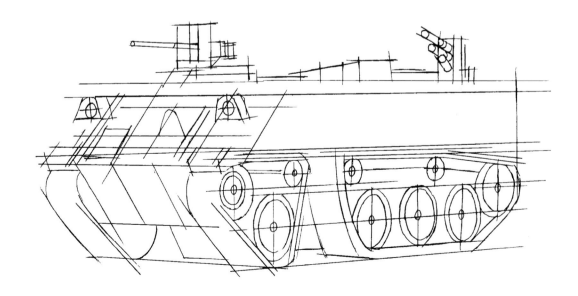

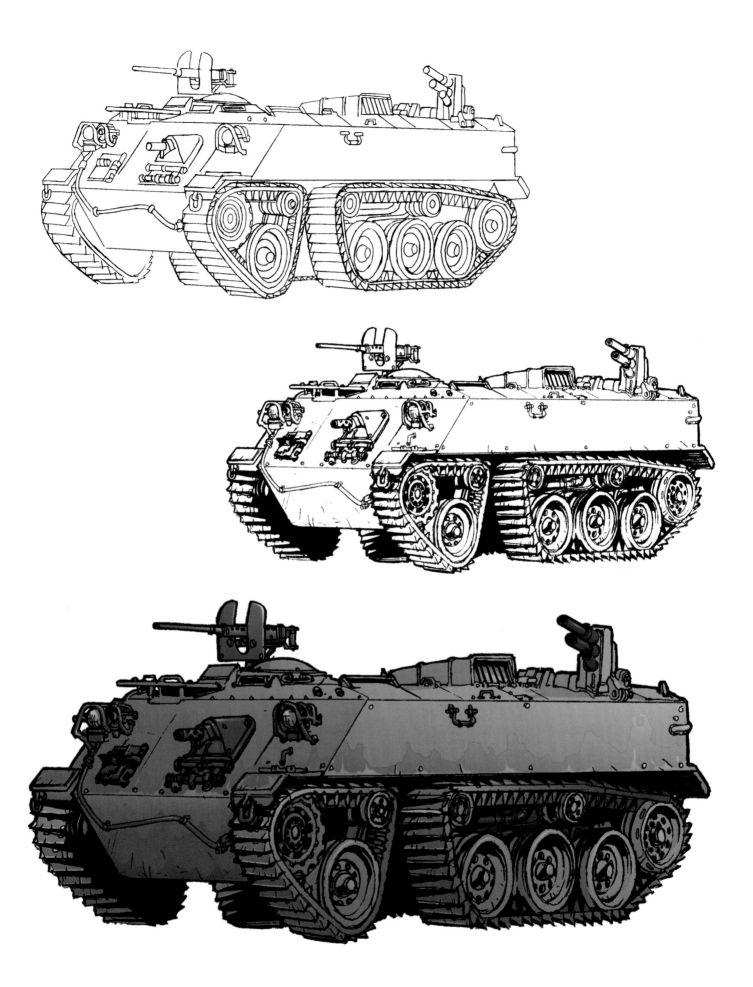

The Bradley Fighting Vehicle System

Bradley amphibious fighting vehicles—M2s and M3s—have been in service since 1981 and are used to transport infantry squads into hostile environments and then provide fire support, and to hunt and annihilate enemy tank regiments. The Bradley is an effective countermeasure against almost all forms of rival armaments; it will obliterate helicopters, bunkers, and missile launchers with ease.

Features include two second-generation FLIR sensors; "hunter-killer target handoff" capability with a ballistic fire control system; embedded diagnostics; integrated combat command and control (IC3) digital communications suite; positional navigation system with GPS and inertial navigation system; and enhanced squad situational awareness with squad leader display integrated into vehicle digital images.

When drawing the Bradley, you will start out with stacked rectangular solid shapes. Because the Bradley is a complex vehicle, the perspective guidelines for the different components will be drawn in at different angles, and you will need one or more detailed reference drawings or photographs, or a toy scale model, so you will know exactly how to place both your guidelines and the detail lines.

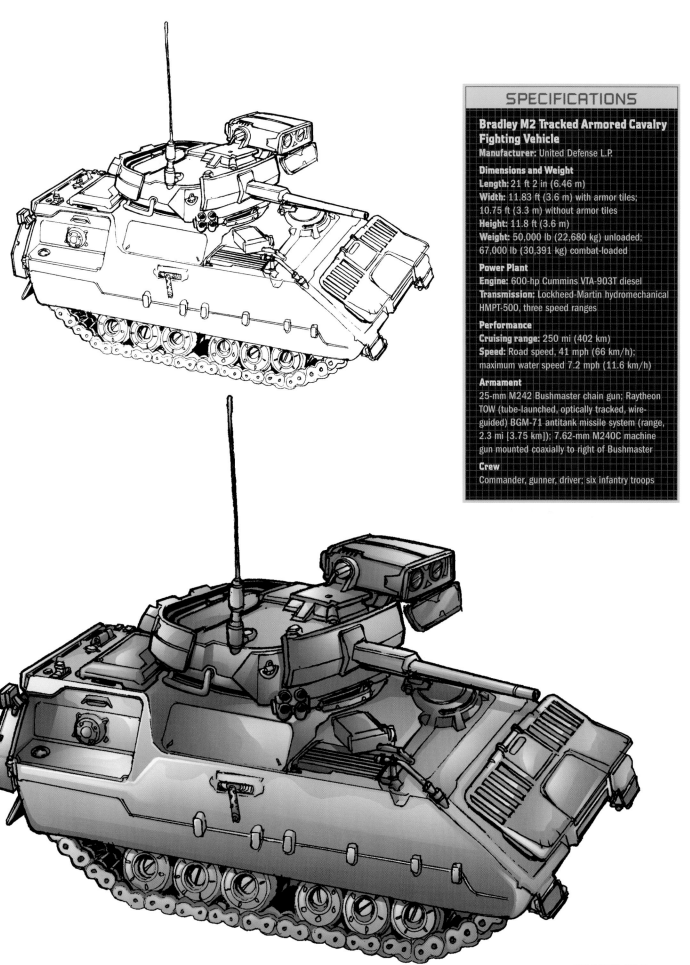

Howitzers (Self-Propelled)

The first use of the so-called self-propelled (SP) howitzers—medium-caliber cannons mounted on tractor chassis—was in World War I. World War II saw the deployment of armored vehicles designed specifically for mounted howitzers, and in the early 1990s technological advances in fire control and positional/navigational systems led to the more widespread use of the M109 series of SP howitzers, despite the fact that their cross-country mobility was inferior to that of both Abrams and Bradley tanks.

The most current model of the SP howitzer is the Paladin Crusader, which is a two-part cannon artillery system consisting of an SP howitzer and an ammunition and fuel resupply vehicle, allowing simultaneous refueling and reloading operations that will replenish the SP howitzer in 12 minutes.

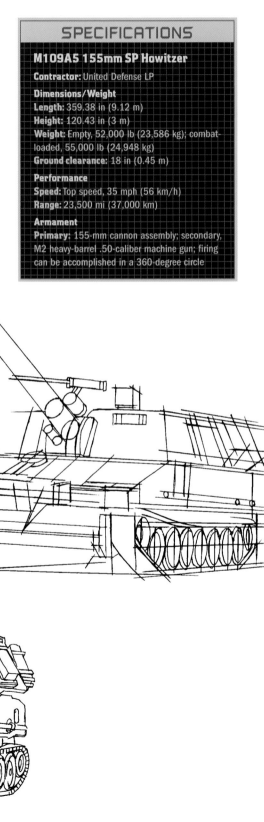

SPECIFICATIONS

M109A5 155mm SP Howitzer

Contractor: United Defense LP

Dimensions/Weight
Length: 359.38 in (9.12 m)
Height: 120.43 in (3 m)
Weight: Empty, 52,000 lb (23,586 kg); combat-loaded, 55,000 lb (24,948 kg)
Ground clearance: 18 in (0.45 m)

Performance
Speed: Top speed, 35 mph (56 km/h)
Range: 23,500 mi (37,000 km)

Armament
Primary: 155-mm cannon assembly; secondary, M2 heavy-barrel .50-caliber machine gun; firing can be accomplished in a 360-degree circle

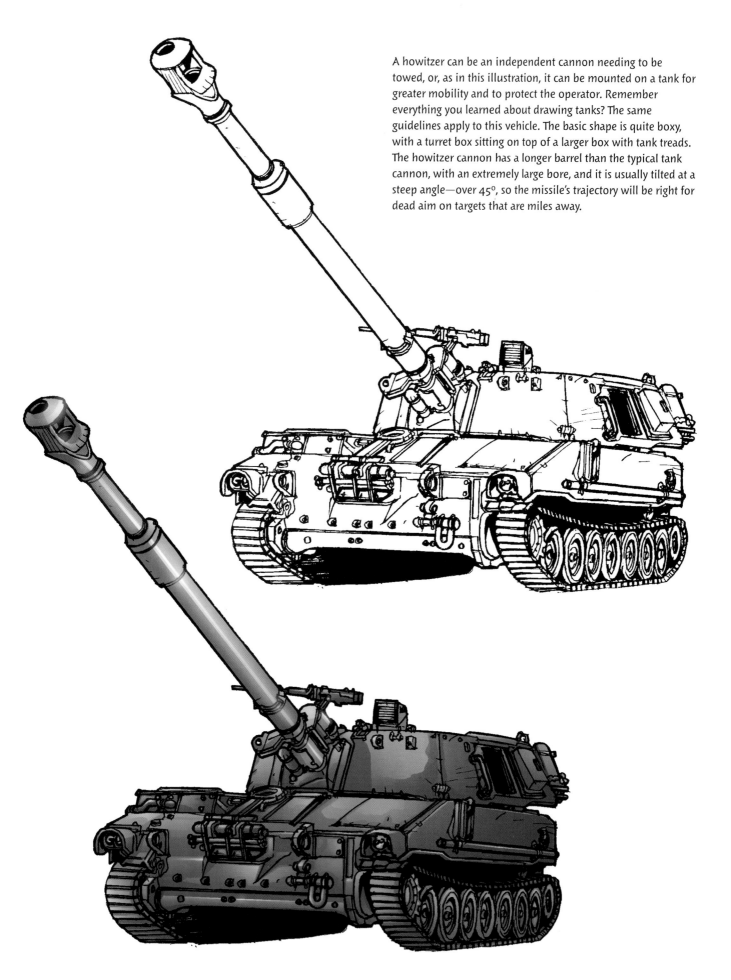

A howitzer can be an independent cannon needing to be towed, or, as in this illustration, it can be mounted on a tank for greater mobility and to protect the operator. Remember everything you learned about drawing tanks? The same guidelines apply to this vehicle. The basic shape is quite boxy, with a turret box sitting on top of a larger box with tank treads. The howitzer cannon has a longer barrel than the typical tank cannon, with an extremely large bore, and it is usually tilted at a steep angle—over 45°, so the missile's trajectory will be right for dead aim on targets that are miles away.

All-Terrain Vehicles (ATVs)

Another name for lightweight ATVs is off-road vehicles, but "off road" doesn't begin to convey the kinds of terrain the combat versions of these amazing vehicles are capable of penetrating. Military ATVs, both 6-wheel and 4-wheel models, can move quickly and safely over just about any surface. You name the terrain—jungle, desert, swamp, boulder-strewn mountains, whatever— a specially equipped ATV will probably be able to traverse it.

With their large displacement engines, rugged suspension, narrow frames, and high ground clearance, these agile vehicles are perfect for the remote and unforgiving locations in which many modern combat operations are mounted. For example, the John Deere company's M-Gator, which was designed as a kind of super golf cart, was reconfigured for the military and used effectively in both Afghanistan and Iraq. Humvees, which are nearly one and a half times as high and weigh nearly ten times as much as M-Gators, are not only much more difficult to transport and drop into enemy territory, but are, according to military sources, not capable of navigating the most rugged high-altitude terrains.

SPECIFICATIONS

Polaris Sportsman MV (Military Vehicle)
Manufacturer: Polaris Industries

Dimensions/Weight
Length: 89 in (2.3 m)
Width: 47 in (1.2 m)
Height: 51 in (1.3 m)
Weight: 550 lb (249 kg)

Power Plant
500-cc liquid-cooled twin-cylinder four-stroke Polaris Liberty 700 engine

Performance
Fuel capacity: Total of front and rear tanks, 8.75 gal (33.1 L)
Speed: Up to 45 mph (72 km/h)

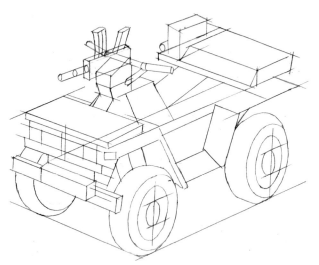

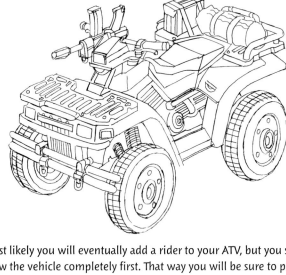

The basic construction of the 4-wheel ATV is similar to that of the Jeep or Humvee, but the proportions are very different. The tires, for example, make up almost half of the ATV's total mass.

Most likely you will eventually add a rider to your ATV, but you still want to draw the vehicle completely first. That way you will be sure to place all the different components in the correct places. Accurate details will really make your drawings stand out. Few artists have all the complex details of any combat vehicle memorized. When you are drawing in the details, use a good photo reference.

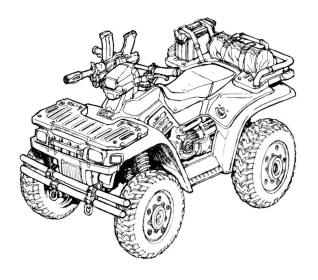

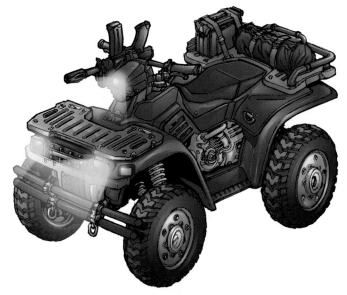

Arctic Crafts

Arctic Propeller Craft

The arctic propeller craft, which is similar to an airboat, is designed as a lightweight and efficient mode of transportation for traversing the arctic plains. The three skis allow the craft to ski across snowfields to quickly provide recon services where traditional craft could get bogged down. The sturdy 350 horsepower engine allows the craft to reach top speeds of over 70 mph on flat glacial straightaways. Braking is accomplished by a series of metal claws that the operator forces into the ice to create drag. A gunner mans the top turret while the driver has a side-mounted machine gun. Nicknamed "the Ice Cream Truck" I don't think you want to be on the receiving end of any of the goodies he's delivering.

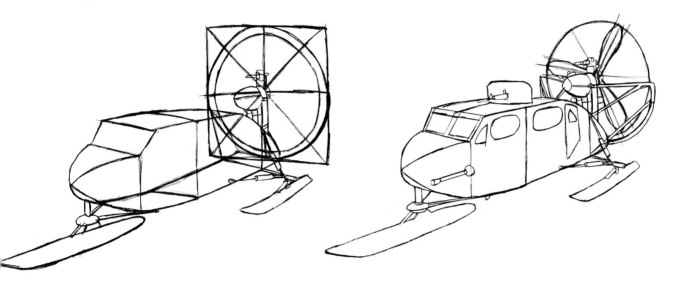

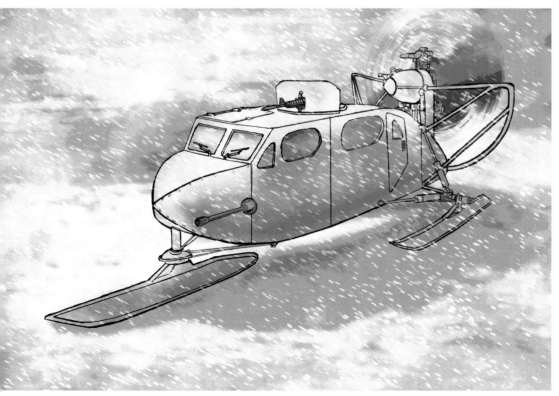

Combat is sometimes the mother of invention. This arctic craft looks like the front fuselage of an airplane plus an engine and propeller lifted from a fanboat, with the whole thing mounted on snowmobile skis. The hull is more or less shaped like a cube, and the propeller cage, though round, must fit in a box.

Snowmobiles

In the opening sequences of *View to a Kill*, Roger Moore, in his last appearance as James Bond, uses skis, a makeshift snowboard, and a super-fast snowmobile to evade a gaggle of black-clad snipers who are chasing him across a snowfield. Today, the military snowmobile, which has a top speed of over 100 mph (161 km/h), has been used to advantage by real-life SOF units operating in arctic climates. Military snowmobiles, like Yamaha's SXViper, can blaze over the roughest terrain to deliver supplies or speed troops to combat situations, and comes with a two-way radio and a GPS for emergency rescue operations. For patrols in hostile territories two soldiers mount up: one drives and the other has a submachine gun at the ready.

This intrepid snowtrooper has his snowboard at the ready in the event that the snowmobile is shot down. When drawing troops equipped for arctic conditions, make sure their uniforms are completely sealed off, sort of like a self-contained environment. Weapons and accessories are stowed in pockets or pouches to protect them from the cold when they are not in use.

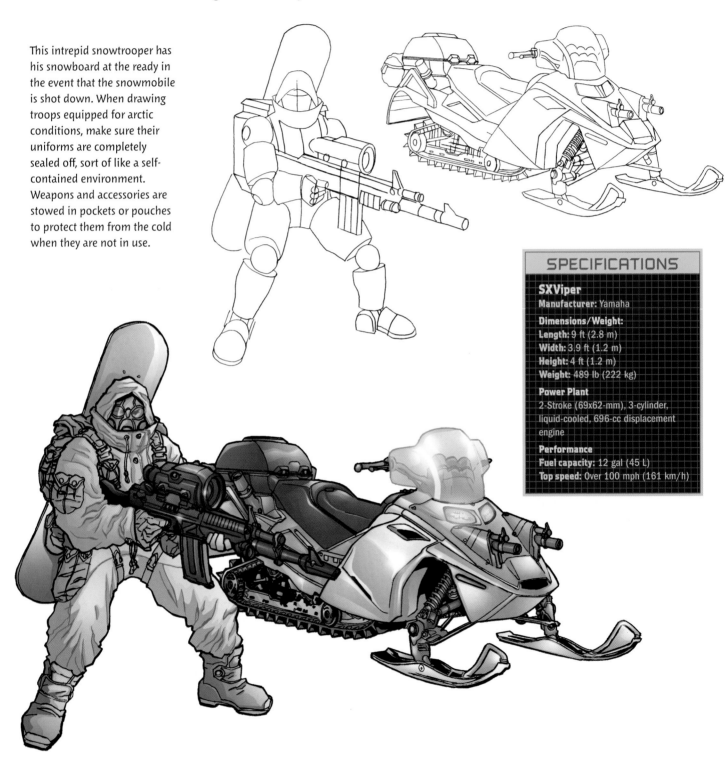

SPECIFICATIONS

SXViper
Manufacturer: Yamaha

Dimensions/Weight:
Length: 9 ft (2.8 m)
Width: 3.9 ft (1.2 m)
Height: 4 ft (1.2 m)
Weight: 489 lb (222 kg)

Power Plant
2-Stroke (69x62-mm), 3-cylinder, liquid-cooled, 696-cc displacement engine

Performance
Fuel capacity: 12 gal (45 L)
Top speed: Over 100 mph (161 km/h)

Motorcycles

Harley-Davidson motorcycles saw combat duty in World War I (over 20,000 cycles, including a model especially designed for desert use that was discontinued after Allied Forces disengaged from North Africa) and World War II (90,000). In the 1990s, each Special Forces Ranger battalion was equipped with ten 250-cc motorcycles that were used to provide security and mobility during airfield seizures. Lightweight motorcycles have also been used traditionally as part of LP/OP (listening post/observation post) communications systems and as an economical, effective mode of transportation for recon scouts.

In 2003 the first M1030 diesel combat motorcycles, based on a Kawasaki chassis and developed by Hayes Diversified Technologies and England's Cranfield University Royal Military College of Science, were manufactured.

SPECIFICATIONS

M1030M1 Diesel Combat Motorcycle
Manufacturers: Kawasaki; Hayes Diversified Technologies

Dimensions/Weight
Length: 7.1 ft (2.2 m)
Width: 3 ft (0.9 m)
Wheel base: 4.8 ft (1.5 m)
Weight: 369 lb (167 kg)
Ground clearance: 10.7 in (27 cm)

Power Plant
Engine: 4-stroke, 1-cylinder, liquid-cooled, 584-cc
Transmission: 5-speed constant mesh, return shift

Performance
Speed: 80 mph (130 km/h)
Range: 400 mi (650 km) at 55 mph (88 km/h)

Humvee

The high-mobility multipurpose wheeled vehicle (HMMWV, pronounced "humvee") entered active service in the various military branches in 1985, almost completely replacing the Jeep. The humvee is a light, highly mobile, diesel-powered, 4-wheel-drive vehicle equipped with an automatic transmission. It comes in several versions built off of a common chassis, the 1-ton M998 truck. It is burly, with a high power-to-weight ratio, and its high ground clearance makes it the logical choice for almost any mission. The humvee is so flexible it can be configured to become a troop carrier, armament carrier (including prefab weapon mounts for TOW missile launchers or a .50-caliber machine gun), S250 equipment shelter carrier, ambulance, scout vehicle, or mobile communications station. The humvee was further modified during the Gulf War—given a more powerful engine, good water storage capabilities, and an open truck bed—and was nicknamed "dumvee" because of its suitability for desert terrain.

SPECIFICATIONS

Humvee
Manufacturer: AM General; O'Gara Hess and Eisenhardt

Dimensions/Weight
Length: 15 ft (4.6 m)
Width: 7.08 ft (2.2 m)
Height: 6 ft (1.8 m) ft reducible to 4.5 ft (1.4 m)
Weight: 5,200 lb (2,359 kg)

Power Plant
Engine: V8, 6200-cc displacement, fuel injected diesel, liquid-cooled, compression ignition, 150 hp at 3,600 rpm
Transmission: 3-speed, automatic

Performance
Fording depth: Without preparation: 2.5 ft (0.76 m); with deep water fording kit: 5 ft (1.5 m)
Range: 350 mi (563 km)
Maximum speed: 65 mph (105 km/h)

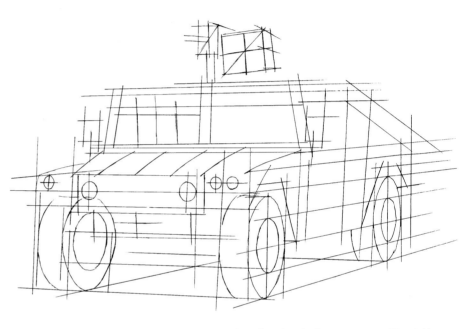

When drawing the humvee, you will quickly notice that it is really just a box on wheels.

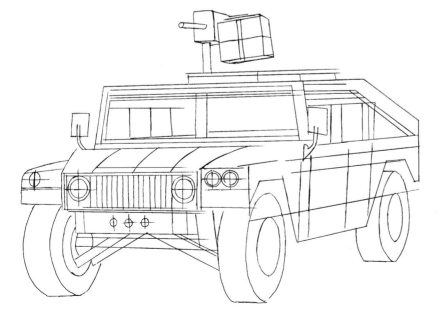
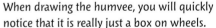

This is the meat-and-potatoes step; here is where everything needs to come together for a successful drawing. Make sure all your shapes are drawn so they work with your perspective guidelines.

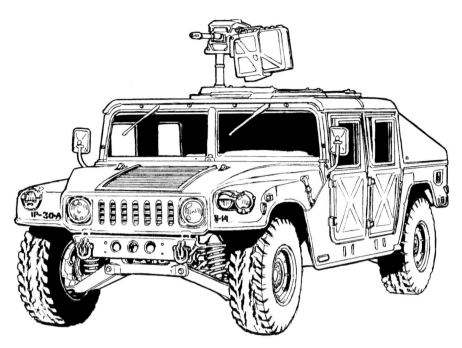

The reward for doing all the hard construction grunt work is a pencil drawing that looks believable. You can now go back and add the details—such as the suspension hardware and the door and window details—that bring the vehicle to life.

Mobile Missile Launchers

Having one of these bad boys greatly assures the odds of your troops getting their mission done without pesky enemy aircraft or projectiles flying into your airspace. Today's missiles offer a long-range, all-altitude, all-weather air defense system to counter tactical ballistic missiles, cruise missiles, and advanced aircraft. They feature a track-via-missile (TVM) guidance system and midcourse correction capabilities. Once they hit their target they pack quite a punch in the form of a 200-lb (90-kg) warhead.

On a much smaller scale is the still-in-development SWORDS (special weapons observation reconnaissance detection system): A weapons platform mounted on a Talon robot will allow soldiers to fire small arms (machine guns), or the M202A1 with a 6-mm rocket launcher, from as far away as 6.2 mi (10 km).

The key rule of real estate is "location is everything," and that is doubly true for war. Ready response from optimal locations with minimum casualties is necessary to defend troops on the move, and mobile missile launchers provide that capability.

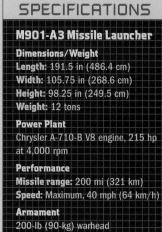

SPECIFICATIONS

M901-A3 Missile Launcher

Dimensions/Weight
Length: 191.5 in (486.4 cm)
Width: 105.75 in (268.6 cm)
Height: 98.25 in (249.5 cm)
Weight: 12 tons

Power Plant
Chrysler A-710-B V8 engine, 215 hp at 4,000 rpm

Performance
Missile range: 200 mi (321 km)
Speed: Maximum, 40 mph (64 km/h)

Armament
200-lb (90-kg) warhead

There seems to be a lot going on in this illustration, but the missile launcher is essentially just a few boxes sitting on a pair of tank treads.

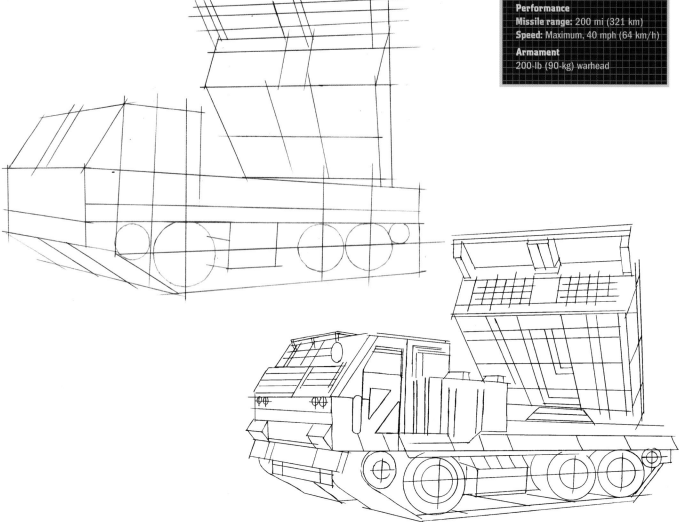

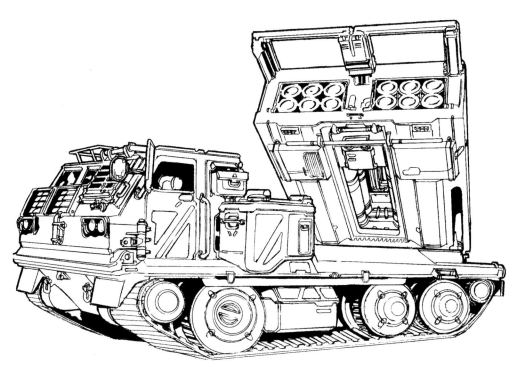

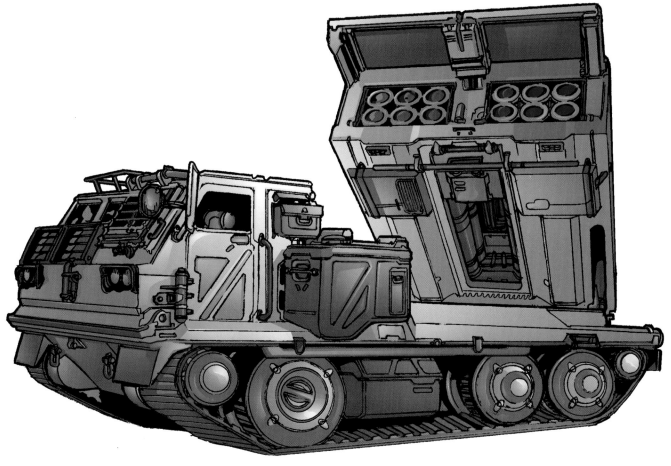

The Airfield

The slogan "Death from Above"—words sometimes painted on the sides of attack aircraft—expresses one of the basic rules of warfare: whoever controls the higher altitude wins the fight. Today's flying war machines are high-tech scientific marvels featuring laser-guided missiles, sophisticated countermeasures, and satellite-linked navigational computers, and they are flown by the best-trained pilots the military has ever produced. In addition to their aerial combat duties, military aircraft offer one of the key ways to transport troops over the long distances typical of today's conflicts.

Once you've mastered all the airships in this chapter, try your hand at designing the jet fighters of tomorrow!

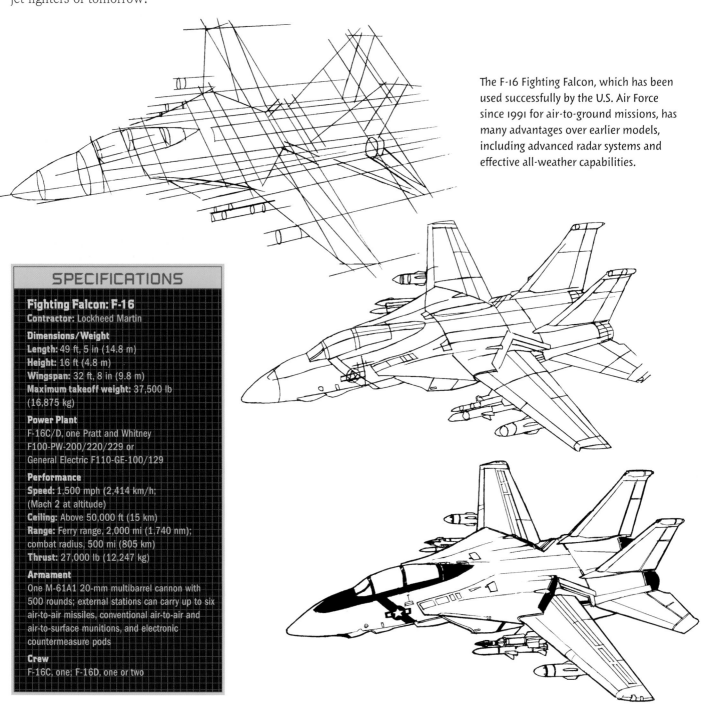

The F-16 Fighting Falcon, which has been used successfully by the U.S. Air Force since 1991 for air-to-ground missions, has many advantages over earlier models, including advanced radar systems and effective all-weather capabilities.

SPECIFICATIONS

Fighting Falcon: F-16
Contractor: Lockheed Martin

Dimensions/Weight
Length: 49 ft, 5 in (14.8 m)
Height: 16 ft (4.8 m)
Wingspan: 32 ft, 8 in (9.8 m)
Maximum takeoff weight: 37,500 lb (16,875 kg)

Power Plant
F-16C/D, one Pratt and Whitney F100-PW-200/220/229 or General Electric F110-GE-100/129

Performance
Speed: 1,500 mph (2,414 km/h; (Mach 2 at altitude)
Ceiling: Above 50,000 ft (15 km)
Range: Ferry range, 2,000 mi (1,740 nm); combat radius, 500 mi (805 km)
Thrust: 27,000 lb (12,247 kg)

Armament
One M-61A1 20-mm multibarrel cannon with 500 rounds; external stations can carry up to six air-to-air missiles, conventional air-to-air and air-to-surface munitions, and electronic countermeasure pods

Crew
F-16C, one; F-16D, one or two

BUILDING A FASTER PLANE

Four forces act on aircraft in flight—lift, weight, thrust, and drag—and together these determine how fast a plane will be able to fly.

An airplane's *weight* depends on how the plane was constructed and on the payload and fuel the airplane carries. (In the context of this book, *payload* refers to the total weight of passengers and cargo, including armament—weapons and ammunition—that an aircraft can carry.) *Thrust* is the force produced by the engine that propels the plane forward and up. Lift (the force that holds the airplane in the air) and drag (a force which resists the motion of the plane through the air) vary according to the size and shape of the aircraft, air conditions, and flight velocity. One important performance parameter for an aircraft is the *thrust-to-weight ratio*. In general, the higher the thrust-to-weight ratio, the faster an aircraft is able to climb.

In order to build faster aircraft, several technologies had to be improved. First, the drag had to be reduced substantially. This was accomplished largely by developing enclosed, streamlined fuselages and stronger wings that did not require external bracing. This meant the structure had to be made stronger, but if the stronger design meant that the aircraft would be heavier, the reduction in drag would be offset by the increased weight. Thus lightweight but strong materials were developed—both for the plane's body and wings and for the engines. Some of today's super-strong and super-fast jets can safely fly at speeds over Mach 4. Unmanned experimental jets have been clocked at over Mach 7, over 7 times the speed of sound! (Mach 1 is about 720 mph [1,160 km/h].)

Air Force One

Air Force One is a 747, a model that has been a major success story for Boeing. The company gambled over a billion dollars in development costs on the assumption that the world was ready for a bigger, more efficient commercial airliner. Their arrival in 1966 revolutionized commercial air travel, dramatically decreasing the average cost of air fare.

United States presidents have flown on Boeing aircraft for over 60 years, but it wasn't until 1990 that the first two 747s were fitted out as "flying Oval Offices." Air Force One, extensively modified to meet presidential—and military—requirements, has 4,000 square feet with separate conference, dining, sleeping quarters, and office space for the President and his entourage.

Dubbed ANGEL by the Secret Service, Air Force One features the latest in ultramodern specifications, including high-tech missile detection and avoidance systems as well as special shielding to protect against the electromagnetic pulses that would be generated after a thermonuclear attack. Air Force One can be refueled either on the ground or in the air, giving the President a virtually limitless range when traversing the globe.

SPECIFICATIONS

Air Force One (Boeing 747 200B)
Manufacturer: Boeing

Dimensions/Weight
Length: 231 ft 10 in (70.7 m)
Height: 63 ft, 5 in (19.3 m)
Weight: Maximum takeoff weight: 833,000 lb (374,850 kg)

Power Plant
4 GE CF680C2B1 engines, with 56,700 lb (25,719 kg) thrust each

Performance
Fuel capacity: 53,611 gal (202,939 L)
Thrust-to-weight ratio: 0.32
Range: 7,800 statute miles

Passengers
102 maximum including crew

This drawing shows in color the basic shapes the 747 is built up from: The body of the plane is a tapered cylinder; the wing, a tapered rectangular box.

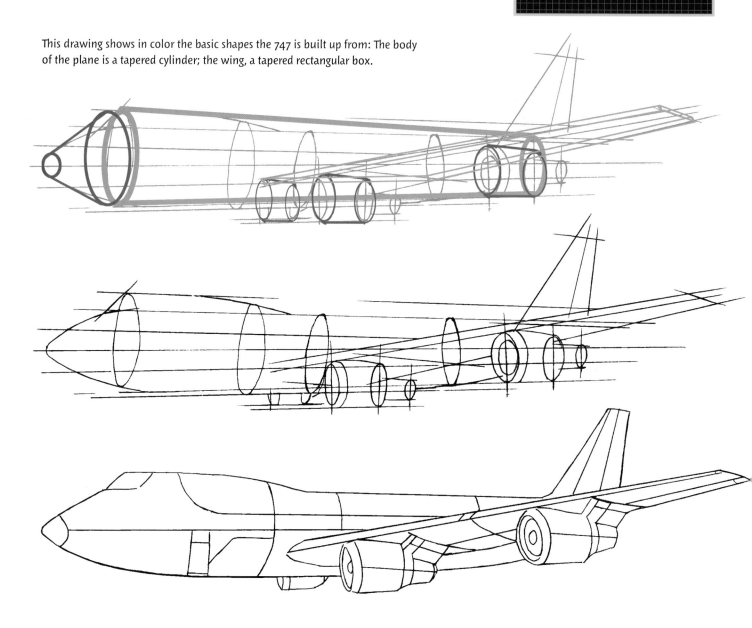

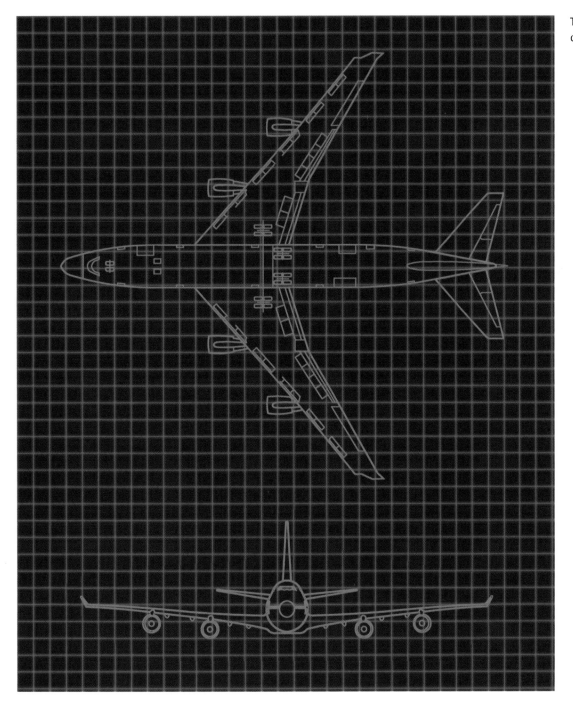

Top view and front view
of the 747.

Fighter Planes

Fighter planes—from World War II's P-47 Thunderbolt and F-6F Hellcat, to the Korean War's F-86 Sabre, to today's B-2 Spirit Stealth bomber and F-15 Eagle—and the pilots who fly them—from the Red Baron and Eddie Rickenbacher to "Forty Second [John] Boyd"—have a stronger hold on the public's imagination than any other type of military aircraft.

Drawing Wings and Tail Fins

The wings and tail fins of fighter planes are not easy to draw, but here are two step-by-step approaches that should help your iron eagles fly with aerodynamic grace.

Wings The wings of most fighter planes are based on four modified triangles. Although the wings on your final drawing will be horizontal and in perspective, let's start with a face-on rectangle for practice.

Step 1. Draw a horizontal rectangle. Find the middle of the rectangle by drawing an X from corner to corner. The point at which the lines intersect is the exact middle of the rectangle. Draw another line bisecting the X and dividing the rectangle into two equal halves.

Step 2. With the overall shape of your plane's wing sections firmly in your mind (you'll need a good photo reference), draw triangles for those parts of the rectangle that will NOT be part of your final wing shape. These are shown in color on the accompanying drawing.

Step 3. Now you're ready to use the technique described above in steps 1 and 2 to rough in the wings for your aircraft. Draw the main body shape of your plane, using perspective guidelines.

Step 4. Draw a rectangle in perspective across the fuselage where the wings will go. (The long edges of the rectangle will be parallel with the horizontal guidelines.) Repeat step 1. The line that divides the rectangle into two equal parts will have the same vanishing point as the two short sides of the rectangle.

Step 5. Looking at your reference photo, repeat step 2, drawing triangles for those parts of the rectangle that will not be part of your final wing shape. Erase those triangles.

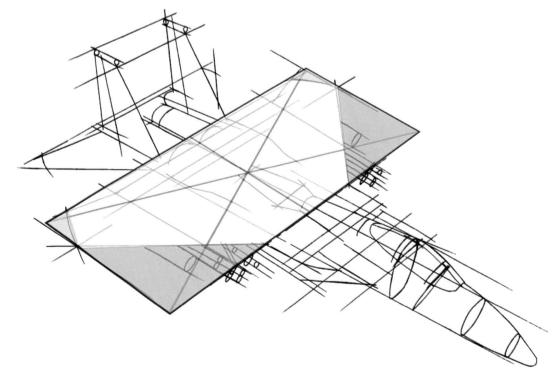

Tail Fins For the tail fins of a jet fighter, you'll use the same principles you used to draw the wings, this time starting with a cube drawn in perspective. For clarity, the accompanying drawings are shown apart from the plane itself. When you are actually doing the sketch, the box, triangles, etc., will be drawn in position at the rear section of the plane.

Step 1. Draw a cube in perspective. The angle of the cube should be based on the guidelines you've drawn for the body of your jet.

Step 2. Next, draw a line parallel to the front top edge of the cube across the top. At the two points where this line meets the top side edges, draw lines down to the front corners.

This will give you two triangles (shown in pink in the illustration), which you will discard. The remaining shapes (shown in yellow in the illustration) are the basic shapes for the fins.

Step 3. Once you have erased all your guidelines, the tail fins will look like this.

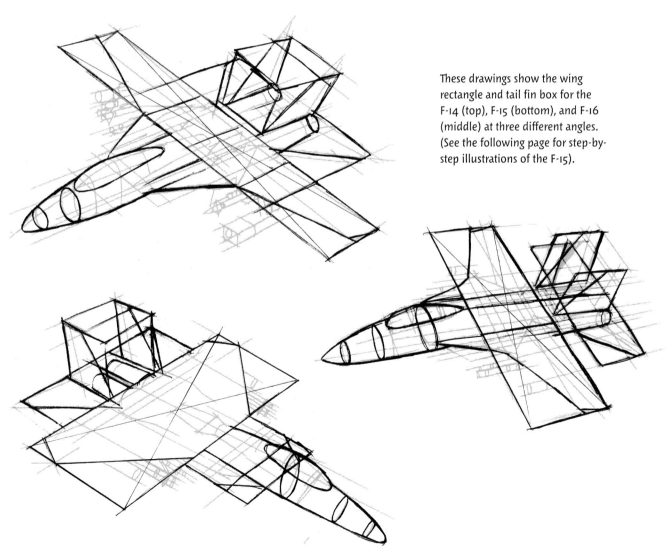

These drawings show the wing rectangle and tail fin box for the F-14 (top), F-15 (bottom), and F-16 (middle) at three different angles. (See the following page for step-by-step illustrations of the F-15.)

Eagle

The F-15 Eagle, which was first deployed in 1974, is a highly maneuverable tactical fighter with unprecedented dogfight capabilities. Its low wing loading (the ratio of aircraft weight to its wing area), combined with a high thrust-to-weight ratio, enables the Eagle to rapidly change direction or perform complex evasive maneuvers without losing significant airspeed. The Eagle's combination of range, speed, weaponry, and aerial agility makes it the current top one- or two-pilot fighter planes in the air today.

The F-15's state-of-the-art features include: advanced radar that can detect and track aircraft at various ranges and altitudes, and a computer-controlled weapons system.

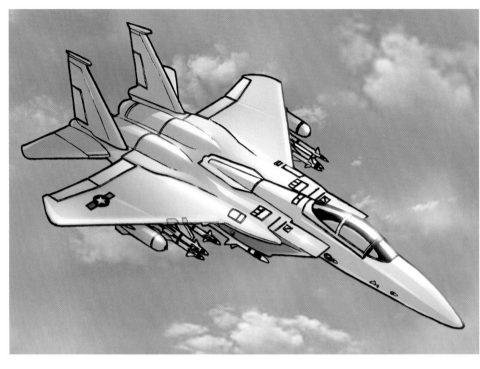

SPECIFICATIONS

F-15A Eagle
Contractor: McDonnell Douglas Corp.

Dimensions/Weight
Length: 63.8 ft (19.44 m)
Height: 18.5 ft (5.6 m)
Wingspan: 42.8 ft (13 m)
Weight: Takeoff weight depends on model—maximum 68,000 lb (30,844 kg)

Power Plant
Two Pratt & Whitney F100 turbofan engines in 29,000-lb (13,154-kg) thrust class

Performance
Speed:* 1,629 knots (1,875 mph) (Mach 2.5 plus)
Ceiling: 65,000 ft (19,812 m)
Range‡: Ferry range, 3,450 mi (3,000 nm); combat radius, over 1000 nm (1,967 km)

Armament
Varies. Examples: 1 internally mounted M-61A1 20-mm, six-barrel cannon with 940 rounds of ammunition; 4 AIM-9L/M Sidewinder and 4 AIM-7F/M Sparrow air-to-air missiles or eight AIM-120 AMRAAMs (advanced medium-range air-to-air missiles), carried externally.

*True airspeed (TAS) is the speed of an aircraft as shown on the aircraft's airspeed indicator, expressed in knots (KTAS) and corrected for specific conditions. Knot stands for "nautical mile per hour." To convert knots to miles per hour, multiply the speed in knots by 1.5.

‡A plane's ferry range is how far it can fly unloaded, with external fuel tanks instead of weapons. Combat range, or combat radius, refers to the distance the plane can fly loaded into combat, fight, and return. Ferry range can be up to 10 times combat range.

The wings and tail fins of fighter planes are not easy to draw, but if you follow the steps outlined on the previous pages, your iron eagles will fly with aerodynamic grace.

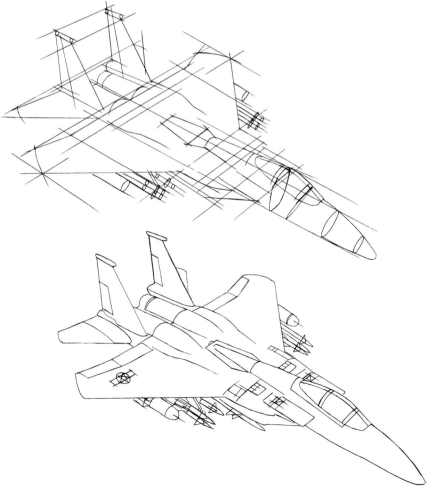

Harrier

The AV-8B Harrier jet, which can take off vertically straight up like a helicopter and then fly horizontally thanks to its V/STOL (vertical/short takeoff and landing) design, is the primary close-air-support intermediate-range attack-mission fixed-wing aircraft for the U.S. Marine Corps and the Spanish and Italian navies. (The U.S., Italy, and Spain are partners in a collaborative international development program.) The Harrier's main function is to attack ground forces from an advantageous elevated position, but in the capable hands of Marine pilots it can dish out trouble to targets in the air as well.

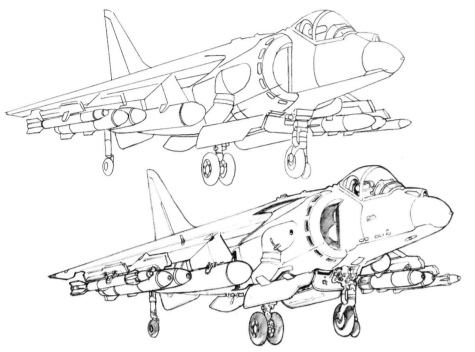

SPECIFICATIONS

Harrier (AV-8B)
Contractor: McDonnell Douglas

Dimensions/Weight
Length: 46.3 ft (14.11 m)
Wingspan: 30.3 ft (9.24 m)
Height: 11 ft, 7 in (3.55 m)
Weight: Empty, 12,800 lb (6,336 kg); maximum takeoff weight, 31,000 lb (14,061 kg)

Power Plant
Rolls Royce F402-RR-408 turbofan engine; thrust, 22,200 lb

Performance
Speed: 630 mph (875 knots) at takeoff and landing; at altitude, 0.98 Mach
Range: Ferry range, 1,600–1,900 nm; combat radius, 142 nm

Armament
MK-82 series 500-lb bombs, MK-83 series 1,000-lb bombs, GBU-12 500-lb and GBU-16 1000-lb LGBs (laser guided bombs), AGM-65F IR Maverick missiles, AGM-65E laser Maverick missiles, CBU-99 cluster munitions, AIM-9M Sidewinders, Lightning II targeting POD to deliver GBU-12 and GBU-16 bombs with pinpoint accuracy.

Crew
Pilot only

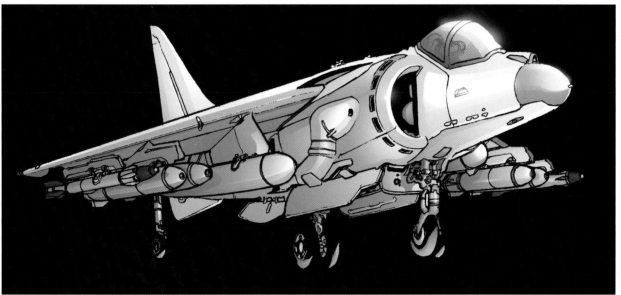

Harriers are complex machines to draw. Photo reference will help a lot, but sometimes you will want to draw a vehicle from a view you cannot find reference for. I keep a shoebox of toy cars and planes close to my drawing desk so I can view the crafts from any angle and get an idea of the basic structure and forms. I thought this was a pretty clever original idea until I started visiting other artists' studios and found that most had their own shoebox of toys next to their drawing desks. Our secret is out, and now you have an excuse to visit the toy aisle: You aren't looking for amusing playthings, you are engaged in serious research.

Nighthawk

The F-117A Nighthawk, the first of which was delivered to the Air Force in 1982, was the first operational aircraft to exploit stealth—radar-shielded—technology. Over 20 years later, this deadly bird of prey is still in use because of a planned weapons system improvement program, which allows the Air Force to modify the Nighthawk to incorporate the latest technological advances. The Nighthawk features a single-seat cockpit, allowing for total control of both the plane and all weapons by one pilot. It can refuel in the air, so the pilot can, theoretically, carry out unlimited missions one after another without ever having to touch down. The F-117A is outfitted with sophisticated navigation and attack systems integrated into its state-of-the-art digital avionics suite; this increases mission effectiveness while reducing pilot workload. As a battle progresses and logistics change, its targeting computer can be updated by ground support on a moment's notice to point one of the aircraft's laser-guided missiles to the target.

SPECIFICATIONS

Nighthawk
Contractor: Lockheed Aeronautical Systems Co.

Dimensions/Weight
Length: 65 ft, 11 in (20.3 m)
Height: 12 ft, 5 in (3.8 m)
Weight: 52,500 lb (23,625 kg)
Wingspan: 43 ft, 4 in (13.3 m)

Power Plant
Two GE Electric F404 engines

Performance
Speed: High subsonic
Range: Unlimited with air refueling

Armament
Two each MK84 2000-pound; GBU-10 Paveway II; GBU-12 Paveway II; GBU-27 Paveway III; BLU 109; WCMD; Mark 61

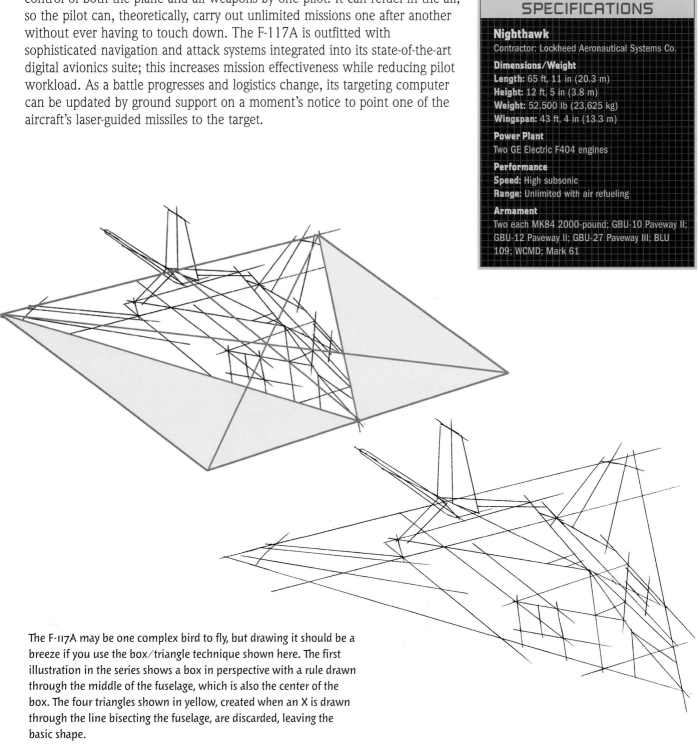

The F-117A may be one complex bird to fly, but drawing it should be a breeze if you use the box/triangle technique shown here. The first illustration in the series shows a box in perspective with a rule drawn through the middle of the fuselage, which is also the center of the box. The four triangles shown in yellow, created when an X is drawn through the line bisecting the fuselage, are discarded, leaving the basic shape.

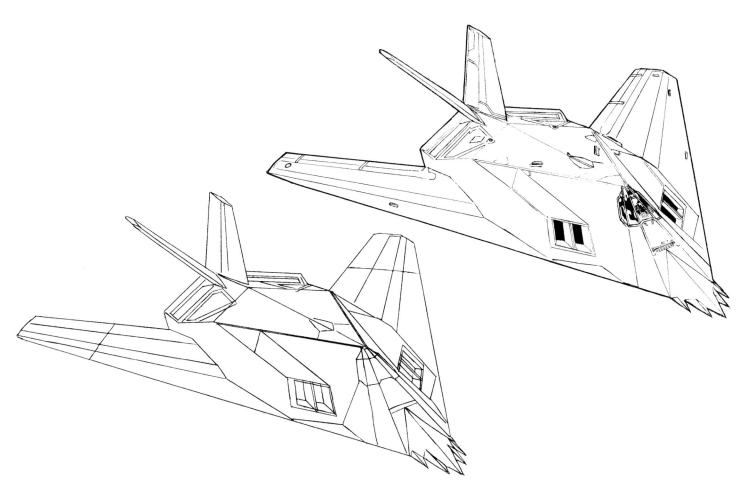
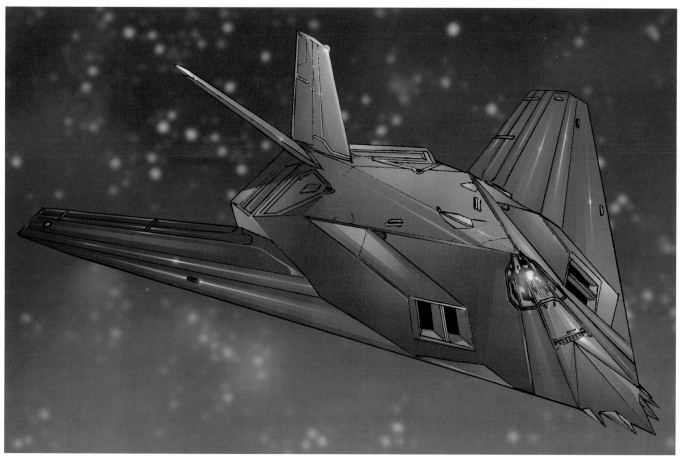

Spirit Stealth Bomber

Perhaps no other airship showboats modern cutting-edge military design quite like the B-2 Spirit Stealth bomber. The B-2 was developed under one of the military's "black," or classified, budgets. The B-2s, which are second-generation stealth, are constructed of carbon-graphite composites lighter than aluminum but stronger than steel, making them virtually invisible to all known forms of radar. Its manufacturer, Northrop Grumman, has developed a new radar-absorbent coating [AHFM (alternate high-frequency material)] to further enhance the B-2's already impressive stealth capabilities.

The B-2 is a low-observable strategic long-range heavy bomber designed to penetrate sophisticated air-defense shields. In other words, it can bomb the heck out of the enemy before they even know it's there. (A B-2 armed with precision weaponry could do the job of 75 conventional aircraft.) It is capable of unleashing attack missions at altitudes of up to 50,000 ft (15,240 m), making it almost a spaceship.

The aircraft carries all of its armament payload of weapons (including conventional and nuclear weapons, precision-guided munitions, gravity bombs, and a wide range of maritime weapons) internally in two separate weapons bays in the center of the aircraft. Each weapons bay is outfitted with a rotary launcher and two bomb-rack assemblies for rapid disbursement of munitions. There are 136 separate computers onboard, so that a crew of only two can pilot this flying wing. With just one aerial refueling a B-2 can reach and strike accurately any target in the world.

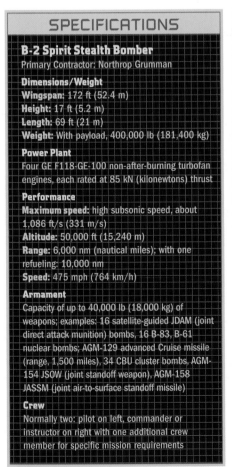

SPECIFICATIONS

B-2 Spirit Stealth Bomber
Primary Contractor: Northrop Grumman

Dimensions/Weight
Wingspan: 172 ft (52.4 m)
Height: 17 ft (5.2 m)
Length: 69 ft (21 m)
Weight: With payload, 400,000 lb (181,400 kg)

Power Plant
Four GE F118-GE-100 non-after-burning turbofan engines, each rated at 85 kN (kilonewtons) thrust

Performance
Maximum speed: high subsonic speed, about 1,086 ft/s (331 m/s)
Altitude: 50,000 ft (15,240 m)
Range: 6,000 nm (nautical miles); with one refueling: 10,000 nm
Speed: 475 mph (764 km/h)

Armament
Capacity of up to 40,000 lb (18,000 kg) of weapons; examples: 16 satellite-guided JDAM (joint direct attack munition) bombs, 16 B-83, B-61 nuclear bombs; AGM-129 advanced Cruise missile (range, 1,500 miles), 34 CBU cluster bombs, AGM-154 JSOW (joint standoff weapon), AGM-158 JASSM (joint air-to-surface standoff missile)

Crew
Normally two: pilot on left, commander or instructor on right with one additional crew member for specific mission requirements

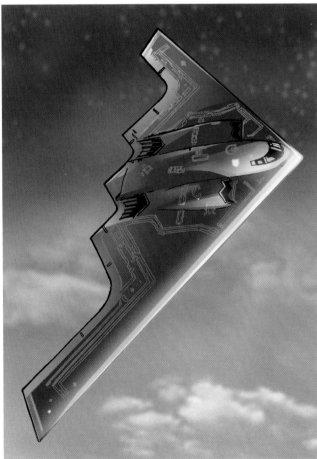

The leading edges of the B-2's "flying wings" are angled at 33 degrees and the trailing edge has a double-W shape, giving the bomber a totally distinctive look.

Tomcat

The supersonic F-14 Tomcat, a highly maneuverable strike fighter, is equipped with the Phoenix weapons system, which can identify and track from one to six "friend or foe" aircraft up to 100 nautical miles away, and, if foe, launch.

The Tomcat has the LANTIRN (low altitude and targeting infrared, night) system, as well as TARPS (tactical air reconnaissance pod system). Boasting the latest in rapid combat data recovery, its FTI (fast tactical imagery) system transmits and receives targeting/reconnaissance imagery, allowing continuous updating of battle strategy.

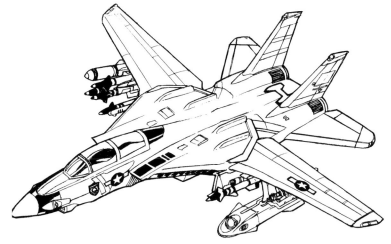

SPECIFICATIONS

F-14 Tomcat
Contractor: Northrop Grumman

Dimensions/Weight
Length: 62 ft 9 in (18.9 m)
Wingspan: 64 ft (19 m) unswept; 38 ft (11.4 m) swept
Height: 16 ft (4.8 m)
Weight: F-14D, empty, 41,780 lb (18,951 kg); maximum takeoff, 72,900 lb (32,805 kg)

Power Plant
F-14A: 2 TF30-414A afterburning turbofans with over 40,000 lb (18,000 kg) total thrust; F-14B/D: (2) F110-GE400 afterburning turbofans with over 54,000 lb (24,500 kg) total thrust

Performance
Speed: Mach 2+ at altitude
Ceiling: 56,000+ ft (17,000 m)
Range: F-14D, ferry range, 1,600 nm; F-14D, combat radius, 656 nm with two 280-gal (1,059 L) drop tanks

Armament
Up to 13,000 lb (5,900 kg); examples: 4 JDAMs (joint direct attack munitions), 6 AIM-7 Sparrows, 4 AIM-9 Sidewinders, 6 AIM-54 Phoenix (the longest-range AAM missile in the world); various air-to-ground precision strike ordnance; 1 M61A1/A2 Vulcan 20-mm cannon.

Crew
Pilot and radar intercept officer

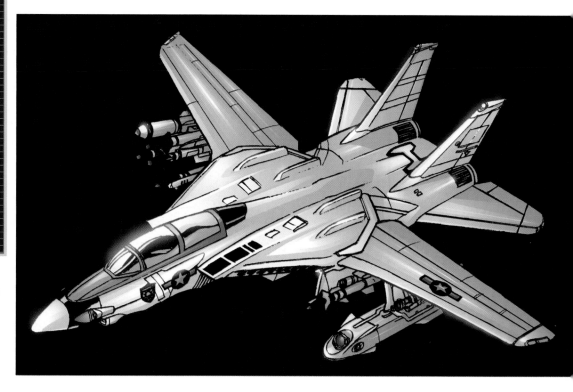

The single-canopy bubble on the F-14 gives the two-person flight team, which splits navigation and weapons responsibilities, a panoramic view of the sky.

Helicoptors

Apache Attack Helicopter

In 1984 McDonnell Douglas delivered the first Apache (AH-64A) to the U.S. Army for active duty. There are now over 2,000 Apaches in service around the world; it has become the first choice for nations able to afford the best technology has to offer. The Apache's chief function is to take out heavily armored high-value ground targets, such as tanks and bunkers, with the Hellfire missile.

The latest Apache models have state-of-the-art imaging capabilities, including, in addition to low-light-level black-and-white views during the daytime, TADS/FLIR (target acquisition designation sight/forward-looking infrared sight), which provides thermal images during all light and weather conditions, and a DVO (direct view optics) sensor, which provides real-world or magnified images during the day and early evening.

The AH-64 fleet consists of two models, the AH-64A and the AH-64D (Longbow). The specifications given here apply to both unless otherwise indicated.

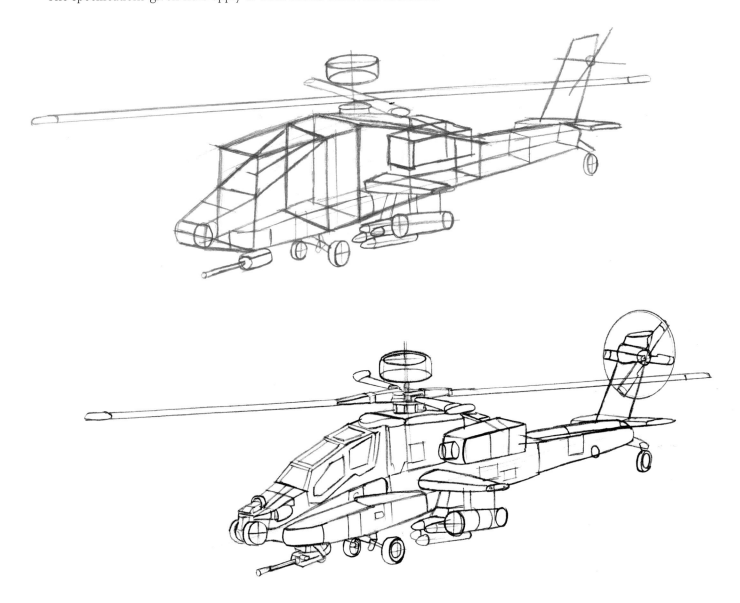

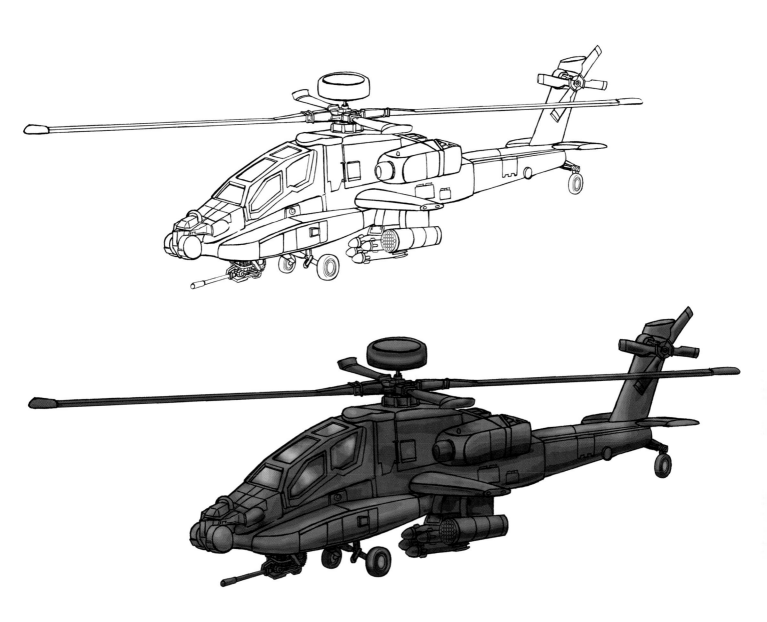

SPECIFICATIONS

AH-64

Contractors: Boeing McDonnell Douglas; GE

Dimensions/Weight
Length: 58.17 ft (17.73 m)
Height: 13.30 ft (4.05 m)
Wingspan: 17.75 ft (5.23 m)
Weight: Maximum
gross weight, 17,650 lb (8,000 kg)

Power Plant
Twin GE gas turbine engines, 1,890 shaft hp each (AH-64A)

Performance
Airspeed: Cruise, 145 mph (233 km/h)
Range: Ferry range, 1,180 mi (1,900 km; 1,025 nm); combat radius, 93 mi (150 km); combat radius with one external fuel tank, 186 mi (300 km)

Armament
Up to 16 Hellfire missiles; 30-mm M230 chain gun; Hydra 70 rockets

Crew
2 (pilot and copilot/gunner)

The basic shapes on which the Apache is built are boxes and cylinders. All of the additional lines in the cockpit and fuselage here (drawn much darker than you should draw them when you are adding details) are contained within the original box shapes. In the second step, many of the final details have been added, but a number of guidelines are still evident. The final details—cockpit glass, armaments, paneling, etc.—are not drawn in until all superfluous guidelines have been erased.

Huey

The U.S. Army contracted for a new Medevac (medical evacuation) helicopter—Bell's Model 204 HU-1 Iroquois—at the end of the 1950s. The versatility of the Huey, as it was soon affectionately called (the designation "HU" was later changed to "UH"), was legendary. In Vietnam, in addition to their Medevac operations, Hueys were used for troop transportation, search and rescue, air assault, and Special Operations, and at the end of the conflict over 5,000 were in service in Southeast Asia.

The Huey has been the most widely used military aircraft of the modern era, serving all four branches of the U.S. military and the armed forces of at least 48 other countries. It is probably a good thing that the military does not award service medals to vehicles, as the Huey would never get off the ground under the weight of the ones it deserves.

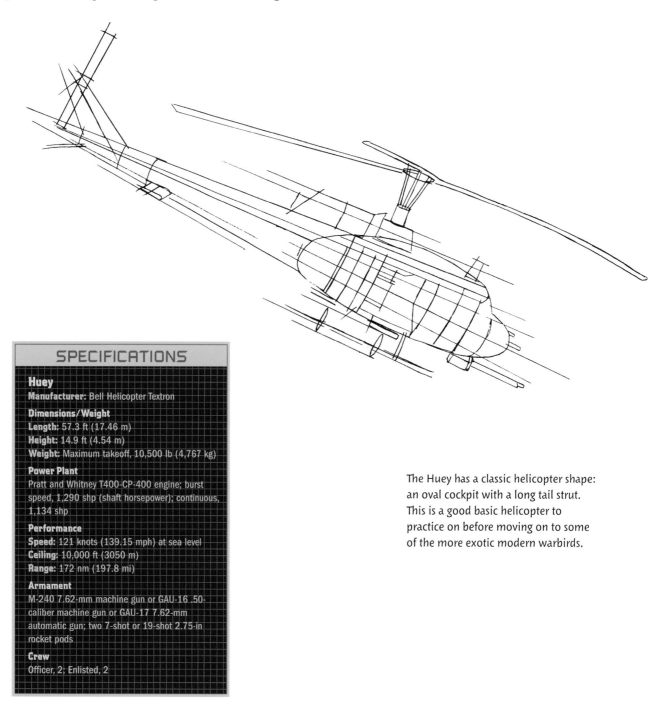

SPECIFICATIONS

Huey
Manufacturer: Bell Helicopter Textron
Dimensions/Weight
Length: 57.3 ft (17.46 m)
Height: 14.9 ft (4.54 m)
Weight: Maximum takeoff, 10,500 lb (4,767 kg)
Power Plant
Pratt and Whitney T400-CP-400 engine; burst speed, 1,290 shp (shaft horsepower); continuous, 1,134 shp
Performance
Speed: 121 knots (139.15 mph) at sea level
Ceiling: 10,000 ft (3050 m)
Range: 172 nm (197.8 mi)
Armament
M-240 7.62-mm machine gun or GAU-16 .50-caliber machine gun or GAU-17 7.62-mm automatic gun; two 7-shot or 19-shot 2.75-in rocket pods
Crew
Officer, 2; Enlisted, 2

The Huey has a classic helicopter shape: an oval cockpit with a long tail strut. This is a good basic helicopter to practice on before moving on to some of the more exotic modern warbirds.

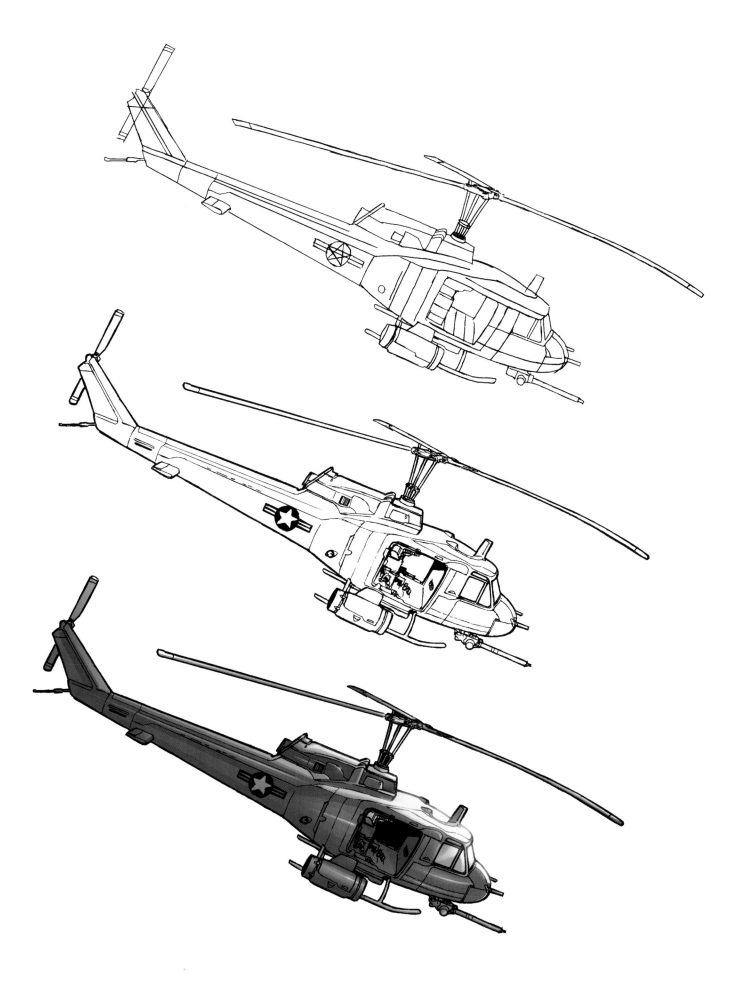

Pave Low

The H-53 series (the HH-53 was christened the "Super Jolly Green Giant," or "Super Jolly" for short, during its Vietnam tour), represents the USAF's largest and most powerful long-range helicopter. Typically, the Pave Low is flown by a flight crew of two pilots, with two pararescue technicians (PJs) in the hull section who are available for rapid action. Introduced in 1966, the Pave Low has been modified so it can better perform missions at night and in adverse weather conditions.

SPECIFICATIONS

Pave Low
Manufacturer: Sikorsky

Dimensions/Weight
Length: 92 ft (28 m)
Height: 25 ft (7.6 m)
Rotary diameter: 72 ft (21.9 m)

Performance
Speed: 165 mph (264 km/h)
Ceiling: 16,000 ft (4,849 m)
Weight: Maximum normal takeoff weight: 46,000 lb (18,900 kg); maximum takeoff weight during war, 50,000 lb (22,680 kg)
Payload: 37 troops or 24 litter patients and 4 PJs or 8,000 lb (3,600 kg) cargo
Range: 630 mi (550 nm)

Armament (for MH-53J)
Two 7.62-mm electric miniguns, one on each side; one .50-caliber (12.7-mm) machine gun mounted to tail ramp

Hercules

The primary mission of the C-130 Hercules is large-scale transport of troops and equipment, but its flexible design enables it to be configured for many different types of operations, including airlift support, Antarctic ice resupply, medical missions, weather reconnaissance, aerial spray missions, fire fighting, and personnel evacuations. Equipped with a large aft loading ramp and door and large interior compartments, the C-130 can accommodate a wide variety of cargo, from utility helicopters to six-wheeled armored vehicles, as well as troops and standard palletized supplies for ground or air delivery. Utilizing specially designed parachutes, the Hercules can airdrop loads up to 42,000 pounds, making it the chief means of distributing supplies behind enemy lines.

SPECIFICATIONS

Hercules 130-J

Contractor: Lockheed Martin

Dimensions/Weight
Length: 97 ft, 9 in (29.3 m)
Height: 38 ft, 10 in (11. 9 m)
Wingspan: 132 ft, 7 in (39.7 m)
Cargo compartment: Length, 40 ft (12.31 m); width, 119 in (3.12 m); height, 9 ft (2.74 m)
Weight: Maximum takeoff, 155,000 lb (69,750 kg)

Power Plant
4 Rolls-Royce AE 2100D3 turboprops, 4,700 hp each

Performance
Speed: 417 mph (362 KTAS; Mach 0.59) at 22,000 ft (6,706 m)
Ceiling: 28,000 ft (8,615 m) with 42,000 lb (19,090 kg) payload
Range: At maximum normal payload [34,000 lb (15,422 kg)], 2,071 mi (3,333 km)

Crew
3 (two pilots and loadmaster)

The cargo plane is a technological marvel, but its finished form is simple, sleek, and smooth. Cargo planes are an example of "less is more"; this airworthy plane is able to slice through headwinds and deliver provisions where they are most needed.

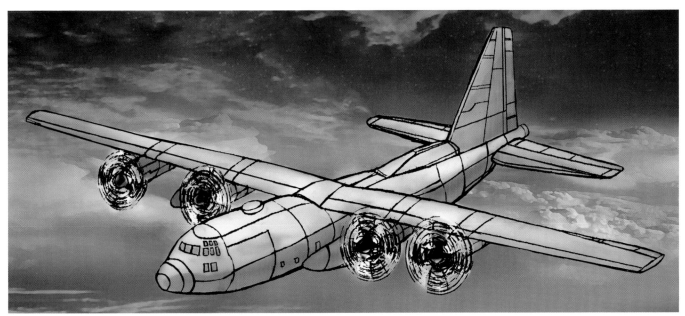

The Marina

The fleet of the U.S. Navy has a long and illustrious history, from the earliest battleships to today's state-of-the-art nuclear-powered submarines to tomorrow's littoral (coastal) combat ships.

In addition to the massive battleships carrying heavy artillery that pounded enemy bunkers to clear the way for ground troops, amphibious watercraft have been used for transporting troop and equipment for beachhead operations, as escape vessels for troops on clandestine SOF missions, and as aircraft carriers serving as floating runways for helicopters and fighter jets. The Navy uses command ships to orchestrate large-scale combat tactics miles away from the shore—and away from enemy firepower. Wherever there is a waterway, there is a way to exploit it for a military advantage.

Battleships

For over a century battleships of various shapes and sizes served the naval armed forces. They played significant roles in WWII and Vietnam, carrying troops and supplies across bodies of water as well as providing fire support and mobile airstrips for fighters and helicopters. (During the 1940s, battleships routinely carried one or two floatplanes. In the 1950s, a switch was made from floatplane(s) to helicopter(s). More recently, a few battleships were called back to active duty to supply massive fire support for skirmishes in Iraq and Kuwait. (The term "massive" does not overstate the case. See the next page for statistics on the awesome firepower carried by one of these behemoths.)

The United States built its first battleship, the *USS Texas,* in 1895; the last, the *USS Wisconsin,* was launched in 1943 and fired its last combat gunfire during operation Desert Storm in February of 1991. There are no battleships on active duty today. Most stand as decommissioned memorials to a time when metal and brute strength ruled the seas.

Over the years, different classes of battleships, all with state names, were constructed. The specifications given here are representative of Iowa class battleships as a whole.

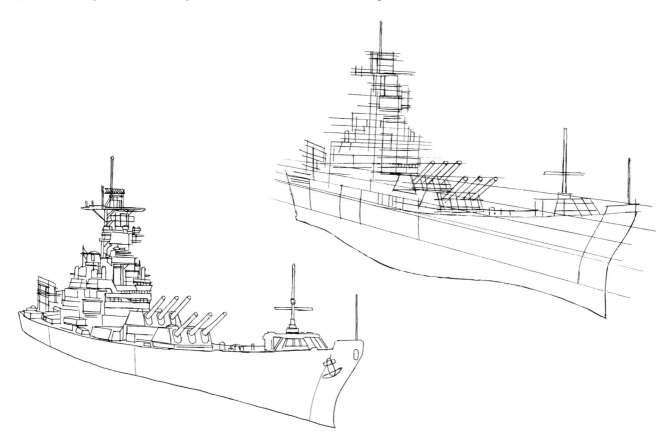

SPECIFICATIONS

Iowa Class Battleships
Manufacturer: U.S. Naval Shipyard

Dimensions/Displacement/Draft
Length: Overall, 890 ft (271 m); water line, 860 ft (262 m)
Beam: 108 ft (32.9 m)
Full load displacement: 57,000 tons
Draft limit: At 57,000 tons: 37 ft (11.3 m)

Power Plant
Eight boilers, four geared turbines, four shafts; 212,000 shaft hp

Performance
Speed: 33+ knots
Fuel capacity: 2.5 million gal (9.5 million L)

Armament (Typical Iowa Class)
Nine 16-inch/.50-caliber guns in three triple turrets; twenty 5-inch/.38-caliber dual-purpose guns in 10 twin mounts; eighty 40-mm antiaircraft guns in 20 quadruple mounts; fifty-seven 20-mm antiaircraft guns; eight armored box launchers for 32 Tomahawk cruise missiles; four quadruple canister launchers for 16 Harpoon antiship missiles; four Vulcan/Phalanx weapon systems for aircraft/missile defense

Crew
Typical: 74 officers, 1,579 enlisted

Despite the complex weaponry of battleships, drawing them is governed by the same basic rules of construction and perspective that apply to drawing simpler craft. Take your time to establish vanishing points before trying to place all of the various masts, guns, and decks. Remember that the hull sits partially underwater. Although it will not be entirely visible in the final drawing, it should be incorporated into your design process during the early stages.

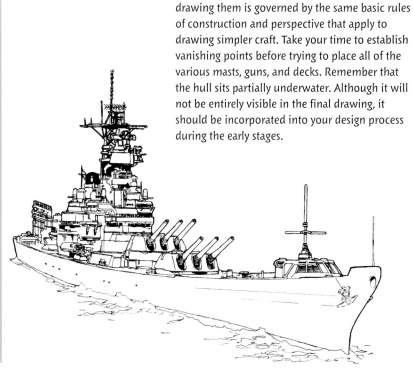

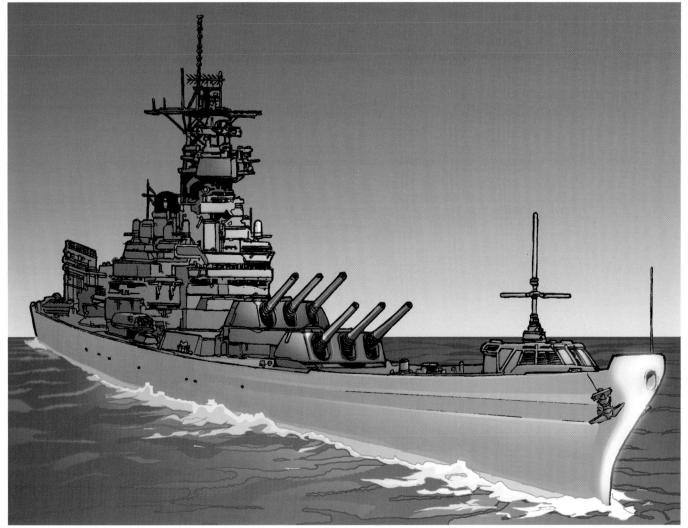

Aircraft Carriers

The aircraft carrier is the centerpiece of the modern naval forces. It provides a floating runway for aircraft that is essential for both sustained and hit-and-run missions. Logistically, the aircraft carrier's mission is threefold:

- **In peacetime.** To provide a credible, sustainable, independent forward presence and conventional deterrence

- **In times of crisis.** To operate as the cornerstone of joint/allied maritime expeditionary forces

- **In war.** To operate and support aircraft attacks on enemies, protect friendly forces, and engage in sustained independent operations

The positions and movements of aircraft carriers are carefully watched, as they are usually the first visible indication of an upcoming military action. Carriers must be ready and in place before troops can engage in any attack action where air support far from friendly territory is required. The aircraft carriers of the U.S. Navy are continuously deployed, patrolling the world's hot spots, and can be called into action on a moment's notice.

SPECIFICATIONS

Nimitz Class Aircraft Carrier
Contractor: Newport News Shipbuilding Co.

Dimensions/Displacement/Draft
Length: Overall, 1,092 ft (332.85 m)
Width: Flight deck, 252 ft (76.8 m)
Beam: 134 ft (40.84 m)
Displacement: Full load, approx. 97,000 tons
Draft: 33.7 ft (11.3 m)

Power Plant
Two nuclear reactors, four main engines

Performance
Speed: 30+ knots (34.5+ mph)

Armament
Two or three (depending on modification) NATO Sea Sparrow launchers, 20-mm Phalanx close-in weapons system (CIWS) mounts (3 on USS Nimitz and USS Dwight D. Eisenhower and 4 on USS Carl Vinson and later ships of the class)

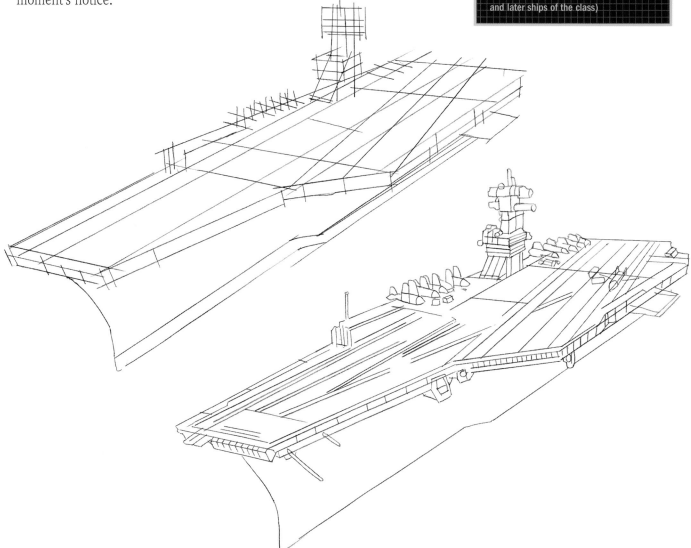

A LESSON FOR LANDLUBBERS: MARITIME VOCABULARY

A ship has to displace a volume of water equal to its weight in order to float. Thus the weight of large ships is given in tons (or metric tons), and referred to as *displacement*.

The *draft*, or *load line*, which is measured in feet (or meters), is how much of the ship is under water. Permissible load lines for different displacements are regulated by national and international standards.

A speed of *1 knot* is a speed of *1 nautical mile per hour*, which is 1.152 mph (1.85 km/h). The nautical mile is about 0.15% longer than the so-called statute mile.

Aircraft carriers, like battleships, are fiction favs, and have been featured in numerous films, including The Hunt for Red October, Clear and Present Danger, and Behind Enemy Lines. Nimitz-class carriers are relatively easy to draw, and once you've got the basic design down, you can add jet fighters ready for takeoff, as well as an escort ship or two. (To give you some idea of the scale of these behemoths, modern destroyers are about one-half the length of an aircraft carrier.)

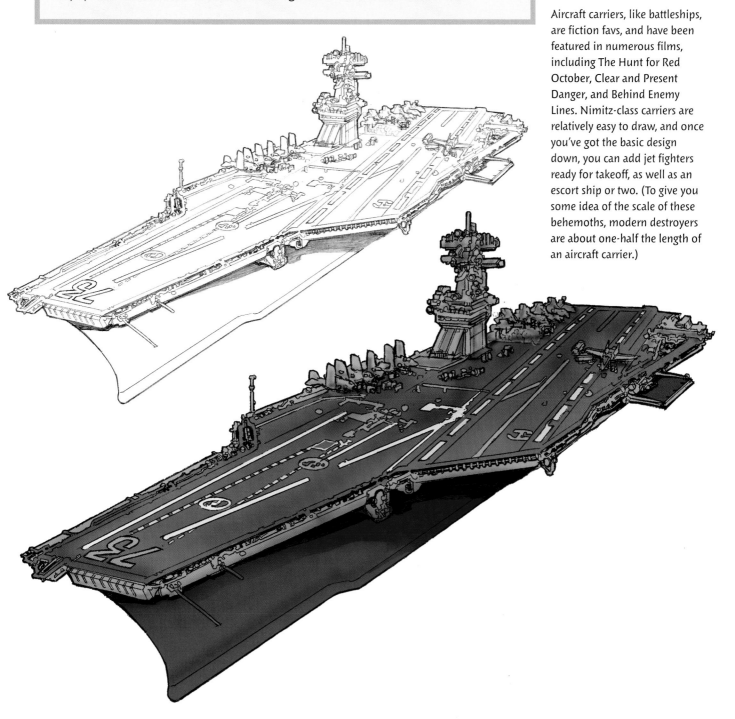

Destroyers

Destroyers are aptly named: They are the warships that enemy naval forces most fear encountering. The bulldogs of the sea, destroyers are multitask vessels. They actively hunt down submarines and engage in offensive sea-to-air and sea-to-land salvos. They are often deployed to protect and support larger, less maneuverable naval vessels, acting as fast-moving bodyguards able to take the fight to any amphibious enemy at a moment's notice.

Over the years since the first destroyer—the *USS Bainbridge*, commissioned in 1902—plied the seas, these ships have undergone more modifications than any other type of naval vessel, as their smaller size makes them ideal for testing new technology.

The first major modification—radar—was tested in 1937 and became regular equipment for the Arleigh Burke class of destroyers that served during World War II. Later models of the Gearing class, probably the best-known configuration, were armed with surface-to-air missiles, and in 1954, the *USS Gyatt* became the first guided-missile destroyer.

The two modern destroyer classes, Spruance and Arleigh Burke, feature gas turbine engines as their main propulsion system, a first for the Navy. The Arleigh Burke class, named after the Navy's most famous destroyer squadron combat commander and three-time Chief of Naval Operations, is one of the most deadly floating arsenals ever put to sea. Destroyers in the Arleigh Burke class are equipped with the Aegis weapons system, which is able to detect incoming missiles or aircraft, identify the threat level of each, and guide the missiles to their targets (up to 100 at any given time).

Currently, there is a fierce debate over what tomorrow's Navy fleet should consist of. The Navy has scaled down its request for 24 DD(X) destroyers to five, and has asked Congress to authorize construction of sleeker, faster boats that would be able to patrol both shore and, via river, inland. Congress, Northrup Grumman, and General Dynamics (between them Grumman and General Dynamics control all U.S. shipbuilding) argue that the bigger ships are necessary, both militarily and economically. (The DD(X), at one-third the size of existing destroyers, would utilize stealth technology to make it show up on enemy radar screens as about the size of a fishing boat. But at a price tag now at $3.3 billion and climbing, the DD(X) may never be built.)

SPECIFICATIONS

Arleigh Burke Class Destroyer
Builder: Bath Iron Works

Dimensions/Displacement/Draft
Length: 505.25 ft (154 m)
Beam: 67 ft (20.4 m)
Draft: 30.5 ft (9.3 m)
Displacement: Full load, 8,300 tons

Power Plant
Four GE gas turbine engines giving 100,000 hp to two shafts

Performance
Speed: 30+ knots

Armament
Varies. Vertical launching system (29 cells forward, 61 aft to house SAMs), Tomahawk weapons system, continuously upgraded antisubmarine warfare systems; .54-caliber MK-45, MK-15 Phalanx close-in weapons system (CIWS)

Crew
23 officers, 24 chief petty officers, 291 enlisted

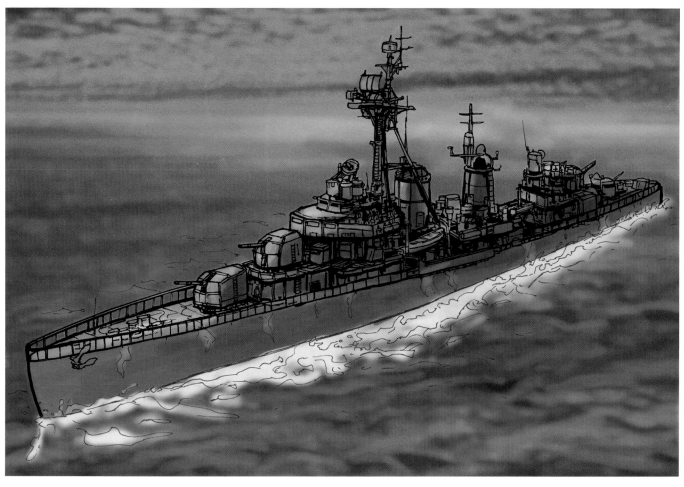

Air-Cushioned Vehicles

There are several types of air-cushioned vehicles (ACVs), including hovercraft and surface effect ships (SES). ACVs are ideal for rapid amphibious or land assaults. They can ride a cushion of air directly over barriers that would stop most land vehicles and plot an intercept course using the shortest route. Equipped with full firefighting, first aid, and rescue apparatus, the larger ACVs are extremely effective crash rescue/recovery units that are capable of rescuing survivors trapped behind unstable debris.

ACVs produce virtually no acoustic, magnetic, or pressure signatures, so they can also skim right over terrain salted with land mines and other antipersonnel booby traps. If an explosion does occur under a mine countermeasure (MCM) ACV, the air cushion absorbs the shock, allowing the craft to continue safely on its course.

Technical equipment includes today's most advanced lightweight sonar, navigation, and tracking systems. Large ACVs can also be equipped with a bow ramp to carry small conventional or tracked vehicles, or a combination of people, cargo/armaments, and vehicles. The armament that can be carried by a given military model ACV depends on the power of the engine. For example, the SK5 series, which was deployed in Vietnam, typically carried window-mounted M60 machine guns, .50-caliber machine guns, and a 40-mm grenade launcher.

There are hundreds of different hovercraft models available worldwide. The specifications given here are for a craft manufactured by Griffon Hovercraft and is based on a design by Sir Christopher Cockerell, the inventor of the hovercraft. (Headquartered in Southampton England, Griffon has a U.S. branch in Connecticut.)

SPECIFICATIONS

8000TD(M) Hovercraft
Manufacturer: Griffon Hovercraft

Dimensions
Length: 21.20 ft (6.6 m)
Beam: 11 ft (3.4 m)
Height: Hovering, 5.5 (1.7 m)

Power Plant
Two 800-hp (596-kW) diesel engines

Performance
Endurance: 3.5 h
Fuel consumption: 50.6 gal/h (230 L/h)
Speed at full payload: 40 knots
Maximum payload: Approx. 9 tons
Obstacle clearance: Approx. 4 ft (1.25 m)
Wave height: For passenger operation, 6.6 ft (2 m)

You guessed it; the hovercraft is basically built off of a blocky guide shape. Build the rear propulsion blades the same way you would an airplane propeller, starting with a box and drawing your circular blades to fit inside.

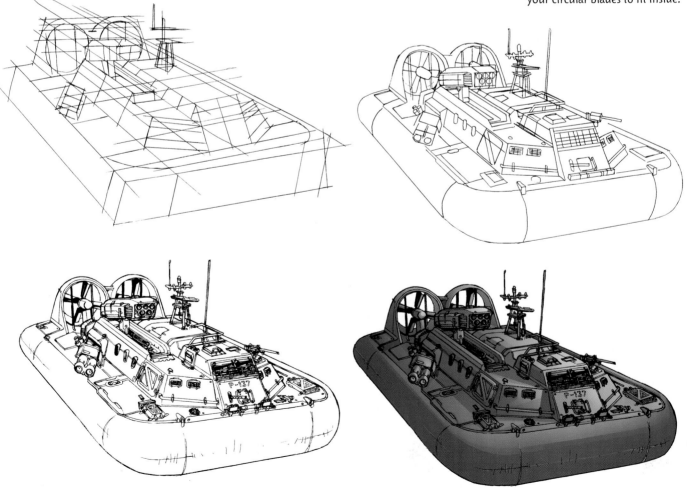

Riverboats

The important role played by U.S. riverboats in Vietnam—the "brown water Navy," so-named because of the muddy color of the Mekong Delta waterways—is not widely known. In the late 1950s, the South Vietnamese Navy organized river assault groups (RAGs), but it wasn't until the mid-1960s that U.S. riverboats (patrol boats, river—PBRs) began to make a significant contribution to the war effort. Without rudders or propellers, and drawing less than 2 feet (0.6 m) of water, the PBRs could patrol the narrow waterways and make extended trips upriver, drawing a minimum of enemy fire. PBRs were armed with machine guns and a 40-mm grenade launcher. In 1967, the Army and Navy jointly created the Mobile Riverine Force, aka Task Force 117, which was actively engaged in the war effort until 1970, when the last of the brown-water boats were handed over to the Vietnamese.

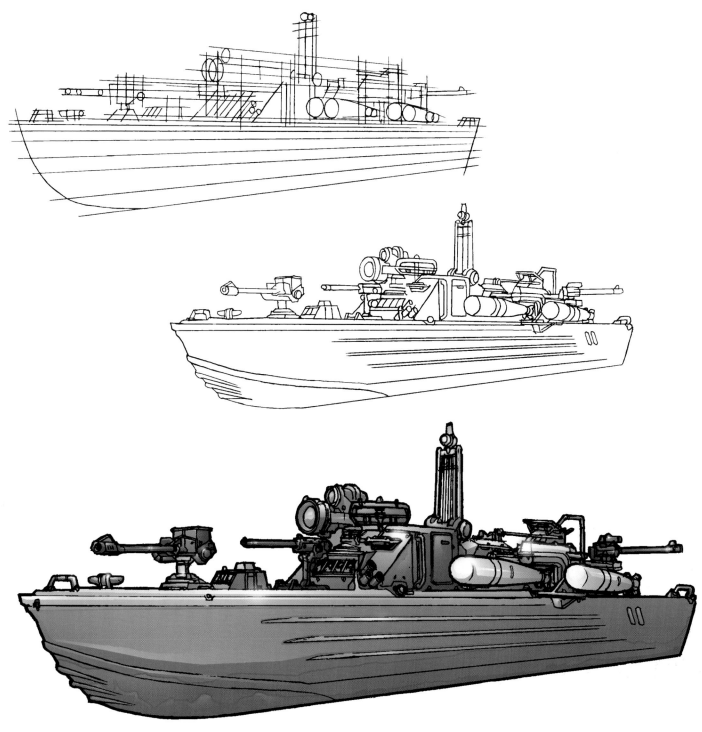

Submarines

Submarines are an incredible example of the successful merging of scientific and military technology. Before the development of submarines all nautical warfare took place on top of the water. Submarines literally opened up a whole new battle theater.

Submarines traverse the seaways by utilizing a complex system of ballast and auxiliary tanks to control their buoyancy. Buoyancy, or the ability to float, is achieved by displacing an amount of water that is equal to the weight of the submarine. A sub floats when its ballast tanks are full of air. For diving, the crew fills the ballast tanks with water until the sub is dense enough to sink. Submarines have a unique capsule shape, which affords maximum structural stability under the immense water pressures they must withstand.

The first nuclear-powered submarine, the *USS Nautilus* (SSN 571, where SSN stands for Submarine, Nuclear Propulsion), was launched in January of 1954. Today's SSNs combine the basic Nautilus design principles with a hull design that gives subs the ability to move under water at much greater speeds than those that could be reached by the early models.

The specifications below are for a Virginia class fast-attack submarine, designed for dominance not only in the ocean but also in coastal waters, a must in this era of terrorist threats. Ten more Virginia class submarines have been contracted for, and the Navy hopes to have five of those in the water by 2008.

The artist has drawn a modified cylinder, much like a cigar, for the base shape of the sub. This modern design, officially called a "teardrop hull," was developed after engineers studied the bodies of whales. It significantly decreases the hydrodynamic drag on the sub.

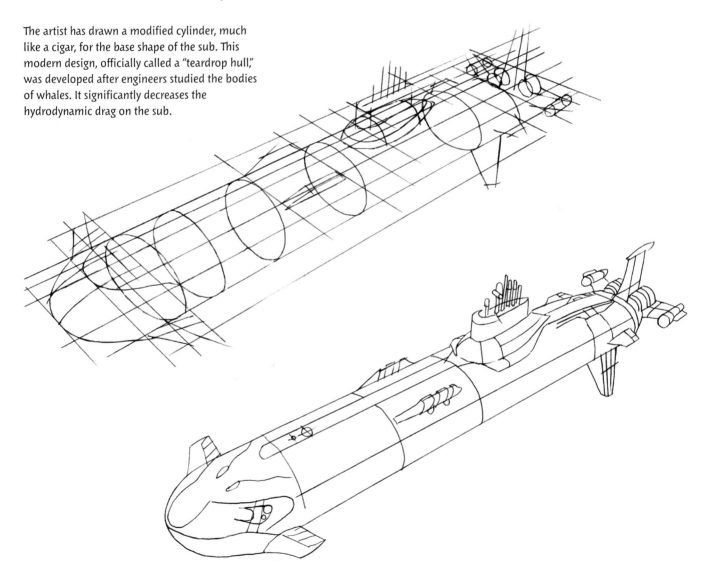

SPECIFICATIONS

Virginia Class Submarine

Builders: General Dynamics; Northrup Grumman News Shipbuilding

Dimensions/Displacement/Draft
Length: 377 ft (115 m)
Beam: 34 ft (10.4 m)
Displacement: Surfaced, 7,800 tons
Draft: 30.5 ft (9.3 m)

Power Plant
One nuclear reactor

Performance
Speed: Surfaced, 25 knots; submerged, 32 knots
Diving depth: 800 ft (244 m)

Armament
12 VLS (vertical launch system) tubes, 4 torpedo tubes for 16-Tomahawk salvo capability

Crew
113

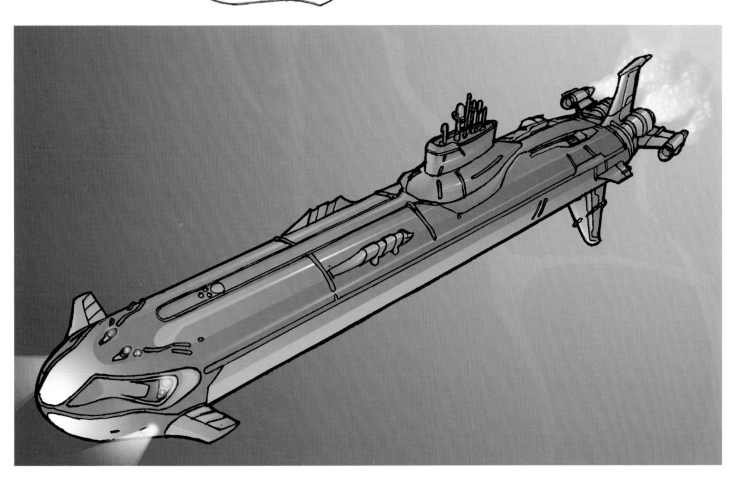

Art Assault: Your First Mission

All right, recruits, report to the ready room for a briefing on your first mission. This is not a drill. Repeat, this is not a drill.

Listen up, troops. By now you've reviewed the Intel reports and are well-versed in the parameters of what it takes to draw a successful military comic. Your mission is to draw a four-page skirmish from the plot provided. Don't panic. I know you've got what it takes. As a training aid I got a couple of my ace operatives, artist Dan Norton and colorist Joseph Damon, to take a crack at the mission, and—no surprise—these two Art Militia madmen went above and beyond the call of duty to complete the task with flying colors.

The Plot

The basic plot for the story involves a soldiers of fortune team, and the sequence will be featured in *Trigger Guard* comics.

- *Page 1.* Two helicopters carrying a crack commando team are flying over a jungle at the break of dawn. They are getting their gear ready for the mission. Their CO gives them the command to move out, and the team rappels out on rope lines toward the jungle floor.

- *Page 2.* The team makes a quick recon scan of the enemy-occupied village, then moves into action, taking out the perimeter guards, setting up its own sniper, and sneaking into the village to engage the enemy.

- *Page 3.* All-out attack! The commando team hits the village hard, shooting vehicles and fuel drums, causing the drums to explode. They mow down the enemy soldiers, who are caught totally off guard.

- *Page 4.* The surviving enemy forces are rounded up and taken prisoner. We now see the true purpose of this encounter. It wasn't simply an ambush to take out a guerrilla soldier stronghold; it was primarily a rescue mission. The CO helicopters in, leaps out, and busts down the door of one of the shacks, where he finds two straw dummies. A photo is attached with a knife to one of the dummies: It's a picture of the CO's wife and son. On the back of the photo is the horrifying message, "You'll never see them again!" The hardened commander turns and sheds a tear for his missing family, feeling the anguish and frustration of being one step behind their captors.

Plot Summary vs. Full Script

Once you have your basic story line, you need to decide what kind of script you are going to give the artist. There are two basic kinds of scripts: (1) a plot summary and (2) a full script. A plot summary, like the one in this chapter, is really just a loose framework. You'll go with a plot summary when you're working with an artist who is also an accomplished storyteller. You provide just enough information for the artist to understand what you are going for and then you cut him or her loose to fill in the details. A plot summary may or may not have the sequences broken down by page number. Sometimes an artist will get a plot and page count (22 pages for a standard comic book) and will be told to break the mission down in whatever way works best—as long as it comes in at the right page count.

A full script goes into detail: not only does it give a complete story line, but it also breaks down the story page by page and panel by panel, thus setting the narrative pace. Full scripts are similar to film

scripts: They specify dialogue, angles, lighting, sound effects, and even characters' facial expressions. There are pros and cons to both approaches. With a plot summary, the artist has almost total freedom of artistic expression, but may turn out pages that radically differ from what the writer originally envisioned. With a full script the writer will get back pretty much what he or she has put down on paper, but won't get spontaneity and the on-target suggestions that talented artists can offer.

Okay, this is a pretty straightforward little tale with an emotional kick at the end. I knew the pages were in good hands when I assigned them to Dan and Joseph so I chose to go with a loose plot outline.

Composing the Pages: The Pencil Stage

Page 1, panel 1, is what is called an establishing shot: It provides much of the basic information for the sequence: The reader immediately understands the where (a jungle), the when (near sunrise), and the who (troops in helicopters). Establishing shots may not be as much fun to draw as panels showing a warrior with both gun barrels blazing, but they are part of a standard storytelling technique for comics and film: You start out from a distance to set the stage and then you move in closer for the action.

There is a lot of fantastic composition work in the way Dan laid out his panels. Check out the dramatic rappelling shot from panel 5, which is a worm's-eye view. The reader is looking up at the troops, and the helicopter's silhouetted fuselage really pops the characters' forms off the page.

▶Here we have a new location and a new establishing shot. In panel 1 Dan has expertly rendered a guerrilla jungle village consisting of several bamboo huts; plenty of military gear (trucks, ammo, guns, fuel barrels, etc.) is in plain sight. Panels 6 and 7 together comprise a beautifully laid out example of what is known as Z composition. American comic books read from left to right, so comic artists often compose adjacent panels so that the viewer's eye will move in a Z from the end of one panel on the right over to the next panel on the left.

In panel 6 the sniper's rifle is the top of the Z, which ends at the shell burst, then moves your eye to the soldier in the middle ground of panel 7. His rifle is the diagonal cross-bar of the Z, which leads the eye onto the main soldier in the foreground. That soldier's rifle leads the eye across the panel from left to right, and signals the reader to turn the page. The firepower evident in this panel—not least the oversize machine gun carried by the foreground solder—is a clue to what the first panel on page 3 will show. It's simply brilliant page design by Dan Norton.

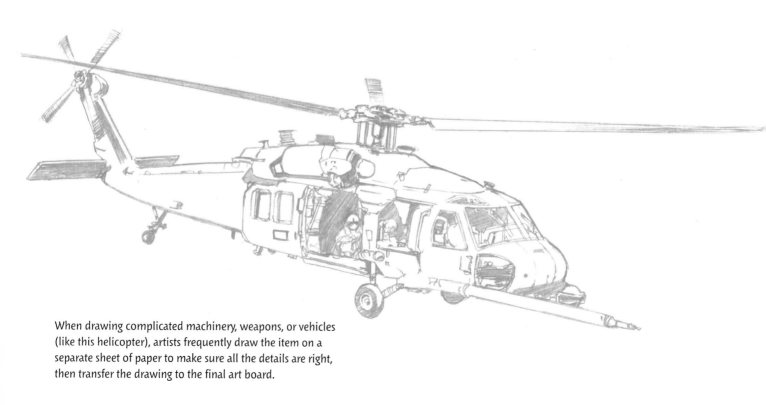

When drawing complicated machinery, weapons, or vehicles (like this helicopter), artists frequently draw the item on a separate sheet of paper to make sure all the details are right, then transfer the drawing to the final art board.

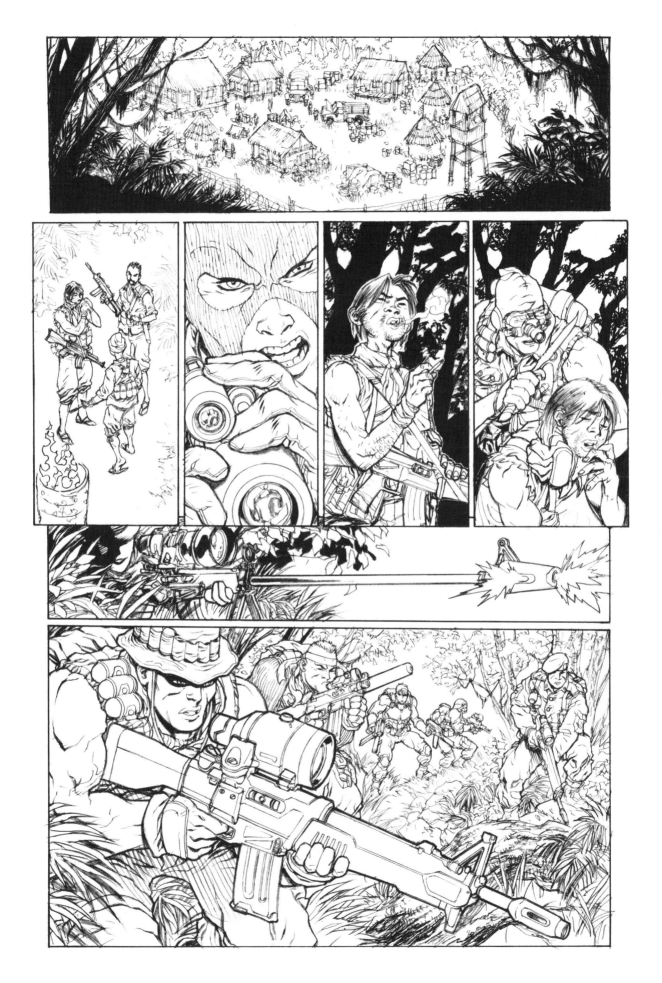

Page 3 is where the plot-summary option really pays off. Dan has taken the bare-bones "all-out attack" and turned it into a masterful depiction of what might be called "orderly chaos". All hell is breaking loose, but the narrative sequence is totally coherent.

The panel-to-panel movement on this page is marvelous. Notice, for example, how the Ninja's leg in panel 3 points both up and slightly to the right, providing a visual anchor that holds the page together. The entire page is another example of ingenious design—and what separates a battle-tested artist from a raw recruit.

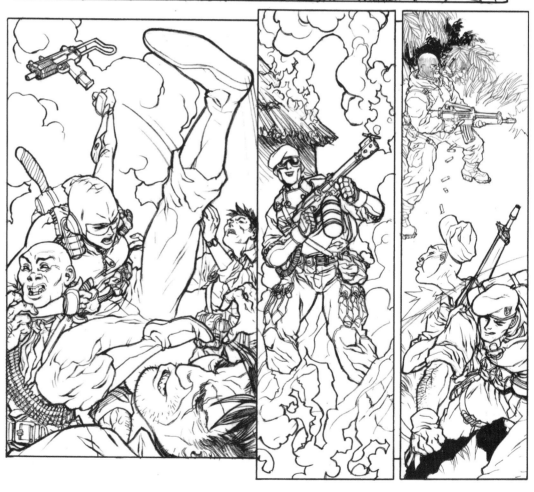

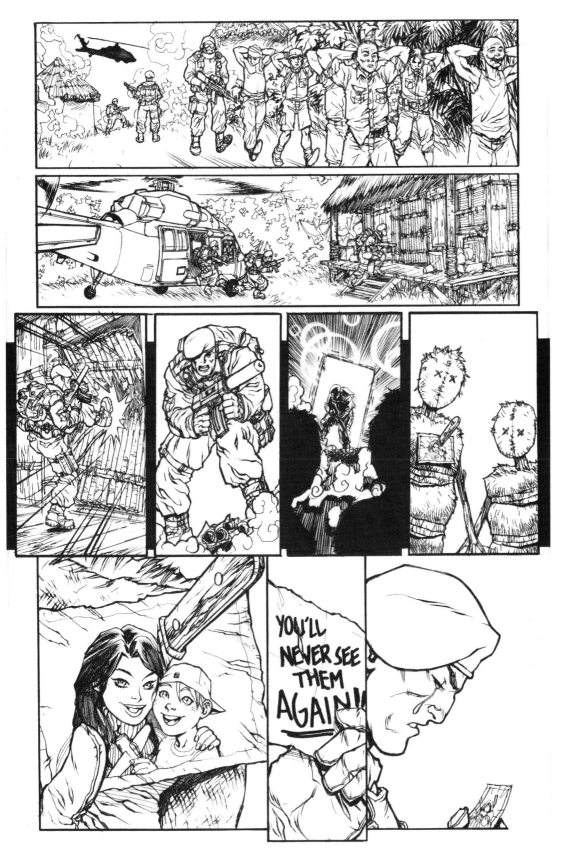

Dan was given a lot of information to convey on this page, and he has done it all well. We have the visual cues that the battle is over and a clean-up operation is under way and from this we immediately move into the heart of the story, the dramatic entrance of the CO. Dan is able to shift gears and go from heart-stopping action right into the gripping emotional drama of the officer's profound loss. A small battle has indeed been won, but the underlying goal of the battle—the rescue of the CO's wife and child—is out of reach.

Inking and Coloring

After the pages leave the penciler's hands, they are approved by the editor and, usually, sent to an inker. In this case Dan Norton had nailed the story so perfectly that I chose to give the pages directly over to colorist supreme Joseph Damon. JMD, as he is known around the biz, did double duty here by digitally inking Dan's original line work. Digital inking, known as "dinking," involves cleaning up, darkening, and accentuating certain details in the pencil sketches. Dinking is done using a computer program such as Adobe Photoshop.

After the pages were digitally inked, Joseph set about coloring them. I gave him minimal hints on what colors to use, but he did a wonderful job of following Dan's lead. One major problem any colorist has with a sequence featuring jungle warfare is how to color the characters, who must be wearing camouflage designed to let them blend in with the jungle foliage, in a way that makes them stand out from the background. As you can see, Joseph did a tremendous job of separating characters and surroundings by varying hues, tones, and shades of colors.

Well-placed colors can be just as effective as strong composition in leading viewers' eyes where you want them to go. For a good example, look at page 3 (shown on page 139). In panels 1, 4, and 5, Joseph uses the oranges and yellows of the explosions to draw in the viewer's eye. But in panel 3, he cleverly shows only the explosions' smoke—a neutral gray—and the Ninja figure dominates the scene.

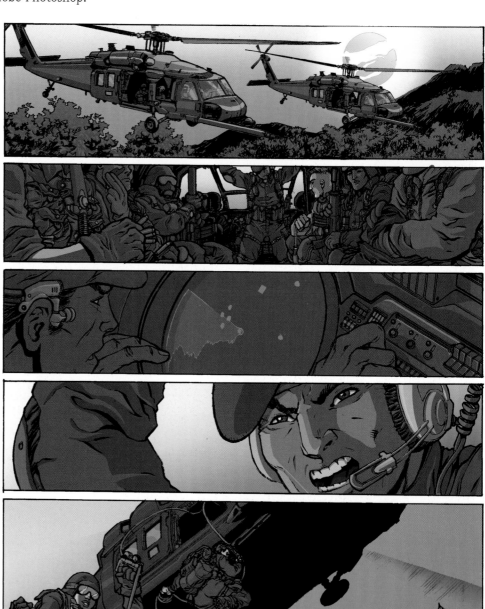

Page 1 final.

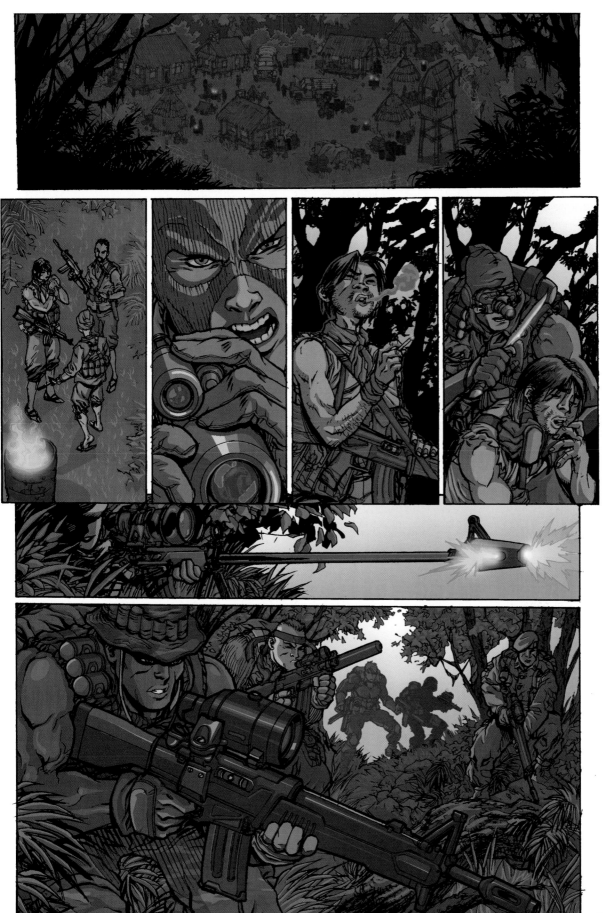

Page 2 final.

Page 3 final.

Page 4 final.

Now all that is left is to send the pages off to a letterer to add word balloons, dialogue, and sound effects.

Bugle Reveille

Okay, troops. Now that you've seen how a couple of Special Forces–caliber artists tackled the assignment, it's time you gave it a shot. When you came to me, you were rank greenhorn amateurs, begging to be molded into disciplined artists of war. I've taught you all I can; now it is up to you to go on. It takes practice, practice, and more practice. Do you think I hit the bull's-eye the first time I fired my M16? Heck, no. It took time, sweat, and patience (not to mention disciplinary push-ups) to learn the ins and outs of firing a weapon. Like my dear sweet old drill sergeant used to say, "Anything worth doing is worth doing well." Truer words have never been spoken. So I hope I've been able to motivate you to give it your all with true military Gung-Ho! spirit. Never give up. Never surrender. You've got your orders. Now get drawing!

DISMISSED!

Index